the nature
of computer games

Digital Formations

Steve Jones
General Editor

Vol. 16

PETER LANG
New York • Washington, D.C./Baltimore • Bern
Frankfurt am Main • Berlin • Brussels • Vienna • Oxford

DAVID MYERS

the nature
of computer games

PLAY AS SEMIOSIS

PETER LANG
New York • Washington, D.C./Baltimore • Bern
Frankfurt am Main • Berlin • Brussels • Vienna • Oxford

Library of Congress Cataloging-in-Publication Data

Myers, David.
The nature of computer games : play as semiosis / David Myers.
p. cm. — (Digital formations; vol. 16)
Includes bibliographical references and index.
1. Computer games—Social aspects. 2. Play—Social aspects.
3. Semiotics. I. Title. II. Digital formations; v. 16.
GV1469.17.S63M94 794.8—dc21 2002154657
ISBN 0-8204-6700-6
ISSN 1526-3169

Bibliographic information published by **Die Deutsche Bibliothek**.
Die Deutsche Bibliothek lists this publication in the "Deutsche
Nationalbibliografie"; detailed bibliographic data is available
on the Internet at http://dnb.ddb.de/.

Cover design by Lisa Barfield

© 2003 Peter Lang Publishing, Inc., New York
275 Seventh Avenue, 28th Floor, New York, NY 10001
www.peterlangusa.com

My fondest memories are of watching my daughters play.

Contents

Prologue

This book is a compilation and consolidation of my research on computer games, players, and play over the last decade. Many of the notions presented here have been published earlier and elsewhere. Some of these notions have been revised, extended, and, I hope, clarified. Others remain close to their original forms. I am indebted throughout to the game designers and players whose work and play I have sometimes directly and many times vicariously experienced and enjoyed. I am also indebted to the editors, readers, and colleagues who have taken time to read and comment on earlier works. I cannot name all of these two groups; both have been invaluable.

I feel very fortunate to have experienced computer game play as it has evolved from the relatively simple beginnings of *Spacewar, ADVENT,* and *Hammurabi* to the more complex designs of today. Were I unfamiliar with play within those initial game designs, I believe many of my conclusions concerning computer game play might be much different. Certainly, it is difficult to evaluate either game design or game play without participation in the interactive processes that determine both.

The book is divided into thematic parts and, within each of those parts, short chapters. I will not outline the entire argument of the book in detail here; I will briefly outline the logic that partitions it.

Part 1: Computer game genres

Part 1 concerns the relatively brief evolution of computer game design and play. This evolution has created distinct genres of computer games that are distinguished with reference to their semiotic forms

and processes. Some of the details of the computer game genre analysis in chapter 4 and chapter 5 appeared originally in Myers (1990a, 1991); that earlier analysis is updated and expanded significantly here.

Chapter 1: Introduction discusses *Spacewar* and some of the terms and concepts associated with the subsequent semiotic analysis of computer games.

Chapter 2: Symbolic form provides a more comprehensive list and explanations of semiotic terms and concepts. The argument here attributes characteristic differences between action and adventure games to differences in semiotic form. *Spacewar* and *ADVENT* are used as both early and representative examples of genre types.

Chapter 3: Symbolic process deals with some important and fundamental distinctions between semiotic forms and semiotic processes—particularly as regards the role-playing genre and its relationship to the adventure genre. The themes in this chapter are considered in more detail later in part 3's chapters on interactivity.

Chapter 4: Intrinsic form summarizes distinctions in the semiotic form of the action, adventure, and role-playing computer game genres as well as the most likely cognitive origin and some basic characteristics of human semiosis. The taxonomy of computer game genres presented in this chapter is an extension of Myers (1984). These topics are discussed in further detail in reference to *Doom* and *Might and Magic* in part 4.

Chapter 5: Derivative forms explains the derivation of simulations, wargames, and strategy games from more fundamental semiotic processes described earlier. A more involved discussion of the computer game strategy genre takes place in reference to *Civilization* in part 4. The figure at the end of chapter 5 provides an overview of some of the basic signs and signification processes associated with a hierarchical taxonomy of computer game genres. *Cruxic* signs and *anticonic* signs—included in this figure—are described in more depth in chapter 11 and chapter 13, respectively.

This first section is something of a warm-up: a cursory, historical account of the evolution and shape of computer game genres in order to introduce important terms and concepts for further analysis.

Part 2: Play as semiosis

Part 2 provides a more formal account of the nature and origin of computer game genres. This second section conducts a formal analysis of semiosis and discusses the relevance of that analysis to play in general and to computer game play in specific. The core of this argument appeared first in Myers (1999).

Chapter 6: Generic form emphasizes distinctions between models and mimicries prior to introducing the symbol set from Spencer-Brown's *Laws of Form* (1972). The elemental symbols of Spencer-Brown's "calling" and "crossing" are subsequently used to map the semiotic processes of play and paradox.

Chapter 7: Semiotic conditions uses the Spencer-Brown system to define values of *convention, paradox,* and *novelty*. These three values—each a common outcome of a natural human semiosis—are then mapped from their functions within logical paradox to their functions within significations of play.

Part 3: Interactivity

Part 3 defines the characteristically *interactive* process that guides a natural semiosis over time and during play.

Chapter 8: Interactivity reviews problems associated with defining interactivity and some characteristic definitions of interactivity currently in use in the humanities and the social sciences.

Chapter 9: Defining interactivity isolates a definition of interactivity based on Rafaeli & Sudweeks (1997). This definition is offered as a reconciliation of the formal vs. functional dilemma caused by contrasting methods of conceptualizing interactivity within media studies and interpretive criticism.

Chapter 10: Valuing interactivity places interactivity within a semiosis of play, which includes both significations of opposition and significations of contextualization. This chapter also argues for a phenomenological account of interactivity during play—an account put forth in the chapters following.

Part 4: Interactive play

Part 4 provides a phenomenological account of computer game play with reference to play within three specific computer games, each represent-

ing a separate computer game genre. Each chapter in this part offers a brief (rather journalistic) history of the representative game's design and then a characteristic summary of significations of play within that game.

Chapter 11: The phenomena of computer game play recounts the development of the *Doom* computer game series. Play within *Doom* is characterized by the signification of iterative sequences of visceral oppositions culminating in the signification of the *crux,* or *cruxic* sign(s). This latter signification results in the construction of a nonvisceral *context of design.*

Chapter 12: Might and Magic focuses on the *Might and Magic* computer game role-playing series, with an extended analysis of play within *Might and Magic VII.* Semiosis within the role-playing genre ends with the transformation of context into character. Further signification then requires either an expansion of context or play within alternative genres.

Chapter 13: Civilization examines the design and play of *Sid Meier's Civilization* as an exemplar of the computer game strategy genre. I have discussed this game earlier in Myers (1992b)—and elsewhere—though that earlier discussion concerned *Civ I;* here, the most detailed analysis concerns the design and play of *Civ II.* The entire *Civilization* series design, through incorporation of game design elements that transform game context, is presented as an *anticon.* The *anticonic* form reproduces those formal properties of human semiosis that motivate both construction and resolution of semiotic paradox.

Part 5: Conclusions

This last and briefest section contains a single chapter, *Chapter 14: Summary and implications.* This chapter highlights the implications of the claims made by this book for media theory and play theory. These implications are suggestive rather than definitive. Some of the notions here have been considered in passing in other contexts (e.g., Myers, 2001).

These five parts are intended to have a cumulative effect and, thus, are intended to be read in the order they are presented; I make this recommendation particularly for readers who are unfamiliar with semiotics (or, alternatively, intimately familiar with cultural semiotics). I introduce im-

portant terms and concepts in the early parts and chapters that are put to more rigorous use in the later ones.

Those more interested and experienced with computer game play than with the particulars of semiotic analysis will find part 1 and part 4 most accessible. These parts are the sections of the book most directly concerned with the history and play of computer games.

PART 1

COMPUTER GAME GENRES

Chapter 1

Introduction

During 1962, Steve Russell and his colleagues at MIT put the finishing touches on *Spacewar*[1], the first video game.[2] *Spacewar* was designed as a demonstration program for the PDP-1, a newly minted mainframe computer with an innovative operating system allowing simultaneous users. As it was first conceived, the game had a purely utilitarian function: to sell PDP-1s. Yet, despite being the first of its kind, and despite its intended use as a marketing tool, *Spacewar* followed a pattern of design and play characteristic of subsequent electronic games.[3]

Spacewar was *representational;* that is, the game signified something other than itself. In the space-race spirit of the 1960s, *Spacewar* represented a dogfight between two competing spaceships: a thin ship labeled "Needle" and a slightly thicker ship called "Wedge." These ships began the game at opposite corners of a rectangular display, armed with a limited number of torpedoes and a limited supply of fuel. *Spacewar* players moved their ships with thrust and rotational controls, using fuel as they did so, and attempted to blast their opponents' ships out of their common space.

Other demonstration programs for the PDP-1 were also simulations: *Bouncing Ball,* for instance. And, like *Spacewar*, these programs were modified over time. But the evolution of these nonplayable simulations followed a different path than that of playable simulations like *Spacewar*. *Bouncing Ball* and other, similar programs were modified to make their representations more realistic; and, once an acceptable level of verisimilitude had been reached, their designs were locked in final form. *Spacewar*, however, was both simulation and *game,* and its design was evaluated and modified according to different rules.

The software governing the movement of the two ships in *Spacewar,* originally intended to simulate real-world physics, was altered not only to make it more realistic but, in many respects, to make it less so—particularly when modification was required to meet pragmatic needs of either human player or mechanical device. For instance, although the game forced the two ships to accelerate and decelerate according to accepted laws of physics, the ships' rotation ultimately adhered only to laws of play—in order to avoid some messy statistical complications involving changing moments of inertia.

Pragmatics also motivated changes to routines that coded and calculated each ship's position on the screen. The problem in this instance was not the statistical complexity of the calculations but the mechanical limitations of the PDP-1 and the human eye. While the game's original software tracked ship movements accurately, the PDP-1 had neither the memory nor the speed required for all positional calculations to take place quickly enough to preserve an illusion of motion. A flicker-free display was achieved with a revised graphics coding scheme—more efficient and "realistic" to the human eye, but no more mathematically accurate than the original.

Other components of the revised versions of *Spacewar* were similar compromises between representational accuracy and mechanical necessity. The most dramatic change was the insertion of a large gravity well in the center of the screen that relentlessly pulled both competing ships toward its destructive core. Forcing each player to react to the pull of gravity—in addition to a belligerent opponent—greatly enhanced game play. But there was a limit to the number of such complications that did so. The effects of the gravity well applied only to the two ships—not to the missiles the ships launched toward each other.

Another revision was the addition of a background star field. Originally, Needle and Wedge battled against a solid black display. However, during the heat of battle, the relative positions of the ships were hard to determine. Placing stars behind the ships provided contrast necessary to track the ships in flight. Although a simple random star field would have served this purpose, the final star field was given a representational as well as functional role. The stars behind Needle and Wedge were fixed to

represent the true positions of stars as seen from Earth—including each star's relative level of brightness.

And, in a final nod to the laws of play, *Spacewar* extended each ship's pseudo-realistic movement through an imaginary "hyperspace," which, when called upon, resulted in the random displacement of the ship on the screen. Hyperspace movement was, in effect, the same fundamental movement that took place between the end of one game and the beginning of the next. It was player-ship movement outside the game entirely, a desperate movement of last resort, carrying with it some probability of total destruction; this culminate, *recursive* movement trumped laws of both physics and game in order to reset time to that initial point where anything, once again, might happen during play.

By 1962, *Spacewar* had assumed the basic shape that would carry it from the bowels of the PDP-1 into electronic gaming lore. Still, play and revision continued. In 1971, Nolan Bushnell distributed the *Spacewar* design as *Computer Space,* the first commercial arcade game. Shortly after, in 1979, Bushnell's company, Atari, released a *Spacewar* descendent—*Asteroids*—that became that company's best-selling game. *Asteroids* had many of *Spacewar*'s original features, with several twists. Some of *Asteroids'* innovations resulted from technological improvements to game hardware; others, the more interesting, were more fundamental conceptual changes to game software.

By 1979, computer hardware had much improved graphic displays. The realistic ship movement of *Spacewar,* often hard to see and always difficult to control, was streamlined and redesigned in *Asteroids* to take advantage of higher resolution displays. The result, however, was not a more realistic representation of movement in space; rather, the more sophisticated displays used chunky, cartoonlike symbols that were more easily discerned and manipulated by human players.[4]

Mechanical improvements also allowed *Asteroids* game designers to make several conceptual modifications to the original *Spacewar* design. Unlike *Spacewar, Asteroids* was a single-player game, beginning with a Wedge-style spaceship in the center of the screen. From this point forward, the game software served as both game context and sole game opponent.

At the beginning of the game, the lone spaceship within the game was besieged by rough-hewn asteroids floating in from all angles. The player-ship could either dodge these obstacles using thrust and rotational controls like those in *Spacewar,* or it could destroy them with torpedo-like missiles, just like those in *Spacewar.* Or, as a last resort, the ship could invoke the random displacement of hyperspace, just like in *Spacewar.* Unlike *Spacewar*, however, the *Asteroids* software incorporated something very much like the supragame movement of hyperspace during extended game play—the movement from one game "level" to the next.

Initially, the single player of *Asteroids* had a simple task: to clear the screen of invading asteroids. Each time the last asteroid was destroyed and all game obstacles overcome, the software restored the asteroids to their original, pristine condition—except that now those asteroids appeared more rapidly, more frequently, and at increasingly more difficult angles of intercept.

This strategy of sustaining game opposition through recursive software design had simply not been available under the limitations of the PDP-1 hardware.[5] While the appeal of the original *Spacewar* was dependent on the vagaries of human opponents, play within *Asteroids* could be more carefully planned and choreographed to maintain the oppositions of play over time. *Spacewar's* gravity well, originally inserted only to enhance game play between two human players, had become—in the asteroids of *Asteroids*—sufficiently complex and so cleverly designed as to sustain game play without the aid of a human opponent.

This feature was common among electronic games and most particularly among action games: the ability to motivate and sustain *individual* play. This was normally accomplished through implementation of an increasingly difficult (but theoretically infinite) series of levels of play; these levels inevitably repeated fundamental *cognitive* (signification) processes that occurred during individual play. This feature was so common and persistent that it could be located within multiple-player as well as single-player games, and all electronic games—all games in general—could be identified according to the mechanics of an iterative and, at advanced levels, *recursive* play. These mechanics were quite similar from one game to the next, and from one player to the next. A game that exploited these

processes most successfully was a game that was played widely, intensely, and repeatedly.

After forty years, *Spacewar* is still being played—and still being revised. There are retro-versions of the game that remain loyal to the original's feel and function. Yet, while these versions are faithful in spirit, contemporary designers are not above the occasional software tweak.

There are also many separate and sophisticated descendants of *Spacewar*. None of these is so far removed from its predecessors, however, that its derivation is not clear. It is quite easy to map the design path from *Spacewar* to *Asteroids* and, subsequently, from *Asteroids* to a variety of contemporary computer games (such as Chris Roberts' *Wing Commander* series).

Each of the fundamental characteristics of *Spacewar* design and play— its representational (and *oppositional*) origins, the pragmatics guiding its design modifications, and the fundamentally repetitive nature of its extended play—mark subsequent computer games. It is, in fact, the pervasiveness of these characteristics that more generally distinguishes between play and nonplay.

In the discussion to follow, I will develop several themes first obvious in the design of *Spacewar*. The first is the degree to which computer games— and, more generally, play behavior—are rooted in a distinctive representational form. The second concerns the short but informative evolution of electronic games. This evolution, as demonstrated by countless examples beyond *Spacewar,* has been unerringly toward *visceral* representations accessible within a natural human semiosis—with significant implications for media theory. The third theme concerns the repetitiveness (some might say addictiveness) of computer game play. This play and replay has *cognitive* and *recursive* qualities that, in association with a common representational form, position games and gaming as *semiotic* objects and processes.

Chapter 2

Symbolic form

A major portion of the original *Spacewar* game was designed to represent, as realistically as possible, the movement of ships through space. Although the ship symbols—Needle and Wedge—were simple two-dimensional abstractions, the *patterns* of those symbols over time (within the limited resolution of the PDP-1 display) simulated laws of physics.

The physical realism of *Spacewar,* however, was never essential to game play. In fact, as the game was modified over time, it became less realistic. Although the modified symbol patterns within *Spacewar* no longer represented the movement of physical objects through space, those patterns were not random. Very early in the history of computer games, game symbol patterns coalesced into a limited number of computer game *genres.*

Spacewar was the first *action* game—a genre dominated by *first-order* signs (see appendix). That is, the signs (signifiers) of Needle and Wedge within *Spacewar* initially represented (signified) ships in space, but, over time and during play, these signs came to signify no more than Needle and Wedge, two abstract symbols within the game. Once their signification was confined to the game context, the value and meaning of Needle and Wedge became *denotative*—determined solely by the physical presence (form and function) of the Needle and Wedge symbols within the PDP-1 display.

For instance, "missiles" in *Spacewar* denoted small, rectangular points of light within the PDP-1 display, limited in number, which moved from the tip of Needle/Wedge when a control button was pressed at a constant rate, at a constant velocity, in a constant direction (unaffected by the gravity well), either until coinciding with Needle/Wedge, at which time Needle/Wedge disappeared from the screen and all rectangular points of

light disappeared from the display and the game was reset, or until a certain time had passed and a certain distance had been reached, at which time a small, rectangular point of light disappeared…and so forth.

The extent to which these specific characteristics of *Spacewar* missiles within the game display coincided with characteristics of other ("real-world") missiles was entirely superfluous to game play—except perhaps to the extent that such coincidence allowed players to learn more quickly the characteristics of *Spacewar* missiles.

Similarly, first-order, denotative signs characterize all games within the *action* (sometimes referred to as *arcade*) genre. Symbols within action games are interpreted (given value and meaning) by players through the sensory (most often visual) characteristics and patterns those symbols exhibit during play. For this reason, written instructions explaining action game rules are eschewed by players who prefer to experience action game designs and understand action game rules through their visceral "feel."

Another early (1972) and very different computer game genre prototype was William Crowther's *Colossal Cave Adventure* (*ADVENT*), the first of the *adventure* game genre, in which game play was dominated by *second-order* signs—in this particular case, by words rather than by images.

Unlike *Spacewar, ADVENT* (designated by six all-capital letters due to the peculiarities of FORTRAN and the PDP-10 on which it was first constructed) was played with a keyboard rather than a joystick. *ADVENT* play was asynchronous (turn-based) rather than synchronous (real-time). And *ADVENT* gamers had different goals and means to achieve those goals than did *Spacewar* players. Most significantly, *ADVENT* gamers had no human opponent (like *Spacewar*), nor the relentless opposition of game context (like *Asteroids*); *ADVENT* game play was more a process of exploration and discovery than competition. In Crowther's original *Colossal Cave,* for instance, the goal of the player was simply to explore the cave, and player-character choices within the game were patterned after those that might have faced a real person attempting to explore a real cave.

Very much like the original *Spacewar,* then, the original *ADVENT* design was a simulation, an attempt to represent real-world objects and events. Crowther, an accomplished spelunker, faithfully described many

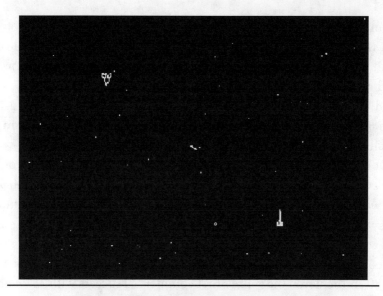

Figure 2.1: *Spacewar* begins (screenshot).
Wedge is at top left; Needle is at bottom right.

YOU ARE STANDING AT THE END OF A ROAD BEFORE A SMALL BRICK BUILDING.
AROUND YOU IS A FOREST. A SMALL STREAM FLOWS OUT OF THE BUILDING AND
DOWN A GULLY.

Figure 2.2: *ADVENT* begins (screenshot).

features of Kentucky's Mammoth and Flint Ridge caves in the game, and
his descriptions were colored with a realistic spelunker's vocabulary (e.g.,
"Y2," indicating a secondary passage). Unlike *Spacewar*, however, the game's

realism was achieved indirectly—through a *connotative* signification process. *ADVENT* play, guided by *second-order* signs, required a prelearned human language rather than a prewired human eye for signification.

Through distribution over computer networks, *ADVENT* was widely played; and, like *Spacewar, ADVENT* was revised over time. Just as with *Spacewar,* virtually all these revisions decreased the game's realism, and virtually all made the game more fun to play.[1]

Don Woods in 1976 was among the first to dramatically rework the game's cave exploration theme. At about the same time that the *ADVENT* code was translated from FORTRAN to Unix, Woods inserted a number of fantasy elements into Crowther's game world, including magical items located at various cave locations and several new obstacles (puzzles).

Scott Adams later translated the basic adventure game format to the TRS-80 and achieved the genre's first commercial success with *Adventureland* (1978); soon after, *Adventureland*'s popularity was eclipsed by the much broader based popularity and play of Infocom's *Zork* (1979).

Each of these successive revisions decreased the original game's realism and increased the need for *significations of contextualization* during play. That is, assigning values to game design elements in the original *ADVENT* (e.g., prioritizing which cave passage to take) was accomplished largely through trial and error, whereas assigning values in the revised versions of the game entailed some knowledge and understanding (or *signification*) of either the game context (e.g., a key in one part of the cave unlocked a door in another part of the cave) or the broader contexts of language and drama (e.g., keys unlock doors, swords are more effective weapons than knives, etc.).

In order to effectively value first-order signs, the action game player merely had to possess the proper, biologically endowed sensory apparatus. This apparatus, by default, included embedded cognitive mechanisms that, in a biological process parallel to the social process of determining linguistic value, determined the values and meanings of action game signs and sign patterns. Thus, significations of contextualization within the action genre, while equally vital to game play, were less dependent on cultural knowledge and, as a result, less variable than significations of contextualization within adventure games.

Because of the contrast between the linguistic signifiers of adventure games and the more visceral signifiers of action games, adventure games were labeled "interactive fiction" by Infocom and others interested in establishing a marketing niche for the genre. Whether or not "interactive fiction" accurately described the adventure game genre (the term was ultimately more useful for marketing purposes than for literary analysis), the term did mark a fundamental difference between the action and adventure genres. And, indeed, throughout the history of these two genres, differences in their symbolic forms have paralleled differences in their play: Action game play promoted competition among players; adventure game play (particularly those adventure games emphasizing role-play) promoted cooperation among players.

The denotative signs of action games evoked a common (visceral) context within which numerous and varied oppositional relationships could be immediately and unambiguously valued. Connotative signs, on the other hand, required a more active and conscious effort during significations of contextualization, which constructed a nonvisceral *context of design*. This context of design tolerated fewer and less varied oppositional relationships during subsequent signification and play.

These basic differences in the signification processes during play of action and adventure games led to distinctly different methods of extending play within each genre. Action game play—here exemplified by *Spacewar*—was extended through an *iteration* of context (i.e., progression through a series of "levels" of play.) Adventure game play, on the other hand, was extended through the iteration of elements *within* the game context. *ADVENT,* for instance, went through several revisions: adventure350, adventure370, adventure440, adventure550, and the like. Game play and context were identical in each of these; differences among them were only in the number of points (treasures) available to collect within the cave. (Crowther's original *Colossal Cave* was a mere five-treasure version.)

Adventure games also had less replay value than action games due to these same differences in semiotic form. For, once the semantic context (values and meanings) of the adventure game had been determined, semiotic play (the signification process) within that game was complete. Within action games, however, semiotic play was never complete. Action games

provided iterative contexts of generic semiotic form rather than a single context of fixed semantic content; it was only during the immediacy ("real time") of play that the denotative signs of action games were assigned value and meaning. Thus, signification during action game play took the form of a continuous meaning-making process[2], while signification during adventure game play took the more limited form of a single meaning-making event.

Summary

The genres of action and adventure can be distinguished in two fundamental respects. The first is the type of sign found most commonly within each genre. The second is the type of signification applied most commonly within each genre. To a great degree, these two distinctions are derivative of each other.

Sign types can be either denotative or connotative, first- or second-order. Significations are either oppositional or contextual. Significations of contextualization construct a context of design and result in the assignation of existent (conventional) values and meanings within that context. Significations of opposition are only possible within a preexisting context and might—under conditions later to be described—result in the assignation of supracontextual, or novel, values and meanings.

Chapter 3

Symbolic process

Though the original *ADVENT* and its revisions were inspired by *Dungeons & Dragons* and similar role-playing games, computer adventure games and computer role-playing games came to occupy separate genre categories. Currently, these two genres are distinguished from the action genre by their mutual reliance on second-order signs. But ultimately, it is the connotative signification *process* promoted by adventure and role-playing games—not simply their reliance on second-order *signs*—that distinguishes them from games within the action/arcade genre.

After *ADVENT,* the adventure genre moved through several superficially distinct forms: the original text adventures; graphic adventures (e.g., *Myst*); and third-person graphic adventures (e.g., *King's Quest*). The differences among these were the result of differences among game signifiers; each employed the same basic signification process.

Myst (1993) players explored an island much as *ADVENT* players explored a cave, but that island was represented visually rather than linguistically. The *Myst* screen shots were quite detailed—much more realistic, for instance, than the star background in *Spacewar*—but these images retained their connotative function within the adventure genre. The images on the *Myst* screen did not (as did the images on the *Spacewar* screen) determine the values or (denotative) meanings of signs within the game. The *Myst* visuals were more illustrative than explicative, and those symbols that were used to construct, signify, and solve the visual puzzles and mazes of *Myst* had little relevance to the game's broader contexts of play.

The visuals in Sierra On-Line's *King's Quest* games (the first of this long-running series was written and programmed by Ken and Roberta

Williams in 1983) were likewise used connotatively. The third-person perspective that the *King's Quest* series added to the genre attained meaning during game play through exactly the same signification process as the first-person perspective of *ADVENT*. In fact, all adventure games, graphic or text, first- or third-person, could be translated into the original, *ADVENT*-style text format with little fundamental change in their game play.

Role-playing games shared many of the same signifiers as *ADVENT, Myst,* and other adventure games, but role-playing game symbols had broader and more significant functions than those symbols had in adventure games. Perhaps the most obvious difference between the two genres was the emphasis on symbol *transformations* within role-playing games. There were, however, other important differences as well.

Electronic role-playing games were originally designed as simulations of simulations, rather than, as was the case with the first action and adventure games, as simulations of real-world objects and events. The first paper-and-pencil role-playing games—*Dungeons & Dragons* is the archetype—were patterned after tabletop wargames[1] that attempted to be as historically accurate as possible in their depiction of armor types, weapon sizes, encumbrances, and the like. This meticulous attention to realistic detail was, over time and during play, diminished within role-playing games. Instead, role-playing game design came to focus on player-*characters* and, by extension, player-character *interactions*. By the time role-playing games were translated into electronic form, they had evolved from realistic, quantitative simulations to more loosely structured templates for social interaction.[2] During play of the first computer role-playing games—at least in part due to hardware limitations of the period—these social interactions took place more often outside than inside the game.

During the early 1980s, I began my first rigorous observations of the game-playing process in a small computer store just outside the University of Texas campus called Computers to Go. That store sold hardware and software for personal use, but it also rented Apple II computers—and

computer time—to UT students. Most often, students rented time on the desktop systems inside the store to play games, and the games students most often played were two role-playing games, *Wizardry* and *Ultima,* which well represented the role-playing genre then and now.

My analysis of game play (Myers, 1984) described the activities of the game players within Computers to Go and those player interactions that took place before, during, and after play. This analysis showed the importance of an ongoing contextualization process that gave meaning to symbols within role-playing games. This contextualization process emphasized an important difference between role-playing games and their adventure-game predecessors: *Wizardry* and *Ultima* were not self-contained in the same sense that *ADVENT* (or *Spacewar*) was self-contained. Both *Wizardry* and *Ultima* were complex game *systems* that encouraged a signification process extending beyond the time spent in front of the computer playing the game.

> Many [role-playing] gamers keep extensive notes, records, and ledgers of their individual game experiences. These papers are necessary for bookkeeping in some of the more complex role-playing and multiplayer games [i.e., simulations of board games and wargames]. In both types of games the papers look the same: They are composed of facts and figures largely unintelligible to anyone but the player who wrote them. Yet their personal value is far greater in role-playing games than in multiplayer games. After multiplayer games these notes are irreverently discarded; after a role-playing episode the notes are carefully revised and stored away to aid future game-playing.
>
> It is obvious that the latter notes, filled with statistics and data that are boring and mundane to any other player, achieve the status of valuable personal diaries and have dramatic meaning to their owners....
>
> One of the few things that will draw a regular gamer away from his solitary game-play experience is the chance to tell of past experiences. These stories are exchanged as older people might exchange baby pictures. During the process, information is gained about the game software, the game world is made more persuasive and real by sharing it with others, and real-world social relationships are formed that may continue to exist outside the game-playing environment.
>
> Myers, 1984, p. 176

In many ways, significations within the role-playing game mirrored social significations outside it. That is, the signification process that oc-

curred during play was the same signification process that occurred during social interactions. This signification process involved contextualizations of the same sort as adventure games, but it required that those contextual significations involve *multiple* characters. Role-playing games commonly involved player control of multiple characters, and, equally importantly, each of these characters could occupy multiple roles within the game. This meant that even if the role-playing gamer controlled but a single character, transformations of that character during the game provided multiple-character perspectives.

Let me clarify this point with a brief description of generic role-playing game design—pertinent to both *Wizardry* and *Ultima* as well as more contemporary games.

Role-playing characters are created prior to the beginning of play. Commonly, these characters are created from some limited number of die rolls (see Myers, 1992a for a more detailed description of character creation systems). This process of character creation is most often at least partially random and, as such, relatively insignificant to subsequent play. Yet, many computer game players (and paper-and-pencil game players) spend hours randomly rolling and re-rolling dies in order to make sure their characters have the highest possible values within available characteristic categories (strength, dexterity, etc.). Each of these successive die rolls *represents a different character within the game,* so that, prior to beginning play, players must establish some context (regardless of its accuracy) for evaluating characters within the game. That is, they assign connotative values to character symbols in order to choose among them. In contrast, players are unlikely to spend any time whatsoever choosing between Needle or Wedge or any similar player-character signs within an action game.

Also, commonly within role-playing games—again, unlike the common situation in action games—players control multiple characters. This was literally the case in *Wizardry,* in which a six-member party of player-characters explored a dungeon. And, while players controlled a single character in the original *Ultima,* that character could be transformed during play into several different character types (fighter, wizard, explorer). Each of these character types was more effective than another at some

point during play, and, therefore, each type had to be evaluated on the basis of its relationship to others. The options presented by multiple characters within role-playing games, as well as the potential to transform individual characters into alternative character types, required the assignation of connotative values to characters and, subsequently, the evaluation of those values within the greater game context.

This signification process is exactly the same process that assigns roles and values to individuals in a classroom or a workplace or any other real-world social setting: It requires knowledge of a social context and how that context defines and values individual roles within it.[3] In most real-life contexts, however, individuals might deny, resist, or otherwise alter social transformations. In role-playing games, these transformations are irresistible. Players are given no choice over whether their player-characters are transformed; players are given choices, to a limited degree, only over *how* their characters are transformed. And, significantly, these *how* choices are neither randomly nor capriciously made.

Few role-playing gamers make character choices based on their personal preferences outside the game context—or on the basis of any factors irrelevant to game play. Refusing to participate in or simply ignoring the contextualization processes of role-playing games is very rare, particularly among dedicated gamers. Almost without exception, advanced players of role-playing games are extremely knowledgeable of game context, and these advanced players choose characters and character transformations entirely on the basis of that knowledge.

While the identification of players with their characters inside role-playing games is very real, this identification does not result from any close parallel between game character and player personality. The notion, for instance, that players "act out their fantasies" within role-playing games is not quite true. Rather, players *construct* fantasies—often quite different from any held previously—through an elaborate signification process that places their player-characters at the center of a broad web of connotative values. These complex semiotic systems define characters during play and might contain a variety of signs (i.e., different character types: thief, wizard, fighter, etc.). The specifics of these signs (their *denotative* values) are irrelevant to game play—and to game appeal. The signification *process* that

constructs and sustains player-character roles motivates play, not the specifics of the signifiers transformed by that process.

For this reason, players willingly accept conventionally ugly, embarrassing, and/or offensive characters if those characters are more effective during game play (e.g., more highly valued within the game context). And, realizing this, game designers go to some lengths to balance character choices within a game, so that all player-character choices are not channeled toward a single character or role, which would then diminish and, eventually, eliminate contextual signification during play.

Sometimes, these attempts at play balancing have fallen short, resulting in a game biased toward the choice of a particular character type—a game that confines its significations of play to a single oppositional relationship: the "good" character versus all others. This lack of balance among player-character choices is a particular danger when role-playing games have attempted to reproduce preexisting contexts.[4] For instance, designers of role-playing games based on popular comic books have found it very difficult to adhere simultaneously to the rules of the comic book and the rules of play within the role-playing genre.

> Greg Gordon reached this conclusion in designing *DC Heroes*: "[how magic worked in the DC comic-book universe] had me panicked. The game did not work that way. If magic Powers are superior to others, why would any Player in his right mind choose another sort of Power?"
>
> Myers, 1992a, p. 433

Ultimately, the realistic simulation of movement in space was not consonant with play in *Spacewar*. Likewise, role-playing game designs that attempted to simulate preexisting semiotic contexts were able to do so only insofar as those contexts did not impede the characteristic signification processes of the role-playing genre.

Computer role-playing games then, like computer action games, like computer adventure games, have a conventional representational form without that form's conventional representational meaning or value. Although game signifiers and signification processes—dominated by oppositions within action games and by contextualizations within adventure/ role-playing games—are common both inside and outside of play, what

those signifiers and processes signify during play is unique. Ultimately, the signs and symbols of computer games reference only their own signification—or a natural human semiosis.

Chapter 4

Intrinsic form

If the fundamental characteristics of electronic games are understood as semiotic, then it is easier to understand the evolution (or lack thereof) of those characteristics over time. For instance, the role-playing genre slowly usurped the popularity of the adventure genre, and there were specific semiotic features of the adventure genre that foreshadowed its fall.

ADVENT and subsequent adventure games placed the game player in the awkward position of valuing game symbols within the adventure game context while, at the same time, constructing a large portion of that game context during play. Without design elements (including game rules) guiding significations of contextualization, adventure games were unable to motivate a uniform and consistent contextualization during play. And, as the number and complexity of symbols increased within these games, it became increasingly necessary to impose a consistent contextualization process in order to sustain extended play. Without such a process, the adventure genre was forced to prolong play through pattern and symbol *repetitions;* the genre could not, as the role-playing genre could, extend play through the *transformation* and *expansion* of context common within a more natural signification process.

To some degree, perhaps, the number of random choices in early adventure game designs mitigated this conflict between out-of-context and in-context play (and perhaps delayed the genre's popular demise). Random choices—e.g., randomly choosing which of several directions to go within a maze, or the trial-and-error choices necessary to solve a par-

ticular puzzle—resulted in game play in the absence of a broader game context, so that the player could passively (blindly) construct that context. This preliminary play then served as prelude and background to a more active and purposeful contextualization process during subsequent play.

But at some point during extended play, adventure game designs simply fell apart of their own weight. The signification processes of the first adventure games were hopelessly muddled by a lack of context for player-character choices; play within those games was strongly biased toward player-character surprises (or *actions*) rather than player-character revelations (or *roles*). Eventually, inevitably, the isolated puzzles, surprises, and tricks of the adventure genre lost their appeal.

The many stylistic incongruities of the many revised versions of the *Colossal Cave* mirrored the adventure genre's inconsistencies of semiotic form. The realistic geological detail of Crowther's creation became intertwined with giants, trolls, and vending machines. These incongruities—often described as part of the original game's "charm" but seldom repeated in subsequent designs—are probably best considered lucky accidents that helped (temporarily) hide the semiotic dissonance within the genre.

Compared to the adventure genre, the role-playing genre was a more consistent and coherent representation of the connotative signification process associated with second-order signs. Role-playing characters were created according to strict rules that assured their proper signification within the game context and, during that signification, *expanded* the game context. Just as *Asteroids* had provided a more structured and predictable form of oppositional play than had *Spacewar,* role-playing games provided a more structured and predictable form of contextual play than adventure games.

If we can attribute the popular failure of a particular genre to inconsistencies of semiotic form, then we should likewise be able to attribute the success of various computer game genres to consistencies of form. Very early in the history of electronic games, two basic forms—the role-playing genre, consistent with the second-order signs of human society, and the action genre, consistent with the first-order signs of the human sensorium—came to dominate game design and play. It was remarkable

how quickly these forms coalesced into definitive genres, and it was equally remarkable how little these genres were later altered by otherwise radical changes in computer gaming technology.

All current computer game genres can be understood as some combination or refinement of semiotic oppositions, contextualizations, and their associated significations. However, in order to understand fully the function of these processes within game play, they must be placed within the biological limits of human cognition.

For instance, important aspects of role-playing character design seemed to adhere to Miller's (1956) determination of human immediate memory and absolute judgment being limited to plus or minus seven "bits" or "chunks." The conclusions of Miller's classic article, which obviously predates computer gaming, are worthy of emphasis here:

> First, the span of absolute judgment and the span of immediate memory impose severe limitations on the amount of information that we are able to receive, process, and remember. By organizing the stimulus input simultaneously into several dimensions and successively into a sequence or chunks, we manage to break (or at least stretch) this informational bottleneck.
>
> Second, the process of recoding is a very important one in human psychology and deserves much more explicit attention than it has received. In particular, the kind of linguistic recoding that people do seems to me to be the very lifeblood of the thought processes.
>
> Miller, 1956, p. 96

Indeed, an assumption of the argument here is that the relatively small number of semiotic processes at the root of play are equally at the root of broader cognitive functions and higher-level representational thought. "Recoding" (as mentioned by Miller above) is then plainly associated with signification. Certainly the consistency of the limits imposed on cognitive stimuli (signifiers) within electronic game design have intriguing formal similarities with the limits imposed on visual and aural stimuli in other contexts.

This position is similar to that taken by literary theorists—e.g., Lakoff (1987), Johnson (1987)—who have found literary metaphor to result from the abstraction of common features of the human sensorimotor experience. (See also Brandt, 2000.) Theory of this sort assumes that natural

experiences—such as those involving force, motion, and space—are somehow mapped from nonmetaphorical to metaphorical domains. This mapping process then serves as the foundation for human conceptual systems, and all human conceptual systems are therefore dependent on and initially determined by the mechanics of the human body and how that body is wired for sensory feedback in a natural world. A full understanding of cognitive biology is then necessary to properly understand the origin and nature of all subsequently generated semiotic relationships.

Other notions of cognitive limits focus on more tightly constrained, function-specific features of symbol use. For instance, theories of generative grammar have long recognized limits on the formation of layered or embedded sentence (or other meaning-making) structures in natural language—imposed on the potentially endlessly recursive processes of an abstract language by the limited interpretive capabilities of human communicators.[1,2] The origins of these limits are found, over time, in a natural history of the human species (and, in this instance, are especially important, since limits on recursion figure prominently in the significations observed during play).

As a simple example of observable limits among game symbols, again consider character generation systems within role-playing games. Paper-and-pencil role-playing games commonly construct their characters of seven (plus or minus two) character attributes; this number is very consistent across many different role-playing game designs. In traditional *Dungeons & Dragons,* for instance, there were six character attributes: strength, dexterity, constitution, intelligence, wisdom, and charisma. *RuneQuest* (1978) had seven: strength, constitution, size, dexterity, appearance, intelligence, and power; *DragonQuest* (1980) also had seven attributes: physical strength, manual dexterity, agility, endurance, physical beauty, willpower, and perception; *GURPS* (1985), a generic role-playing system, used eight character attributes: strength, dexterity, health, intelligence, willpower, charisma, magic attributes, and magic resistance. And so forth.

While other important and consistent features of role-playing character generation systems—such as the extent to which these were probabilistic or deterministic—are also semiotically significant, at this point I

would only note how closely electronic role-playing games retained the design parameters of their paper-and-pencil predecessors, despite the obvious ability of computers to handle greater than seven (plus or minus two) character attribute categories. Is this common feature of role-playing games indicative of common features of their play? Is it indicative of common features of their players?

I will argue that it is.

Of course, observing some particular characteristic of multiple role-playing game designs is one thing, and attributing that characteristic to a biological determinism that causes, among other things, elements of electronic game design to converge upon the number seven is another. Perhaps design similarities among computer games are the result of coincidence, or cultural values, or economic pressures. However, my position is that many of the common features of computer games—and of play in general—reference and represent common features of the human signification process, or semiosis.

In order to consider this position fully, I would note similarities in the symbolic structures of computer games, find similar structures in computer game play, and reveal parallels between common features of play and common features of human semiosis. Of most immediate concern are those common symbolic features of computer games that most tellingly reveal genre types.

Though the action and role-playing genres have remained, for the last three decades, fundamental to computer game design and play, there have been many past and current variations of their basic semiotic forms. The common delineation of computer game genres is now widespread and well known to computer game designers and to game players through the use of these genres for marketing purposes.

In 1990, I analyzed popular categories of computer game genres as a single, hierarchical system built upon the fundamental play processes found in arcade (action) games and adventure games (Myers, 1990a). That analysis described simulations and role-playing games as most similar in form to action and adventure games, respectively; that analysis also positioned war games and strategy games as derivatives of more basic semiotic forms.

More than a decade later, I see no reason to significantly revise that analysis here. I would, however, like to restate my earlier argument in order to use the terms of this essay and in order to comment on several important developments in computer game design that have since helped clarify and confirm my earlier conclusions.

The six genres I used in my original analysis—action (arcade), adventure, simulation, role-playing, wargame, and strategy—still well represent the field (though other, equally comprehensive taxonomies can also be found). Certainly, these six genres are not inclusive of all possible variations of semiotic form, nor are they entirely exclusive of each other. However, the semiotic forms of these six continue to encompass the majority of popular electronic games.

Two "new" genres of games have received a great deal of play since 1990: "action-adventure" and "real-time strategy." Both result from the combination of preexisting semiotic forms, and in fact, if the analysis here is correct, could not have resulted from anything else. If game genre is best explained as semiotic form, and if semiotic form is determined by biological limits of human semiosis, then any subsequent "new" genres must necessarily result from some combination, variation, or extension of a relatively smaller number (I have, so far, suggested only two) of preexisting forms.

Summary

The *action* genre is characterized by its use of first-order, denotative signs and the signification process that gives denotative signs values and meanings; this signification process has cognitive origins and limits. The *adventure* genre is characterized by the use of second-order, connotative signs and the signification process that gives these signs values and meanings; this signification process also has cognitive origins and limits as well as important functions within human social contexts.

Because the adventure genre, as it was originally designed and played, did not employ a signification process either common within or consonant with human social contexts, that genre was superseded by a more natural and self-consistent semiotic form: the *role-playing* genre. The role-playing genre was distinguished from the adventure genre by expansive

and transformative significations of contextualization. These significations of contextualization assigned values to interactions among multiple characters and character types within a social community of play. Other common game genres—simulation, wargame, strategy—have histories long predating the history of electronic games, yet are, among electronic games, semiotically derivative of the action and role-playing genres.

Chapter 5

Derivative forms

Simulations

Conventional computer action games began as simulations of real-world objects and events, but not all simulations are dominated, as action games are, by first-order signs. Since the most critical component of any semiotic system is neither signified nor signifier but the relationship between the two, it is this relationship that simulations must signify. Simulations can then signify semiotic relationships within the other semiotic system either denotatively or connotatively.

For instance, *Microsoft Flight Simulator,* a popular, long-lived computer simulation commonly marketed as a game, reproduced on the computer screen in some detail the cockpit controls of various airplanes. That detail, however, precipitated a different visceral experience than the detail of the cockpit attached to the 30-foot wingspan of a 2000-pound Cessna Skyhawk. Of more concern to *Flight Simulator* designers than cockpit realism was the relationship between manipulations of the on-screen cockpit controls and the resulting flight characteristics of the on-screen plane. That is, it was more important (and difficult) to simulate the semiotic system (relationships among signifiers and signifieds) of small-plane flying than to "simulate" any isolated signifier(s) or signified(s) associated with small-plane flight. Thus, flight simulators were not most fundamentally distinguished by the appearance of their planes or clouds or landscapes but by the subjective "feel" of their "flight engines."

Game "engines" are central to other genres as well and, in general, refer to those software algorithms that maintain coherent and meaningful relationships among game signs. Within simulations, these relationships

among game signs signify relationships among signifiers and signifieds within some other (nongame) semiotic system. A simulation is, therefore, a *composite* or, perhaps better, a *procedural* signifier, with its signified being the semiotic "engine" of some semiotic system other than its own. If so, then the game simulation can be said to *model* the other semiotic system.

Electronic simulations of other semiotic systems, however, have a semiotic form inherently at odds with their semiotic value. The signifiers within the computer game simulation (relationships among signifiers and signifieds) are not valued, as signifiers normally are valued within a semiotic system, according to their relationships with other, similar signifiers (i.e., relationships among signifiers and signifieds within the *Other* semiotic system). For this reason, the simulation as signifier is often conflated with the simulation as signified. The conflation of signifier and signified is called an *icon;* simulations, despite the best intentions of their designers, are frequently interpreted as icons, or as reproductions of rather than references to the other semiotic system(s) they are intended to signify.

In their role as models, simulations are widely used as educational tools to help learn principles guiding dynamic processes involving multiple variables. However, the use of simulations in education is not without criticism based on *how* those simulations represent dynamic processes.

Often, simulations are used in a manner similar to that of conventional first-order signs. Students play the simulation the same way they would play an action game; during that play, students discover the embedded relationships among signifiers and signifieds that denote the simulation game engine. This denotative signification process is similar to that of the action game in all respects but its intended signified. In the action genre, the signified is located within the game itself; in the simulation genre, the signified is located elsewhere.

However, users (players) of simulations are motivated to equate the simulation's signified with the more normal and immediate result of a denotative signification process: the simulation itself. This is a general principle of signification well worth emphasizing: Formal characteristics of semiotic processes bias their outcomes. Quite rightly, then, critics of the conventional use of educational simulations have pointed out important

differences between "algorithmic" and "experiential" simulations (Wolfe, 1991), or between "rigid-rule" and "free-form" games (Klabbers, 1996a, 1996b). In algorithmic simulations and/or rigid-rule games, there is the tendency to equate map (model/procedural signifier) with territory (that which is modeled/signified).

This is not an easy bias to overcome. An awareness of the problem does not, by itself, dissuade the tendency to conflate a procedural signifier with its signified. Acknowledging that two different signifieds (e.g., map and territory) result from the same signification process immediately puts those signifieds in semiotic *opposition;* semiotic opposition then assigns values to those elements in opposition by valuing each within the same semiotic context. However, in order to properly distinguish between map and territory, it is necessary to value these within different contexts. Unfortunately, the proper context within which to value the territory—the *Other* semiotic system—is simply not available through a denotative signification process originating within the map.

Alternative uses of simulations in education have addressed this issue. Instead of being used as a procedural signifier, the simulation is instead used as a contextual signification *process.* This process has the potential to generate semiotic systems similar to the semiotic system that the simulation references. In this use, the value (meaning) of the simulation *connotes* the value (meaning) of a semiotic process apart from it. A simulation used in this way *mimics,* rather than models, its signified.

Used in this way, a simulation and its signification process are similar to the connotative signification process of a role-playing game. A single instance of simulating (or role-playing) is valued only within the larger context of multiple instances of simulating (or role-playing). The simulation's signified is then discovered through multiple, extended, and/or recursive play, and is valued as a semiotic context within which multiple simulatings share common features. During this connotative signification process, the previously oppositional relationship between signifier and signified, or between map and territory, is transformed into a contextual relationship: Mappings are *constrained* by territory, or, alternatively, maps are assigned values within the semiotic *domain* of territory—a domain connoted through an accumulation of mappings.

> It should be stressed that free-form games are not formless games. They provide the actors with a history of the social system involved, taking into account their various perceptions and positions. They refer to a realistic social structure as the initial condition for the game.... metarules have to be accepted in terms of space and time.
>
> Klabbers, 1996b, p. 101

Differences similar to these between rigid-rule and free-form games (and/or between algorithmic and experiential simulations) can be found within electronic simulations designed and played as games.

Microsoft Flight Simulator (MFS) used first-order signs and a denotative signification process which evolved over time in parallel with the ability of gaming technology—hardware and software—to more realistically model the aerodynamics of fixed-wing flight. It was an algorithmic, rigid-rule game. Once the *MFS* flight model—its game engine—had reached an acceptable level of verisimilitude, the only further refinements to game play came from creating more realistic (visceral) signifiers within that model. This is a common evolutionary pattern within the action genre; the game engines of the action genre are, ultimately, based on commonly experienced algorithms of nature.

In contrast, the popular *SimCity* series used second-order signs and a connotative signification process; its format and play were closer to that of an experiential, free-form simulation (though not nearly so close as "autopoietic" simulations—see Klabbers, 1996a). Over time, the original *SimCity* sequence of games (the original was published in 1989; *SimCity 3000* was released in 1999) became, as many other computer games have also become, more visceral in its sensory displays; that is, its signifiers became more realistic and natural. However, the realism of *SimCity* never approached the realism of *MFS*, and, unburdened by the laws of aerodynamics, the *SimCity* engine saw application within a wider variety of contexts: *SimEarth, SimAnt, SimFarm,* and so forth. These have culminated most recently in a role-playing variant: *The Sims.*

This application across contexts is not possible with the game engine of a more rigid-rule, algorithmic simulation. Flight simulators such as *MFS,* for instance, are not so easily translated to other mechanical—and certainly not other social—contexts. The ongoing development of the *Sim*

games, distinct from the development of *MFS,* demonstrates a common evolutionary pattern within the role-playing genre: Games within this genre are extended through transformation and resulting expansion of game context.

Whereas *MFS* clearly attempted to simulate (model) flight, it was more difficult to describe the signified of the *SimCity* series. The generic qualities of the series' game engine argued against the representation of any singular signification process or any specific set of semiotic relationships peculiar to city planning (in *SimCity*), or evolution (in *SimEarth*), or warfare (in *SimAnt*). The *Sim* series connoted, more than anything else, the signification process of simulating; as a group, then, the *Sim* games were simulations of simulations. And, just as simulations of nature ultimately conformed to algorithms of nature, simulations of simulations ultimately conformed to algorithms of semiosis.

Wargames

The wargame genre is a subcategory of the simulation genre and contains the same embedded semiotic tension between denotation and connotation. Wargames add a competitive or oppositional element to the simulation; this is significant in that it leads to the eventual deconstruction of the simulation's model within the strategy genre.

Competitive play within wargames entails symbol oppositions that are consistently valued only within an algorithmic, rigid-rule context. The rules of board wargames—applied equally to all players—create and maintain such a context and are, in this function, analogous to the software engines of rigid-rule electronic simulations. Game rules and software engines are not transformed by wargame play; that play is constrained by the domain of rules. Wargame play, then, consists of a signification process that values oppositional elements within a common rules context.

Historically, the purpose of wargames was, given a common battlefield and well-defined fighting units within that field, to test the outcome of different patterns of conflict. The value of any particular unit—whether tank or musketeer or spaceship—was determined by its relationship to those units that opposed it. This is analogous to how words are valued within a natural language—with one very important exception. Unlike

words within a natural language, units within a wargame were *fixed* in terms of their relationship to context. It was only the relationships among units (their *oppositions*) that remained open and valued during play. In a very real sense, then, the outcome of the wargame was determined by and implicit in its rules. However, it was seldom possible to definitively calculate the complicated string of probable outcomes these rules entailed. For this reason, the values of wargame units were often approximated through the conceptual trials and errors of play. During this play, wargame opponents could be said to be cooperating toward a mutual goal: a more thorough understanding of wargame unit values.

In 1981, the same year Nintendo's Mario character appeared in *Donkey Kong,* Douglas Lenat wrote a software program—EURISKO—that helped him win the national *Traveller Trillion Credit Squadron* competition, a "futuristic war game, played in accordance with two hundred pages of rules specifying design, cost, and performance constraints for the fleet" (Whitaker, 1987). Set in the fantasy universe of the pencil-and-paper role-playing game *Traveller, Traveller TCS* was a typical board wargame, with rules and context fixed. Players entering the competition built their fighting units (starships) with the same amount of resources (a trillion "credits") and according to the same set of rules. These fleets were then placed in competition with one another to determine a winner. Lenat and EURISKO won the competition hands-down in 1981; in 1982, under a different set of rules, Lenat and EURISKO won again; and then, in 1983, the rules were changed to eliminate Lenat and EURISKO from further competitions.

EURISKO's great advantage over its human competitors was not during the final battle phase of the competition but during the initial fleet-building phase. EURISKO was able to explore the implications of the *Traveller TCS* rules more fully than a human player—at least in part because the program was able to explore those implications more objectively and, within a set of heuristics provided by Lenat, more randomly. EURISKO was also better able to test the values of its (semi-)randomly produced fleets through oppositional play.

One component of the EURISKO program produced the fleets; another pitted these fleets against each other in anonymous electronic com-

petitions that took place much more quickly than competitions between human opponents. Effectively, EURISKO simulated multiple instances of human play. And, over time, EURISKO's compressed play resulted in a more thorough understanding of the semiotic system of the *Traveller TCS* rules.

The EURISKO software, through its tireless conceptual shadow-boxing, was able to determine, within any game-rules context provided it, the relative value of game units within that context. The rules context did not have to be that of a wargame, nor did the units valued have to be units within a game; these "units" simply had to be constructed from the same software engine—the same rules—which constructed their semiotic context. EURISKO, for instance, proved equally capable of valuing "units" within VLSI (Very Large-Scale Integration) circuits and LISP (LISt Processor) code. In the vocabulary of artificial intelligence, EURISKO was an *expert system,* and human players of wargames, over time, take on characteristics of an expert system.

EURISKO demonstrated the mechanics of the semiotic activities that wargames motivate during play—at least during winning play. It was one of the first examples of how well software might serve as an artificial opponent for human players—particularly within algorithmic, rigid-rule games. And, significantly, the subsequent development of EURISKO highlighted important differences between significations of opposition and significations of contextualization during play.

Ultimately, a wargame like *Traveller TCS* could be played out. Depending on the complexity of the game context, there was some finite limit to the number of possible variations—and oppositions—of units within that context. Once this limit had been reached, the only way to extend play was to expand the rules context. The expansion of context then became a function of contextual play—or a connotative signification process—which lay outside the wargame genre.

Lenat's refinement of the EURISKO design attempted to extend its application to a wider variety of semiotic domains—perhaps even *all* such domains. In effect, Lenat wished to create an expert system of expert systems—a machine that would not simply explore all the nooks and crannies of a rigid-rule game context, but would be able to construct new

rules and relationships beyond that context, perhaps even beyond games entirely.

However, from the beginning, Lenat had closely monitored EURISKO's activities and served as that program's contextual guide. By Lenat's own admission, the winning space fleets in the *Traveller TCS* competition could not have been constructed by EURISKO—or Lenat—operating alone. EURISKO's contribution had been the *oppositional* variations of game units; Lenat's contribution had been the organization, prioritization, and, finally, *contextualization* of EURISKO's prolific output. In his subsequent attempt to create a generic expert system, Lenat had to extend EURISKO's play— its signification processes—beyond significations of opposition; EURISKO had to operate *on* (not within) game rules and contextualize those rules within some other, broader, rules-of-rules context. But then, EURISKO would also have had to contextualize those rules within some other, rules-of-rules-of-rules context, and so forth. In artificial intelligence, this was a version of the "frame problem" (which can be seen, in this circumstance, as a consequence of the "symbol grounding" problem).[1]

Ultimately, EURISKO had to come up with its own set of heuristics—a semiotic system—guiding the construction of semiotic systems. Lenat believed rules for rulemaking might be derived, as they seemed to be during human signification, from significations of opposition—a signification process at which EURISKO had proven facile. But, so far, this has not been the case.

Since 1984, Lenat's grandiose CYC (EnCYClopedia) software project (Lenat, 1995) has attempted to simulate the human use of natural language—including the ability of natural language users to innovate, to construct novel concepts and contexts from conventional concepts and contexts. Though this attempt is ongoing, it has not achieved the success hoped. Rather, CYC has become an extremely complex, but otherwise conventional, database of rules governing the use of natural language.

Over the past decades, this has been a common outcome of expert systems—including expert systems designed to play games. Their successes have resulted from their ability to mimic (and, in many cases, improve upon) an oppositional signification process, a signification process

characteristic of the wargame genre. The failures of expert systems have resulted from their inabilities to mimic a contextual signification process, a signification process characteristic of the role-playing genre.

The inability of otherwise successful expert systems to extend semiotic values beyond rules-determined contextual boundaries argues that opposition and contextualization are separate signification processes that operate independently of one another. Although each process might operate on the productions of the other (first-order or second-order signs), each operates on those products in a distinct manner. So, whereas EURISKO and other expert systems operated on second-order signs (such as those within a natural language), they did not operate on those signs with a contextual signification process equivalent to that of human semiosis.[2]

The wargame genre, like the simulation genre to which it is related, has two distinct signification processes at its core: opposition and contextualization. The brute strength of iterative opposition—whether applied to the rules of *Traveller TCS* by EURISKO or to the rules of chess by Deep Blue—results in optimum wargame play. The application of iterative opposition alone, however, does not result in characteristic human play. Though the opposition of units within the wargame genre is constrained within a rigid-rule semiotic domain, the opposition of units within human play is not.

Human wargame play—and most particularly human wargame play against artificial opponents—often shows the human competitor taking refuge in her ability to contextualize, to break the laws, to rewrite the rules, to crack the software engine, or, in some other way, to *cheat*.[3] This was, in fact, exactly how EURISKO was finally defeated in *Traveller TCS*: The human players stepped outside the boundaries of the wargame context; they changed the rules of play.

When the wargame rules context is breached—inevitable at some point during extended human play—the wargame genre is transformed into some other genre of play. And, if similar transformations continue, play might well extend beyond the conventional domain of games.

Strategy games

The strategy genre includes some of the most successful and engaging achievements of electronic game design. This genre resolves the tension

between denotation and connotation in other genres with a symbolic sleight of hand that simultaneously models (represents) and mimics (replicates the functions of, or references) human semiosis. Strategy game designs accomplish this through the manipulation of game context; however, though the strategy genre motivates contextual transformations through formal design, this genre, like those previously discussed, is not distinguished solely by formal characteristics. It is player *interaction* with game form that ultimately determines genre, and strategic play often occurs within games other than those that typify the genre.

Strategy game play requires significations of opposition for the same reason that wargame play requires them—to properly value units within a common context; but strategy games do not, as wargames do, assume full player knowledge of that common context either prior to, during, or after play. Much more than the wargame genre, the strategy genre emphasizes the discovery of game rules (game engines) during play; this discovery process is necessary because strategy game contexts fully emerge *only* during interactive play. *Traveller TCS,* for instance, was a wargame as played by EURISKO; as played by Douglas Lenat, however, the same competition was a strategy game. EURISKO's focus was on the implications of the *Traveller TCS* rules; Lenat's focus was on the optimization of EURISKO's play within those rules. This optimization process was not motivated by the rules of *Traveller TCS;* it was and is, however, motivated by human play.

In the wargame genre, the values of game units are fixed in their relationship to game context, but not in their relationship to each other. The values of human opponents during wargame play are also not fixed in their relationship to each other; wargame play determines the oppositional relationships among units and among players. This is true of strategy game play as well—only more so.

During initial play within the strategy genre, *no* semiotic relationship—either oppositional or contextual—is well defined. Strategy game play, then, contains elements of wargame play within it—just as any strategic plan must involve, at some level, the tactical implementation of strategy. In addition, however, the *optimization* of play within the strategy genre must contain (or contextualize) a variety of oppositional relationships, including those assigned during play. This recursive valuing and revaluing

of game units through defining and redefining the game context distinguishes strategy games from wargames.

In effect, the strategy genre divorces the wargame from its conventional function as an algorithmic simulation. Though strategy games use the same basic signification process as wargames—oppositional play within a rigid-rule context—these games extend wargame play beyond its genre boundaries. Strategy games are procedural signifiers, as are simulation games; but strategy games do not, as do algorithmic simulations (including most wargames), prioritize the modeling of real-world objects and events. The signification process of strategy games is closer to that of an experiential simulation: Strategy games *mimic* significations of contextualization during play. Contextual significations are mimicked through the discovery of context during initial game play and/or through the transformation of that context—and its rediscovery—during subsequent play. Significantly, however, these mimicries are only of the semiotic *form* of significations of contextualization, not of the conventional semiotic products (or values) of those significations.

In experiential simulations, for instance, semiotic values are continuously negotiated in mimicry of some alternative, *Other* semiotic process; that is, there are no values fixed prior to game play (other than those vague guidelines associated with the "metarules" of social structure—see the earlier quotation from Klabbers, 1996b).

In contrast, in strategy games, the semiotic values of game units *are* fixed within a rigid-rule context (e.g., the rules of the game)—and any mimicry of contextual signification motivated by the strategy game remains bound by that rigid-rule context. Or, put another way, the map of the strategy game *is* the territory of the strategy game. Or, put still another way, the semiotic form of the strategy genre is both model *and* mimicry of itself: This form models itself in that it *is* itself; yet, at the same time, this form can only mimic itself, since any rules context determining rules for contextual signification is either nonfunctional (as demonstrated by expert system failures like that of EURISKO) or, alternatively, *paradoxical*.

This peculiar, paradoxical semiotic form most definitively characterizes not only the strategy genre of computer games but, more generally,

symbolic play. It is a form that characterizes the most fundamental mechanics of signification, and it is a form that I shall describe in more detail and with more rigor in the following chapters.

Computer chess is one of many traditional games combining elements of simulation, war, and strategy. Although ostensibly chess simulates warfare, the game makes no strong pretense of realism. The signifiers of chess (the chessboard, for instance) are more abstract than those of the conventional wargame, and its signifieds are much more immediate to the actual experience of play. Further, chess remains a strategy game to the extent that its play is determined by the player's attempt to optimize responses to all possible oppositions, rather than by the player's attempt to win the current game at hand. Large volumes of opening books, in-game notes, and endgame analyses separate chess—and other, similar strategy games—from more Machiavellian wargames.

Though originating as a two-player board game, computer chess is commonly implemented as a single-player game. Many computer strategy games might include more than one player—and many are designed to do so. However, more often than not, the implementation and play of electronic strategy games is solitary. The *SimCity* game designs, for instance, included components of both simulation and strategy, but did not, as did conventional wargame designs, pit equally matched opponents against one another.

Designing strategy games to be played outside the complications of a human opponent allowed the strategy genre—like the role-playing genre—to emphasize contextual significations. Too many or too widely variable oppositional relationships required a more secure and fixed context; successful strategy game design, on the other hand, could involve very few oppositional relationships.

From the beginning of electronic game design, strategy games proved well suited to computer implementation, particularly within those early hardware platforms that did not provide sensory displays suitable for highly visceral signifiers. Stylized, abstract game units (including text) aided strategy game designs by weakening their signifiers' common relationships to conventional signifieds; these game units, stripped of values of conven-

tion, motivated more novel significations during play. These novel significations had a necessary and dual function within the strategy genre: to determine the contextual rules of the game and to value units of play within contexts constructed according to those rules. The basic mechanics of this signification process could be observed within some of the first and simplest electronic strategy games. An example: *Hammurabi*.

Hammurabi (sometimes *Hamurabi*) was an early "builder," a resource-management game. It was widely distributed in the 1970s as several dozen lines of BASIC code that home computer owners typed into their machines.[4] During initial *Hammurabi* play, a single player was given the task of regulating the economy of a fictitious kingdom through the manipulation of four variables connected (the game assumed) to the kingdom's well-being: acres of land bought, acres of land sold, acres of land planted, and bushels of grain distributed as food. If these variables were kept in proper relationship to one another, the farms and the population of the fictitious kingdom grew; if not, the population declined, and, eventually, the player lost the game. Game play required the player to adjust, on a year-by-year basis, oppositional relationships among the four variables. Each game year established a slightly different context for play—a context transformed by player choices made during the preceding years. With random variables occasionally affecting the game context as well (plagues killing some portion of the population, rats eating some portion of the grain), *Hammurabi* could conceivably be played through an endless series of years, i.e., forever.

Though promoted as a simulation of ancient Sumeria, *Hammurabi*'s austere simplicity and text interface created an abstraction with no meaningful connection to any real-world object or event. Certainly the name and place of the fictitious kingdom were unimportant to game play—as generic as the equally anonymous SimCities of the future. Yet, despite its inadequacies as a simulation, *Hammurabi* was a prototypical strategy game design—and the game still receives sporadic play in something very close to its original form.

Resource-management games like *Hammurabi* assign values to game units both in opposition to other game units and within a context deter-

mined by those units. This context is a closed system within the game's rules, yet it is an open system during the game's play. If the relationship among game units (resources to manage) is initially unstable—or if that relationship is simply too complex to determine stability—then the play of resource management becomes a play of contextualization. In order to win the strategy game, players must not only value game units within a context other than that provided by the game rules, but also construct that context through the assignation of proper game unit values. Under such circumstances, part of game play is to further design the game. (Many wargames, in fact, edge into the strategy genre by giving players the ability to create novel units and scenarios: that is, to construct contexts for play.[5])

Despite the sensation of open, free-form play, however, each successively transcendent context in the strategy game remains constrained by logical—and mechanical—bounds. If nothing else, game rules are constrained by game software; and game software is constrained by game hardware. At some point during the strategy game's mimicry of contextualization, the player is confronted with an obviously incongruous value: the game's end. In the experiential simulation, the experience might go ever on. In the strategy game, the bubble of play eventually bursts.

In several respects, then, this final fate of the strategy game is similar to that of the adventure game. Adventure game players also value game units within a context that those players construct during play; and, eventually, inevitably, the adventure game context cannot be sustained. However, in the adventure genre, contextualizations are *not* constrained by game rules. In the strategy genre, contextualizations *are* constrained by game rules—rules that allow (at least temporarily) contextualizations to be unconstrained by game rules. This latter is a more realistic, a more paradoxical, and ultimately a more enduring semiotic structure than that of the adventure genre.

Real-time and action-adventure games

The fundamental semiotic structure of the strategy genre has deviated little from its origin within early electronic games like *Hammurabi*. *Civilization II,* perhaps the most engaging computer strategy game yet produced, is an ex-

tended resource-management design—a glorified *Hammurabi*—as are most other popular strategy games. However, there have been interesting modifications of this basic design over the past couple of decades. In particular, turn-based strategic play has seen a decline in favor of real-time play.

Initially[6], strategy games were designed to allow sequential player moves—as in the *Hammurabi* example above—which clearly separated player decisions from game responses to those decisions. More recently, the availability of memory space and processing speed has allowed designers to include routines in the game software that react to player decisions on the fly and display those reactions (from the point of view of the human player) instantaneously, or in "real time."

Simultaneously and in parallel with the appearance of real-time strategy games, action games have evolved into action-adventure games, which incorporate characteristic elements of other genres.

These design modifications in strategy and action/adventure games are both examples of the same trend in computer game design. Both modifications have transformed their genres' significations into significations more closely analogous to a natural human semiosis. Real-time strategy games add a visceral component to the assignation of semiotic values within a context of design; action-adventure games add contextual variations to the denotative significations of visceral play. In both cases, these modifications do not fundamentally change the semiotic structures of the genres in which they originate; both modifications are overlays which are implemented either as separate and apart from the dominant signification process of the genre or as game design elements similar to those already present within and characteristic of the genre.

For instance, real-time strategy games allow players to pause the real-time action, either between episodes/scenarios/levels or the like, or, more commonly, whenever desired according to player discretion. These pauses allow players to consider strategic choices fully before implementing those choices in a "real-time" environment. Thus, the "real time" of strategy game play is kept separate and apart from the more reflective (contextual) aspects of play; the strategy game's real-time component is then no more than a look behind the curtains of the game to see, for instance, *Hammurabi*'s wheat fields flourish in the spring, ripen in the summer, and

be harvested in the fall. All decisions affecting those fields are still made in another time and place.

Alternatively, if the designer wishes to incorporate "real time" directly into the contextual significations of the strategy genre, then time can be handled as another resource-management variable. That is, the designer might assign game units different speeds of "real-time" movement. Unit speed is then subject to the same signification process as unit strength or unit number; each unit variable is assigned some relative value in opposition to all others, and these variables are then used, in strategic combination, to construct and transform game context.[7]

The action-adventure game, based on the fundamentally real-time (visceral) significations of the action genre, adds contextual elements only in isolated doses—at save points, between scenarios/levels, or before and after action play (e.g., during initial character creation or subsequent weapon loadouts). These contextual elements have usually taken the form of an ongoing narrative or story line that links otherwise isolated episodes of action play. In this sort of implementation, game contextualizations are kept separate and apart from the action game proper and remain superficial to game play, dependent more on the surface relationships among game signifiers than on the more fundamental relationships between game signifiers and signifieds. The primary use of this sort of contextualization has been simply to extend action game play—just as equally incongruous and superficial design elements were used in a similar way to artificially extend play within early adventure game designs (see chapter 4).

In order to implement a more unified contextualization process linking episodes of action play, action-adventure games would have to evolve—and are currently evolving—toward an action-*role-playing* form. At present, this includes hybrid games like *Deus Ex Machina,* which incorporates role-playing elements within a single-player action-adventure game design; it also includes multiple-player games, like *Ultima Online* and *Everquest,* which have been designed to be played within a social community of players.

Summary

The formal design and structure of computer games can be explained with reference to the significations those games motivate during play. Evidence of

INTRINSIC FORMS:

	ACTION	**ROLE-PLAYING**
DOMINANT SIGNS	first-order (iconic)	second-order
DOMINANT SIGNIFICATIONS	OPPOSITIONAL	CONTEXTUAL
SIGNIFICATIONS DURING PLAY	...embody context.[*]	...expand context.
THE SEMIOTIC SYSTEM OF THE GAME	...models denotative (visceral) signification.	...mimics connotative (social) signification.
EXAMPLE	*Doom*	*Might and Magic*

DERIVATIVE FORMS:

	SIMULATION (ALGORITHMIC)[**]	**SIMULATION (EXPERIENTIAL)**
DOMINANT SIGNS	denotative (composite/procedural)	connotative (composite/procedural)
DOMINANT SIGNIFICATIONS	OPPOSITIONAL-contextual	oppositional-CONTEXTUAL
SIGNIFICATIONS DURING PLAY	...reveal context.	...transform context.
THE SEMIOTIC SYSTEM OF THE GAME	...models Other.	...mimics Other.
EXAMPLE	*Flight Simulator*	*SimCity*

DISSONANT FORM:

	ADVENTURE	**STRATEGY**
DOMINANT SIGNS	second-order	paradoxical (anticonic)
DOMINANT SIGNIFICATIONS	contextual-OPPOSITIONAL	CONTEXTUAL-oppositional
SIGNIFICATIONS DURING PLAY	...extend context.	...embody semiosis.[***]
THE SEMIOTIC SYSTEM OF THE GAME	...???	...models/mimics Other/Self.
EXAMPLE	*Zork*	*Civilization*

[*] Resulting in cruxic signs; see chapter 11.

[**] Includes war games.

[***] Resulting in anticonic signs; see chapter 13.

Figure 5.1: Computer game genres.

signification can be found in the dominant signs of computer game genres; however, the signification process is determined and made manifest only during interactive play.

Action game designs emphasize first-order signs and a denotative signification process; the role-playing genre emphasizes second-order signs and a connotative signification process. Other common game genres can be understood as derivatives of these two basic forms, as indicated within figure 5.1[8]—and the pages following.

PLAY AS SEMIOSIS

Chapter 6

Generic form

I have labeled the fundamental components of human signification, as observed during play of electronic games, *opposition* and *contextualization;* I will, in this section, define these two basic signification processes in a more universal, formal, and precise manner. Identifying these two is a sort of reverse-engineering of play, and it is enlightening to consider what results a similar approach might have in analogous circumstances.

What, for instance, might result from reverse-engineering word-processing software? Normal expectations might include some mimicry of the uses and functions of a targeted word-processing program, e.g., Microsoft Word (MS Word). However, though reverse-engineering might produce a software program—a mimicry—which accomplishes the same tasks with the same keys as MS Word, there would be no guarantee that this program accomplished those tasks *in the same manner* as the original. Indeed, different implementations of MS Word, written in different programming languages within different operating systems on different hardware platforms, may accomplish the same tasks very differently.

In order to create a *model,* rather than a mimicry, of MS Word, I would have to observe more than just the normal uses and functions of the program. I would have to observe the characteristics of the specific platform of implementation (hardware and software) of MS Word, so that I could then make sure that relationships among program uses and program functions within my model (signifier) were accomplished by the same mechanical processes as those within my model's signified (the MS Word word-processing "engine"). And further, in order to evaluate my model fully, I would have to observe the *limits* of the original MS Word pro-

gram—including its malfunctions, if any—so that I could make sure that the relationships within my model resulted in similar bugs and idiosyncrasies.

Of course, this analogy is not applicable to the argument here without important qualifications. For instance, my goals actually concern less the reverse-engineering of electronic gaming software than the explication of the human process of play while engaging that software. For this reason, I am more interested in electronic games *as they are played* than electronic games as they are structured; and, similarly, I am more interested in the individual use of games than in the broader function(s) of those games in contexts other than that of individual play. I assume the primary function of an electronic game—of any game—is more generic and universal than those context-bound, task-specific functions of an MS Word: namely, to motivate the game's continued use and play. Given these qualifications, however, the reverse-engineering analogy is apt.

There are, then, at least three steps necessary to construct an accurate and convincing model of play. The first is to produce a mimicry of play, a rudimentary semiotic machine that *connotes* observed significations of play. That semiotic machine is to be constructed here from significations of opposition and contextualization—although the configurations of these two may or may not match (i.e., *model*) their configurations within a human biological system. I will argue, however, that their formal configuration well *mimics* their signifieds: the significations of play.

The next step is to transform this mimicry into a more realistic model of play; this is a step I will not directly undertake, because I do not believe that current knowledge makes it possible to do so. In order to do this properly, it would be necessary to determine the specific characteristics of the "platform of implementation" of human signification. This platform consists of human cognition and, very likely, human consciousness. The biological hardware and software that characterize this platform are currently undetermined.

It seems fortunate, however, in absence of such a determination, that the signification process being studied is the same process that it is being studied with. That is, in the absence of full knowledge of the precise biological properties of human signification and play, it is useful to focus on the *phenomenon* of play. A phenomenological approach[1] to the study of play is equivalent, in the context of the earlier analogy, to constructing a mim-

icry of MS Word on the very same computer, using the very same operating system and application language, as the original. Although this does not guarantee that this mimicry accomplishes the same signification functions of human play by the same biological mechanisms as human play does, there is at least an increased likelihood of verisimilitude in having the same signification systems—including those of the writer and readers of this essay—involved in the construction of both signifier (formal semiotic machine) and signified (play).

If I can thus finesse matters of platform implementation, the last step in constructing a representative model of play is to determine the *limits* of play ("bugs and idiosyncrasies") so that any signifier of the play process can be evaluated in terms of both its subjective uses (as a phenomenon) and its more objective functions and dysfunctions.

In the play of electronic games, for instance, there are many well-known peculiarities of the play process that might be classified as dysfunctional. One of these is the obsessive quality of electronic game play: its ability to sap a sense of time from players. Another is the extent to which electronic game play does not abide by its stated rules: that is, the amount and quality of "cheating" among players. Another is the degree of repetitiveness in electronic game play—repetitiveness that would seemingly interfere with the novel appeal of play. And so forth.

In general, peculiar and initially unforeseen relationships between activities and outcomes of electronic game play are important to consider in order to determine if any subsequent model of play produces similar relationships. But, more specifically, mapping these relationships is especially significant in attempting to understand *play*. The paradoxical relationships embedded within play seem both critical and self-similar to the play process. And, as it turns out, while these relationships and their outcomes are often dysfunctional within rigid-rule contexts, they have different, more positive functions within special types of rigid-rule contexts. The significations of play are deeply marked with a sort of formal hiccup, a fortuitous—even divine—flaw that invigorates and extends the human signification process beyond that of artificially intelligent formal systems.

Of course, if this were true exactly as I have stated it, then any formal analysis of play must be a paradox itself. I have proposed to build a semiotic

machine based on phenomenal observations of electronic game play. This machine will, I suggest, mimic that process through formal means. But how could it possibly do so? A formal (i.e., well-formed) system can represent a malformed process (as play might well be) only connotatively, and then only during its interpretation by human beings who have some previous phenomenal experience, which allows them to recognize the proper second-order significations of the formal system as signifier.

Because all mimicries require interpreting/playing in order to connote their signifieds, any mimicry of play I offer is as much a semiotic game as a semiotic machine.[2] And, therefore, when and if any electronic game is formed in the image of play—as I will argue games in the strategy genre are—then that game is a *self-similar* mimicry and, simultaneously, a de facto model of play: i.e., it is the thing itself.

In order to construct a formal mimicry of signification—a semiotic machine—I will use, as I have previously (Myers, 1999), the signs and terminology of Spencer-Brown's *Laws of Form*. The Spencer-Brown (S-B) system is based on a single set of symbols representing: 1) the act of a distinction or severance of space into two spaces, and 2) the lack of such a distinction or severance. Severance is represented by the symbol ()[3]; and the absence of severance is represented by a null or empty space:
The () symbol indicates a single, elementary, and irreducible act of signification. It is sometimes called a "call" and sometimes called a "cross."[4] In either case, this symbol represents that act of signification that gives meaning (value) to content: "Thus the calling of the name can be identified with the value of the content....Thus, also, the crossing of the boundary can be identified with the value of the content" (S-B, 1972, pp. 1–2).

By defining the basic act of signification as both "call" and "cross," the S-B system allows that symbol to be used to represent both a signification process determining relationships of opposition (separation) and a signification process determining relationships of contextualization (containment).

> At this [Spencer-Brown's] more primitive level, all acts of distinction and indication are identical: qualitative differences are smoothed out, and focus is reduced

to the mere act of creating boundaries separating *this* from *that*. All distinctions, indications, and values are thus treated alike.

<div align="right">Merrell, 1995, p. 141</div>

Reducing signification to a singular mark of distinction allows Spencer-Brown to create an elegant description of the signification process, which, among its virtues, avoids both the complexities and the vagaries of well-known alternatives. For instance, Peirce's taxonomies of the sign offer as many as 59,049 varieties of signifier-signified relationships.[5] And Saussure's definitions of semiotic form, while serving as foundation for many subsequent analyses, are not themselves formally precise.

But even more important than the elegance of the S-B system is its true-to-life form. The S-B system reproduces naturally occurring conflations within the human signification process. These conflations occur only within a *recursive* signification process—which the S-B system provides for and acknowledges.

The most basic axioms of the system concern what happens when the calling/crossing is applied to itself.

Axiom 1. The law of calling: The value of a call made again is the value of the call.

$$(\;)(\;) = (\;) \; .$$

Axiom 2. The law of the crossing: The value of a crossing made again is not the value of a crossing.

$$((\;)) = \qquad .$$

<div align="right">S-B, 1972, p. 5</div>

It is only during the sequencing of S-B's recursive mark of distinction—only during an active signification *process*—that value is determined. For instance, Axiom 1 above indicates the outcome of a recursive, *oppositional* signification process; similarly, Axiom 2 indicates the outcome of a recursive, *contextual* signification process.

The following theorems from *Laws of Form* then determine the outcome of () when it is applied, more conventionally, to existing elements of content.[6]

$$((A)) \qquad = A \; . \qquad\qquad \textit{Consequence of reflexion.}$$

<div align="right">S-B, 1972, p. 28</div>

$$(A \, B \,) \, A \qquad = (\, B \,) \, A \; . \qquad \textit{Consequence of generation.}$$
$$(\;) \, A \qquad\quad = (\;) \; . \qquad\quad \textit{Consequence of integration.}$$

<div align="right">S-B, 1972, p. 32</div>

In each case, **A** and **B** indicate content for which a value has been assigned or a meaning has been made. A result of **A**, for instance, indicates that all is **A**; there is no distinction between **A** and Other. **(A)** indicates that all is not **A**; there is a distinction between **A** and Other. Similarly, **AB** indicates that all is **A** and/or **B**; there is no distinction between (**A** and/or **B**) and Other. And so forth.

Items of content at the same level of signification—examples include **AB**, **(AB)**, and **(A)(B)**—are distinguished either by their separation (opposition) or not at all. Items of content at different levels of signification—examples are **A(B)** and **(A)B**—may be distinguished either by their separation, by their containment (contextualization), or by both.

The isolation of S-B's consequence of integration—**()**—indicates a distinction without a label: a call without a crossing, a crossing without a call. I will label this undistinguished distinction a *paradox*.

Given the axioms and theorems above, the S-B signification system can be used to explicate forms of signification within electronic game play.

Chapter 7

Semiotic conditions

Though all electronic game play involves signification, not all signification involves game play. It is useful, then, to distinguish, if possible, between signification during play and signification during nonplay. This cannot be a distinction of formal process, since a common signification process is involved. It can, however, be a distinction of outcome. The human signification process produces conventional values, novel values, and paradoxical values.

Novel values are those that, once produced, are used within subsequent signification and, during that use, are transformed into conventional values; commonly, novel values are associated with signification during play. *Conventional* values are those that have been so transformed; commonly, conventional values are associated with signification during nonplay. *Paradoxical* values are those that, once produced, are incapable of being transformed into conventional values; normally, paradoxical values are not associated with a common and natural signification process; however, I wish to make that association here.

With the aid of the S-B system and the previous discussion of game genres and forms, it can be shown how these three distinctive values—of novelty, convention, and paradox—result from a single signification process. Since, according to this argument, significations of novelty and significations of paradox appear prior to those of convention, the production of those values is considered first.

Semiotic conditions of paradox

What constitutes a "value of paradox"? Forms of paradox have been studied for some time.

The modern view of the paradoxes is to the effect that there are two distinct families here, which arise from different sources and which are to be treated quite differently. (This view is now so orthodox that this claim need no documentation.) Although one can find something like this view expressed in Peano (1906), the founder of the orthodoxy was Ramsey.

Priest, 1994a, p. 25

Ramsey (1931) labeled paradoxes as one of two sorts: set/theoretical or symbolic/linguistic. "Set/theoretical" paradoxes were determined by "contradictions which… would occur in a logical or mathematical system itself. They involve only logical or mathematical terms such as class and number, and show that there must be something wrong with our logic or mathematics" (Ramsey, 1931, p. 20).

These are examples of set/theoretical paradoxes:

· *Cantor's: the largest set.* There can be no larger set than the set of all sets. Yet, for any set (including the largest), there exists a larger set consisting of the set of its subsets.

· *Burali-Forti's: the largest ordinal.* If the series of all ordinals is given a number greater than any member of the series, then can the series of all ordinals exist?

· *Russell's: the set of all sets that are not members of themselves.* Is such a set a member of itself, or not? If it is, then it isn't; if it isn't, then it is.

"Symbolic/linguistic" paradoxes are determined by "some reference to thought, language or symbolism, which are not formal but empirical terms. So they may be due not to faulty logic or mathematics, but to faulty ideas concerning thoughts or language" (Ramsey, 1931, pp. 20–21).

These are examples of Ramsey's symbolic/linguistic paradoxes:

· *Liar's: 'I am lying.'* If all statements that I make are false, how can I state that fact?

· *Grelling's: heterological.* "Heterological" means the opposite of "autological," which means true-of-itself, e.g., "printed," "English," and "multisyllabic." Is "heterological" heterological?

· *Berry's: the least integer not nameable in fewer than nineteen syllables.* This integer has been described—as incapable of being described. Which is it?

Priest (1987, 1994a, 1994b) agreed that all above are paradoxes, but argued, contrary to Ramsey, that all paradoxes belong to a single class. Priest demonstrated that Ramsey's symbolic/linguistic paradoxes could be expressed within the same formal context as Ramsey's set/theoretical paradoxes, and, as a result, all paradoxes could be explained and understood as resulting from the same root of self-reference; and, if so, then the differences Ramsey noted between set/theoretical and symbolic/linguistic paradoxes were superficial and unrelated to their basic forms.

I find Priest's analysis persuasive: that there is a single class of paradox, and that that class is determined by formal self-reference.[1] However, I contend, unlike Priest, that the fundamental relation among paradoxes is a function of *semiotic* rather than logical form. That is, the same *signification process* is involved in assigning value within paradoxes; and, further, the mechanics of this singular process, when applied to content possessing certain fixed semiotic conditions, can result only in the assignation of a value of paradox.

What are these fixed semiotic conditions of paradox? There are two sorts: syntagmatic and paradigmatic.[2] Each can be defined using the S-B system.

Syntagmatic conditions of paradox. In order to demonstrate these conditions, convert each of the paradoxes given above to a more generic syntax. For instance, let Russell's paradox—"the set of all sets that are not members of themselves"—be represented as "the A of all A's that are nB." This generic syntagm can then be represented within the S-B system as $A(A(B))$. Within this form, $A(B)$ indicates "A's that are distinct from B's," and $A(A)$ indicates "the A of all A's." Each of the above paradoxes can then be translated as follows:

- *Cantor's*—The set of all sets: $A(A)$.
- *Burali-Forti's*—The series of all series: $A(A)$.
- *Russell's*—The set of all sets that are not members of themselves: $A(A(B))$.
- *Liar's*—The assertion of all assertions that are not true: $A(A(B))$.
- *Grelling's*—The labeling of all labelings that are not true-of-themselves: $A(A(B))$.
- *Berry's*—The defining of all definings that are not definable-with-words: $A(A(B))$.

Does surface similarity of syntax parallel deeper similarity of signification? Yes. Each of these signification sequences results in an endless loop of value assignation: either an infinite progression of values (*Cantor's* and *Burali-Forti's*) or an infinite oscillation of values (all the rest). In fact, there is early validation of this method of explicating the syntagmatic conditions of paradox in the formal reduction of **A(A)** according to the rules of the S-B system:

$$(A)A = ()A \qquad \text{Generation.}$$
$$= (). \qquad \text{Integration.}$$

This result confirms that the symbolic phrase "the A of all A's" is fundamentally paradoxical.[3] However, the semiotic form **A(A(B))** commonly combines and transforms content having *preexisting* values. And, in any preexisting semiotic context with fixed values, not all phrases of the generic form "the A of all A's that are nB" result in values of paradox. Many such phrases result in the more common outcome of pragmatic signification: values of convention. Therefore, there are also important *paradigmatic* requirements of content that must be met in order to produce values of paradox.

Paradigmatic conditions of paradox. The symbolic phrase **(A)A** does not discriminate among content; it is as descriptive of "the dog of all dogs" as "the set of all sets." Many such phrases, however—like "the dog of all dogs"—are bound to values of convention by common use within a preexisting natural language. In order to produce a paradoxical value, the value of **A** must default to that value determined directly and most immediately by the signification process, i.e., the **A** component of **((B)A)A** must be containable or "contextualizable" by itself. "The dog of all dogs" commonly fails this test. "The set of all sets" commonly passes it.

This paradigmatic condition is exactly that described—in the negative—by Russell's (1956) vicious circle principle: *Whatever involves all of a collection must not be one of the collection.*

To avoid paradox, it is sufficient to avoid vicious circles of the **A(A)** sort. However, this self-reflexive form is both critical to paradox and, because of the intractability of the signification process, critical to human

signification. Indeed, it is difficult to imagine human consciousness or self-awareness without the "sensation of sensations" or the "thought of thoughts." Thus, adhering to Russell's principle avoids paradox at the great expense of the human condition. And, while adhering to this principle appears sufficient to avoid paradox, it also appears insufficient to generate the entire variety of paradoxes above. Therefore, a more detailed paradigmatic condition of paradox is necessary to specify the **B** component of **A(A(B))**.

This **B** component must be what I will call "**A**-defining"[4]—that is, there must be a mutual presupposition between content A and content B, *without the simultaneous presupposition of either nA or nB.* If **B** does not have this relation to **A**, then **A(A(B))** reduces to **AB**, a value of convention rather than a value of paradox.

Within the vagaries of a natural language embedded with preexisting values of convention, it is often difficult to determine whether the value of some random content B is in a relation to the value of some random content A such that the paradigmatic conditions of paradox hold. This task is made easier with reference to the S-B calculus.

Here is the normal reduction of **A(A(B))** within the S-B system:

((B) A) A	**= ((((B) A) A))**	Reflexion.
	= ((AB) ((A) A))	Echelon.
	= ((AB))	Algebraic initial of position.
	= AB.	Reflexion.

This reduction occurs in all common circumstances in which **B** is *not* **A**-defining. For example, consider the phrase "The container of all containers that are not lidless containers." This phrase has a syntagmatic form similar to Russell's paradox, but its outcome is no paradox. Its meaning reduces to the conventional value of "a lidless container," or **AB**. This result then indicates that the value of content B (lidless-ness) does not meet the paradigmatic conditions of paradox, or that lidless-ness is not "container-defining."

If, on the other hand, **B** presupposes **A**—as required by conditions of paradox—then it follows that **((A)B) = (B)A** (S-B, 1972, p. 114).[5] Using the substitutions provided by this equivalency, the reduction of **A(A(B))** has a different result:

$$((\,B\,)\,A\,)\,A \quad = (\,(\,(\,A\,)\,B\,)\,)\,A \qquad \text{Substitute } ((A)B) \text{ for } (B)A.$$
$$= (\,A\,)\,BA \qquad\qquad \text{Reflexion.}$$
$$= (\,\,)\,AB \qquad\qquad \text{Generation.}$$
$$= (\,\,)\,. \qquad\qquad\quad \text{Integration.}$$

This result is a value of paradox.

Circumstances in which **B** *is* **A**-defining include this: "The sensation of all sensations that are not human sensations." The paradoxical value that results indicates that the value of content B (human-ness) is "sensation-defining."

In summary, then, these are formal paradigmatic conditions of content that produce a value of paradox during that content's signification within the form **A(A(B))**:

1. Content A is capable of self-reference; that is, **A(A)** exists semantically.

2. Content A and content B are in a relation of mutual presupposition, such that **(A)B = ((B)A)**, or, alternatively, **(B)A = ((A)B)**.

Semiotic conditions of novelty

The semiotic conditions of novelty result in the production of values that are subsequently used to construct—and can become themselves—values of convention. Therefore, the difference between novel values and conventional values is most fundamentally pragmatic—a difference that is diminished and eventually erased through exposure to and practiced use of the signification system in which those values originate (i.e., a natural language).

The single instance in which novel values differ from conventional values in function is in their transformation of values of paradox—which is their most significant semiotic role. Commonly, however, values of novelty produced during significations of play are unmotivated by either the desire or the need to transform values of paradox. This is certainly the case during electronic game play.

During electronic game play, signs are processed in two characteristic ways. The first is through opposition, in which two or more elements of content—e.g., **AB**—are valued according to their distinction(s) within the same game context, or as **(A)(B)**. Simultaneously, game play also might value these two elements through contextualization; this significa-

tion process values elements of content according to their mutual simi-
larities within the same game context, or as **(AB)**. The composite result
of game play then—quite apart from any explicit need to transform val-
ues of paradox—is the transformation of **AB** to **((A)(B))**. This transfor-
mation is exactly that required within the S-B system to transform values
of paradox to values of convention.

Paradigmatic conditions of novelty.

The same basic syntagmatic
form—**A(A(B))**—produces values of paradox, values of novelty, and
values of convention. As has been demonstrated, in most common cir-
cumstances this form reduces to **AB**, or a simple combination of preex-
isting values; this result is a value of convention. Under the paradigmatic
conditions of paradox described earlier, this form reduces to a value of
paradox, or **()** . And, under the paradigmatic conditions of novelty, the
same form reduces to a value of novelty, or **((A)(B))**.

Here are the paradigmatic conditions of novelty:

1. Content A is capable of self-reference; that is, **A(A)** exists semantically.

2. Content A and content nB are in a relation of mutual presupposition,
such that **AB = ((A)(B))**, or, alternatively, **(AB) = (A)(B)**.

Within the S-B system, this latter condition indicates the mutual pre-
supposition of the *negation* of an opposing element (e.g., **A** presupposes
(B)), *without the simultaneous presupposition of that element* (e.g., **A** presup-
poses **B**).

Given these conditions, the earlier reduction becomes:

((B) A) A	= **((((B) A) A))**	Reflexion.
	= **((AB) ((A) A))**	Echelon.
	= **((AB))**	Algebraic initial of position.
	= **((A) (B))** .	Substitute **(A)(B)** for **(AB)**.

This result—**((A)(B))**—is a value of novelty and can be reduced no
further. It can be interpreted generically as [something other than [[some-
thing other than **A**] and/or [something other than **B**]]]—but a more con-
crete example more clearly demonstrates its ability to transform values

of paradox. For instance, I can construct a value of novelty within the semantic domain of Russell's paradox with the following content: [**A** = set] and [**B** = unclassifiable-as-a-member-of-itself-or-not].

Given these elements of content, the form **A(A(B))** becomes "The set of all sets that are not unclassifiable as members of themselves or not." This form reduces to "A set that is unclassifiable as a member of itself or not." And this result effectively transforms Russell's value of paradox into a value of novelty, which can then be used alongside preexisting values of convention to resolve the original paradox.

Guided by formal rules within the S-B system, it is possible to transform each of the earlier values of paradox in the same way: by selecting items of content (content A and content B) related to each other according to the paradigmatic conditions of novelty.[6]

Again, however, though values of novelty are associated with significations of play, the signification process during game play is not motivated to achieve any particular outcome, whether that outcome is a value of paradox, novelty, or convention. Play is *self*-motivated; that is, play is assumed to be a purely formal process—a biological imperative—which operates on whatever elements of content (signifiers) are available. This is exactly why it is so difficult to distinguish between cognitive play and cognitive nonplay—because exactly the same formal process is involved in both.

In the context of play, the formal process of signification becomes more transparent and more likely to produce values of novelty—and paradox—because values assigned during play are less often determined by values within semiotic systems preexisting that play. That is, cognitive play is *emptier* than cognitive nonplay.

Preexisting semiotic systems (e.g., contexts of design) are ordered by pragmatic goals and by values of convention that have proven useful in accomplishing those goals. These values result from an iterative signification process that has, over time, filtered, cordoned off, and disposed of the commonly dysfunctional values of paradox and novelty. During play, however, signification activities gain precedence over signification histories; and, for this reason, signification during play often reveals one of the most critical functions of the human signification process: its ability to generate values of novelty.

The basic form of signification—in mimicry, **A(A(B))**—is most fundamentally a meaning-making machine. This machine has relatively simple mechanics. And these mechanics do not vary from one context to another; they produce different results only when exposed to different elements of content. It is both remarkable of and critical to the human signification process that when this meaning-making machine is exposed to the same content, it inevitably produces the same result, again and again. This is most obvious in the production of values of paradox.

It is beyond the capability of human signification to assign any value to Russell's paradox—or to any of the other paradoxes given—other than that of paradox. In this respect, paradoxes of signification are similar to illusions of vision, which are equally characterized by biological mechanics (of the human eye and brain) and are equally intractable.[7]

The basic form of signification allows the construction of many other paradoxes from elements of content having the proper paradigmatic conditions. For example, "the endpoints of all endpoints that are not reached," is a symbolic/linguistic form of Zeno's famous paradox concerning the illusion of motion. And "the negation of all negations that are not self-negations" is a representation of the paradox inherent in the double negations of a natural language—a paradox that has led some to adopt and advocate an intuitionist logic.[8]

Because it utilizes this same basic form of signification, play—particularly electronic game play—likewise has an intractable form, which can be varied only with either its truncation or its recursive extension. Existing game genres and the nature of play within those genres demonstrate the limited variations of this singular form.

Semiotic forms within play

Street Fighter II (preceded by *Street Fighter* and succeeded by *Street Fighter Champion Edition*) was a video-arcade game designed by the Japanese game company CAPCOM and widely played during the early 1990s. The game was transported to the Super Nintendo game system in 1992. It remains typical of electronic games within the action genre; it is based on significa-

tions of opposition, and its design is fundamentally similar to the designs of many other fighting games within the action genre—i.e., *Mortal Kombat, Virtua Fighter,* etc.

In *Street Fighter II* (*SFII*), elements of content—Street Fighters, or officially, "World Warriors"—are valued in opposition to one another. These character-elements are composed of sub-elements (left kick, right kick, left punch, right punch, etc.), which are also valued in opposition to one another. And these sub-elements are divided into sub-sub-elements (the intensity of each kick or punch: hard, medium, or soft), which are also valued in opposition to one another. These sub- and sub-sub-elements are the *basic characteristics* of each fighter-character; that is, all other characteristics of the Street Fighters (their names, clothes, coloring, etc.) are irrelevant to the mechanics of winning and losing the game and to the inner workings of the *SFII* game engine.

During game play, elements of content are placed in opposition to one another—the Street Fighters fight. A signification of opposition assigns values to fighter-characters in association with the values assigned to their sub-elements (and sub-sub-elements). This game play is both oppositional and, like the signification process that determines it, recursive.

During initial play, if the fighter-character Blanka beats the fighter-character Guile, then Blanka beats Guile only within the context of a specific set of punches and kicks—and counterpunches and counterkicks—thrown during a single game context. Next time, in a different context, the result may be reversed, and Guile may beat Blanka. The opposition of Blanka and Guile in each of these individual game contexts—**(A)(B)**—is *iconic*[9] and typical of symbolic representations within the action genre. Iconic representations do not and cannot represent whether one character-element (e.g., Blanka) is or is not preferable to another character-element (e.g., Guile) within *multiple* game contexts.[10]

During repeated play, Blanka beats Guile some of the time, Blanka beats Chun Li some of the time, Blanka beats Zangief virtually all of the time, and so forth. Each of these results is specific to a particular game context as it is constructed during play. Over time and repeated play, the fighter-character Blanka comes to be valued differently—in a non-iconic way. This representation—e.g. [the Blanka of all Blankas] beats [the Guile

of all Guiles]—is a *distributed* representation, or the contextualization of a large number of iconic representations: $A(A)$.

Ultimately and inevitably, the *SFII* player plays not with oppositions among character-elements but with oppositions among the basic characteristics of character-elements. Blanka's hard punch, for instance, is found to have certain similarities to Guile's hard punch—and certain similarities to and differences from Blanka's hard kick. Likewise, the sub-sub-element "hard" is found to have a certain sort of relation to—and a certain value when placed in opposition to—the sub-sub-element "medium." And so forth.

This advanced level of play involves revaluing (the re-signification of) both iconic and distributive representations. During advanced play, these representations are used to construct values within an alternative, supragame context. These new values—the result of a recursive and hierarchical signification process—result from *formal* representations. Formal representations isolate a particular element of rules-determined content and value that element of content within a rules-free context.

For instance, when the distributed representation [the Blanka of all Blankas] is transformed into a formal representation, $A(A)$ is transformed into something like $A(A(a(a)))$—where (a) indicates a particular sub-element of content, and (a) indicates a particular sub-sub-element of content, and so forth. Each of these sub-elements of content A might be most effective (valued most highly) within a particular game context, but a formal representation values them only *in opposition to each other,* thereby creating a supragame context—$(a)(b) \rightarrow ((a)(b))$—which cannot be constructed during rules-determined game play. Thus, although the function of each element of content is determined strictly by the *SFII* game rules, the value of each element is now determined outside those rules.

When playing with formal representations, experienced players frequently switch fighter-characters in order to access a particularly powerful sub-element (e.g., a devastating roundhouse kick) and then switch back once this sub-element has been used to its best advantage and another is required in its stead. This strategy allows players to create

optimum character-elements from the sub- (and sub-sub-) parts of iconic character-elements; however, at the same time, this strategy subverts the iconic representations and, by implication, the entire *SFII* rules-determined context. In effect, play at this level transforms *Street Fighter II* into a *strategy* game by incorporating the entirety of the basic signification process rather than only those oppositional components that are most often engaged within the action genre.

Or, put another way, the values required by this advanced sort of play are not available within the game engine of *Street Fighter II*—and certainly not during initial and novice play. It is only those players most knowledgeable of the rules of play who are most capable of and most likely to break those rules of play through construction of character-elements outside the context of the game: a common and paradoxical outcome of electronic game play.

Summary

The transformation of game symbols described above—from iconic to distributed to formal representations—involves a parallel transformation of game form from action to role-playing to strategy genre. This hierarchical process involves the sequential construction of values of convention, paradox, and, finally, novelty.

Within this scheme, *iconic* representations value oppositions according to game outcome. These values establish a relation between **(A)** and **(B)**—in which **A** and **B** indicate particular elements of game content and **()** indicates a singular context of game play. These representations result from an *oppositional* signification process, which is common within the action genre and, if restricted to that genre, results in values of convention within a preexisting, most commonly visceral, context.

Distributed representations value oppositions according to game context. These values establish a relation between generic game elements **A(A)** and **B(B)**—in which the semiotic crossing, **()**, indicates multiple or composite game contexts. Within the S-B system (as shown earlier), forms such as these are fundamentally paradoxical. Distributed representations result from a contextual signification process common within the role-playing genre. This process must eventually value contextual rules

for the construction of context and, as a result, create values of paradox which (potentially) deconstruct the game context.

Formal representations value oppositions according to *optimum* game outcome, subsuming earlier valuations. These representations establish an oppositional relationship between particular game elements—e.g., "sub-elements" **(a)** and **(b)**—and, simultaneously, value these elements within a supragame context—**((a)(b))**.[11] These representations result from a recursive signification process common within the strategy genre.

Within the S-B system, this common and recursive signification process is mimicked by the form **A(A(B))**, in which content A and content B display paradigmatic conditions of novelty.

Why is this basic form of **A(A(B))** so fundamental to signification and, by extension, to play? Without a more accurate biological model (rather than mimicry) of the signification process, I can only speculate as to its origin and cause. Curiously, however, this form offers the simplest combination of Spencer-Brown's elementary mark of signification that simultaneously provides:

distinction of item from Other,	**(B)**,
distinction of item from item,	**(B)A**,
distinction of item from class,	**(B)A**,
distinction of class from Other,	**((B)A)**,
distinction of class from item,	**((B)A)A**,
and distinction of class from class,	**((B)A)A**.

And it is precisely because of the singleness and the compactness of this multipurpose form that meaning-making difficulties may well arise—in the conflation and subsequent confusion of item and class. This confusion functions as a serendipitous flaw of signification, a flaw that serves to generate and to resolve values of paradox and therein to distinguish human signification from well-formed systems.

INTERACTIVITY

Chapter 8

Interactivity

Computer games display common genres of form. The fundamental characteristics of computer game genres are rooted in the human signification process that motivates their design and play. This signification process can be mimicked with two relatively simple mechanics of signification: opposition and contextualization. These minimal functions no doubt belie the specifics of the biological implementation of signification within human beings; however, restricting analysis to these two, and then, further, collapsing these into Spencer-Brown's singular mark of signification, (), has a gratifying result: These restrictions create formal conflations of the sort that commonly occur, without recourse, within paradox. And these same restrictions, through recursive application, provide a semantic escape from paradox through generation of values of novelty.

Signification is, as described here, an individual process. That is, this analysis concerns formal properties of play within individual cognition—play that is neither motivated by explicit goal nor defined by social function. However, since it is derivative of signification, all individual and interior play has the potential to serve broader communication functions—by mediating between old and new meanings, or, as the S-B system describes it, by enabling boundaries to be crossed. These boundaries are as easily drawn and crossed between the users of signs and symbols as between the signs and symbols being used.

To a great extent, then, this analysis of play is subordinate to an analysis of the broader communication process that a common and universal signification implies. This communication process is not isolated to play (or, if so, then the domain of play is all-encompassing). Certainly, human

signification occurs during play and nonplay, and this signification does not distinguish between computer game play and play of other sorts. However, computer game play *is* distinguished by the communication medium in which it takes place: Computer-based media—"new" media—are commonly characterized as more *interactive* than "old" media.

Is "interactive" play a meaningful classification of computer game play? Does it help us distinguish between play and nonplay? Is it even true, in general, that new communication media are more interactive than old? And, if so, how does the interactivity associated with a particular communication medium affect signification during electronic game play?

To answer these questions, it is necessary to have a meaningful definition of interactivity as well as the communication process that employs it. This has proven problematic. *Formal* definitions of interactivity focus on mechanical, observable behaviors associated with stimulus-response pairs. For instance, a computer game is considered interactive if that game elicits a variety of player responses and if that game responds in kind to player input. This sort of interactivity is a matter of quantifiable measurement—how often does the game respond and with how many different varieties of response? Although useful, formal definitions of this sort have been criticized as undermining the interpretive significance and semantic validity of human interactivity.

In addition to formal definitions, then, there are *functional* definitions of interactivity. Functional definitions reference the value of interactivity within either social contexts or individual experiences. Such definitions are common among game players and, in more rigorous form, among scholars and critics in the humanities.

Chris Crawford, designer of *Eastern Front, Balance of Power,* and other popular computer games, has emphasized a functional definition of interactivity in his presentations, publications, and products—including in his book *Understanding Interactivity* (2001a). Here Crawford considers whether or not a refrigerator door can be interactive:

> If you want to get academic about it, then yes, the fridge listens (to the opening door), thinks (with all the processing power of a single switch), and speaks (by turning on the light). But this kind of interaction is silly and beneath the intellec-

tual dignity of almost everybody. My concern is with interactivity that has some blood in its veins.

Crawford, 2001b, paragraph 15

Defining interactivity according to the amount of "blood in its veins" is a functional approach appealing more to common sense—or humanist intuition—than to the observation of any formal property of game design or quantitative measurement of play behavior.

However, despite popular pleas for a more intuitive understanding of the formal components of interactivity, humanist accounts often locate the interactive process within a particular medium and/or associate its degree with a particular form of technological structure, design, or implementation. And, without further qualification, this would appear to advocate a media determinism contrary to constructionist assumptions.

Ryan (1994, 2001), for instance, provides insight into the various effects of interactivity, but offers no parallel analysis concerning what biological mechanism determines that interactivity. Instead, Ryan locates particular sorts of interactivity in particular implementations of technological form (e.g., virtual reality systems).

Not surprisingly, the textual mode in which the ideal of interactivity comes closest to literal fulfillment is hypertext, a form of writing made possible by the electronic medium.

Ryan, 1994, paragraph 29

There are at least two difficulties here. One is the level of media determinism implied within functional definitions of interactivity—does valuing interactivity within social contexts require reference to technological contexts as well? The other difficulty posed by a majority of functional definitions of interactivity is whether or not computer games, or, more generally, interactive technologies, are experienced during play (and, therefore, best analyzed) as literary *texts*.

So, there is this dilemma in describing and defining interactivity: Formal accounts of interactivity offer quantitative precision in measuring interactive behaviors, but these measures lack demonstrable internal validity. Functional definitions, on the other hand, emphasize the interpretive com-

ponents of interactivity and restore (at least) face validity to the concept. However, functional definitions often tend to conceptualize interactivity as an act of reading, to locate interactivity within a particular technological context, and to be both less precise and more ambiguous than formal definitions.

In this and the following chapters, I review contrasting functional and formal definitions of interactivity and consider how those definitions might be consolidated by locating interactivity associated with computer game play—and, more generally, with use of computer-based media—within the human signification process.

The problem of defining interactivity

"Interactivity" is widely referred to as a defining characteristic of new media—particularly computer-based media. Here's how the *Journal of Interactive Learning Research* puts it:

> A learning environment is "interactive" in the sense that a person can navigate through it, select relevant information, respond to questions using computer input devices such as a keyboard, mouse, touch screen, or voice command system, solve problems, complete challenging tasks, create knowledge representations, collaborate with others near or at a distance, or otherwise engage in meaningful learning activities. Interactive environments have many functions including entertainment, commerce, and scientific visualization.
>
> Reeves, 1999, paragraph 5

Beyond such broad notions, however, "interactivity" remains on shifting conceptual ground, supposedly originating in communication media characteristics (e.g., "computer input devices" mentioned by Reeves above), yet exhibited and observed definitively only during active communication behaviors.

Within communication theory, the concept of "interactivity" recalls activities associated with interpersonal communications[1]; and the concept's application to new media purports to qualify new media on the basis of how nearly those media replicate interpersonal communications contexts.

Short, Williams, & Christie (1976) introduced media theory to the "social presence" concept[2] and therein established a hierarchy of media

that did and did not possess the ability to convey social information through contextual cues (body language, voice pitch, eye focus, and the like). Thus, a computer-mediated conversation (of the text-only variety in the 1970s) was understood as distinct from an interpersonal conversation because the latter took place in an inherently more "information-rich" (Daft & Lengel, 1986, 1984) environment. Subsequent media theory, under the influence of comparable determinist assumptions, continued to emphasize the role of media characteristics in shaping communication behaviors (Kiesler, Siegal, & McGuire, 1984; Rice & Love, 1987; Culnan & Markus, 1987), and this particular brand of theory retains adherents today: "Social and organizational changes... stem mainly from how communication technology changes what and whom people know, what and whom people care about, and system interdependencies" (Sproull & Kiesler, 1991, p. 3).

However, as computer-based media evolved, communication activities within those media ranged beyond the bounds of social presence theory. Instead of delimiting the social characteristics of communicators, computer-based media—e.g., home bulletin board systems and the Internet—equally often liberated those characteristics and reconstructed them in virtual form. There are now widespread acknowledgment and scholarly study of complex online societies, wherein multiple social presences are created, wielded, and maintained (Boudourides, 1995; Kling, 1996; Sempsey, 1997; Chenault, 1998).

In discussion of these online communities, new media are more often contrasted with their old media counterparts than with interpersonal communications contexts. And, in these redirected comparisons, new media are found to be more engaging, more facile, and more *interactive* than their predecessors. But, just like their old media predecessors, new media characteristics are still understood to shape user behaviors.

Just as Kiesler, Siegal, & McGuire (1984) looked for—and found—correlations between the "paucity of social context information" in computer-based media and the communication activities of users of those media, a short time later, others looked for—and found—correlations between the "interactivity" in computer-based media and the communication activities of users of those media (Heeter, 1989). And, currently, one way to

conceptualize interactivity in media theory remains as formal characteristic(s) of the communication medium.

In parallel, certain theories of text (e.g., New Criticism)—similar to determinist media theories—emphasized formal characteristics of messages (texts) as determining the function (interpretation) of those texts. Other theories of text (e.g., reader-response theory) offered a contrary notion: that formal characteristics were of less consequence than interpretive functions.

Or, in other words, reader-response theorists assumed that

> literature is a performative art and each reading is a performance, analogous to playing/singing a musical work, enacting a drama, etc. Literature exists only when it is read; meaning is an event (versus the New Critical concept of the "affective fallacy").
>
> The literary text possesses no fixed and final meaning or value; there is no one "correct" meaning. Literary meaning and value are "transactional," "dialogic," created by the interaction of the reader and the text.
>
> McManus, 1999, paragraphs 1–2

Shifting the conceptual focus of "interaction" from message/medium characteristics (forms) to audience interpretive performances (functions) allowed reception theorists to locate and prioritize interactivity regardless of the peculiarities of the medium/message involved. And, in fact, reception theory originated within the study of a particular medium—print—that social presence theorists earlier had declared "information poor" and therein unlikely to promote interactivity.

Currently, in both theories of media and theories of text, these two disparate notions of interactivity are found in their own separate domains. The study of formal characteristics of media and how those characteristics affect audiences takes place most often in the social sciences, wherein the concept of media interactivity has gained some empirical validity (Heeter, 1989; Kenny, Gorelink, & Mwangi, 2000). The interpretive functions of audiences are more commonly engaged in the humanities, particularly in the literary analysis of text, where interpretive/cultural studies have strong face validity and intuitive appeal.

Occasionally, media theory and literary theory have recognized problems in ignoring alternative conceptualizations of interactivity. Yet neither theoretical field, operating independently, has been able to effectively bridge the gap between functional and formal definition. Literary theorists, for instance, may acknowledge that "the reader-response approach does not so much analyze a reader's responding apparatus as scrutinize those features of the text that shape and guide a reader's reading" (Harmon & Holman, 1996, p. 427), and contemporary media theorists may argue against characterizing media according to formal characteristics in favor of analyzing media "performance" during use (Rice, 1999). Yet such concessions acknowledge the existence of alternative conceptualizations without an accompanying willingness to deprioritize entrenched assumptions and methods, which maintain a clear distinction between the functional and the formal—a distinction at the root of the confusion concerning the nature and origin of interactivity.

And, unfortunately, despite the relative newness of new media, this is not some freshly minted theoretical problem that might quickly be dissolved in the sudden light of focused attention. The theoretical divide between the functional and the formal has been at least as long-lived as media theory itself.[3]

Indeed, some of the first analyses of interactive behaviors associated with new media—specifically, computer game play—recognized that the conceptualization and measurement of interactivity required contextual data beyond those available from analysis of either text or reader, medium or user, game or player: "A computer game 'aesthetic' cannot be based solely on game content but must consider player-game *relationships* as well—and further detail the interactive *process* of play" (Myers, 1990a, p. 384, italics added).

In the intervening decade or two, those measurements and that conceptualization have not been forthcoming—with the exception of Rafaeli (1988; Rafaeli & Sudweeks, 1997).

Chapter 9

Defining interactivity

Anyone working to conceptualize Internet communication would do well to...
follow Rafaeli's lead when he notes that the value of a focus on interactivity is
that the concept cuts across the mass versus interpersonal distinctions usually
made in the fields of inquiry.

Morris & Ogan, 1996

Rafaeli's solution to the functional/formal schism was this: Instead of
awkwardly juggling conventional distinctions—first prioritizing this
formal measurement, then prioritizing that functional process—Rafaeli
defined interactivity as a functional process, but used formalist methods
to do so. This strategy retained the intuitive appeal of a functional defini-
tion within a more easily quantifiable formal context.

Interactivity is not a characteristic of the medium. It is a process-related con-
struct about communication. It is the extent to which messages in a sequence
relate to each other, and especially the extent to which later messages recount
the relatedness of earlier messages.

Rafaeli & Sudweeks, 1997

Obviously, communication messages "relate to each other" within some
semiotic context. And, therefore, in the mechanics of formally mapping
"the relatedness of earlier messages," Rafaeli had to indirectly map the
semiotic context within which relatedness was constructed and maintained.

Interactivity places shared interpretive contexts in the primary role. Interactivity
describes and prescribes the manner in which conversational interaction as an
iterative process leads to jointly produced meaning.

Rafaeli & Sudweeks, 1997 [italics added]

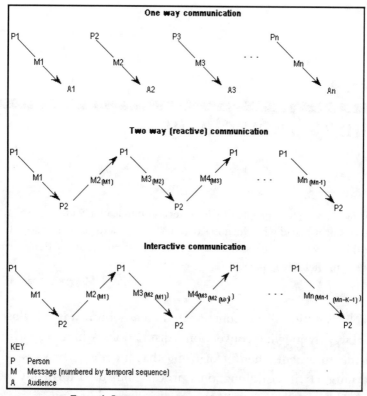

Figure 1. One-way, two-way, and interactive communication.

Figure 9.1: One-way, two-way, and interactive communication.

Source: "Interactivity on the Nets," Rafaeli, S., and Sudweeks, F., in *Network & Netplay: Virtual Groups on the Internet*, p. 176, American Association for Artifical Intelligence, © 1998

It is useful to pay close attention to this mapping and to note that it is based on formal iteration. The figure above displays the importance of this iterative process.

In a slightly different symbolic language, we can represent the interactivity of the third sequence within the figure above as the function **I**:

$$f(\mathbf{I}) = M_{(f(\mathbf{I}))}$$

Though the term was not used in Rafaeli & Sudweeks, this type of function is known in mathematics and logic as a *recursive* function; it is

then important to distinguish between recursion and iteration. A recursive function is one that includes an embedded call—or reference—to itself. Strictly speaking, an iterative function does not include self-reference; but an iterative function can, with a looping process, accomplish the same result as the recursive function with its embedding process. For instance, function **I** can be also expressed iteratively:

$$\text{For } \mathbf{I} = \infty \text{ to } 1, \ f(\mathbf{I}) = M_{(f(\mathbf{I}-1))}$$

The fundamental difference between these two formulae is that the former, recursive function is without immediate bounds, while the latter, iterative function must include some description of bounds or predetermined limits. For this reason, two-way, "reactive" communication in the figure above is better expressed iteratively:

$$\text{For } \mathbf{I} = 2 \text{ to } 1, f(\mathbf{I}) = M_{(f(\mathbf{I}-1))}$$

Within practical human discourse there are similar bounds—pre-existing cognitive limits—on the number of recursions interactive communication meaningfully employs. These bounds are similar to those guiding generative grammars in the formation of layered or embedded sentence structures; that is, these are limits imposed on an endlessly recursive process by biological (formal/structural) characteristics of human communicators.[1]

Incorporating these limits, the Rafaeli definition offered a solution to the functionalist-formalist problem. The Rafaeli definition assumed some residue of human functional processes in formal characteristics of communication messages, and, simultaneously, *ground* human interpretive functions within both the formal characteristics of communication messages and message communicators. This was advantageous in that it maintained the primary strength of both functional and formal domains: It promised the quantitative precision of formalist measurements harnessed to the conceptual validities of a functionalist perspective.

However, the Rafaeli definition of media interactivity was not entirely new as a framework for solving functional-formal dilemma. In fact, the

Rafaeli (1988; Rafaeli & Sudweeks, 1997) definition was very similar to Saussure's much earlier (1916) definition of linguistic "value."

Parallel problems

Language theory has had its own functional-formal debates (see Darnell et al, 1999). The two sides are manned by those linguists who prioritize "langue" over the study of "parole" and those who do the opposite.[2]

A well-known champion of langue is Chomsky: "Linguistic theory is concerned primarily with an ideal speaker-hearer in a completely homogeneous speech-community, who knows its language perfectly" (1965, p. 3). From this perspective, the formal characteristics of langue represent formal characteristics of an "I-language" (internalized language: Chomsky, 1986, p. 21). And this I-language, in turn, represents formal (native or innate) characteristics of human communicators.

> All this leads us to believe that above and beyond the functioning of the various organs there exists a more general ability, that which governs signs, and which would be the linguistic faculty par excellence.
>
> Saussure, 1959, pp. 26–27

On the other side of the language theory battleground is a more functional approach—sharing assumptions with reader-response theory—in which language patterns and forms are less significant than their social and historical determinations. Several contemporary variations of linguistic functionalism are available to contrast with Chomsky's formalism, prominent among them that of the Prague School: "the functionalist approach having the longest continuous history" (Beaugrande, 1997).

In this context, the similarity between Rafaeli's definition of media interactivity and Saussure's definition of semantic interactivity is striking. Both definitions describe how meanings are determined within a natural language. And both definitions, in a very similar way, offer the opportunity for reconciling formalist and functionalist positions.

Saussure found the meaning of words to be as problematic as contemporary media theorists have found the interactivity of media. He preferred to substitute the "value of terms" for the "meaning of words," and he defined a term's "value" this way:

Language is a system of pure values determined by nothing except the momen-
tary arrangement of terms… a system of interdependent terms in which the
value of each term results solely from the simultaneous presence of others.

Saussure, 1959, p. 114

This definition is clearly formalist, defining a term's value as its rela-
tive position within existing term structure ("arrangement"). Yet this defi-
nition also echoes Rafaeli's definition of interactivity, which places the
formal qualities of static message content within a dynamic context of
message use. And there have been those who subsequently have found
Saussure's definition of value capable of promoting the simultaneous study
of formal and functional characteristics of language.

For instance, some biological functionalists have attempted to sub-
sume formalist definitions within broader contexts of human behavior. To
this end, Saussure's structural linguistics has been positioned more as work-
ing methodology than guiding set of assumptions. Use of this conceptual
strategy can be found in Emmeche (1992) and Emmeche & Hoffmeyer
(1991), who subsumed formal qualities of language within a natural (func-
tional or pragmatic) history of the human species.

The concept of language system in Saussure has an ambiguous ontological sta-
tus. On the one hand, it signifies the system that the linguist reveals through the
mentioned methodological abstraction, from the concrete speech acts through
the network of relations of distinctions…. On the other hand, Saussure has a
tendency to treat the language system as an object as concrete as the language
use, i.e., as an autonomous reality… [thus] structuralism can inadvertently lead
to a concept of structure as an independent reality.

Emmeche & Hoffmeyer, 1991[3]

A more unified and basic understanding of signs in living nature must involve a
natural history of signs, i.e., an evolutionary account of sign functions not exclu-
sively bound to the life of the signs in human society (as F. de Saussure originally
conceived as the subject of his semiology).

Emmeche, 1992

This strategy of incorporating formalist definitions and methodolo-
gies into functionalist theory has also found application in literary theory—

see, for instance, Derrida's (1976) comments on Saussure—and in mainstream linguistics as well, including Newmeyer (1999), who recognized, in general, "no fundamental incompatibility between the central tenets of the two [formalist-functionalist] approaches" (p. 483).

Given that a conciliatory interpretation of Saussure's definition of value allows its use as a conceptual perspective capable of reconciling functional processes and formal qualities of language, I suggest that a sympathetic interpretation of Rafaeli's definition of interactivity might be used in a similar manner.

To this end, I would again call close attention to the fundamental similarities between Saussure's definition of value and the earlier definition of interactivity as "messages in a sequence relate[d] to each other, and especially the extent to which later messages recount the relatedness of earlier messages." Both definitions require the identification and measurement of formal characteristics (interdependencies/relatedness) within broader contexts (language system/message sequence). And both definitions focus on a meaning-making process—a *semiotic* process—within situated communications.

Why are these similarities so important?

First, these similarities highlight the similarities—and the equally fundamental nature—of the formal-functional problem in media theory and language theory. In order to overcome problems associated with defining new media interactivity, this fundamental issue needs to be addressed directly. And, more pointedly, the similarities of theoretical problems within media theory and language theory require media theorists to more closely scrutinize the *representational* nature of those "texts" associated with interactivity.

For instance, the most immediate and practical problem facing Rafaeli's definition of media interactivity is how to measure message relatedness. When this problem is placed within the context of language theory, it becomes a problem of measuring the representational characteristics of language, or, put more generally, a problem of semiotics—the same problem confronted here in the attempt to explicate the representational nature of computer games and the semiotic processes involved during their play.

Chapter 10

Valuing interactivity

Locating interactivity within a semiotic process does not of itself simplify measuring interactivity. Semiotics, like media theory and language theory, has both formalist and functionalist derivatives. General semiotics, for instance, has been traditionally a formalist approach; social semiotics, on the other hand, has been functionalist in assumptions and practices.

Andersen (in press, 1997) offers one of the few extended examinations of interactivity within a semiotic process; his is a formal treatment in which interactive signs are "unique to the computer medium" (1997, p. 216). According to Andersen, an interactive sign has tokens

> distinguished from the other signs on its level by permanent features…, and during its lifetime it can change transient properties…, these changes being functionally dependent upon its handling features. In most cases it can perform actions that change transient features in other signs.
>
> Andersen, 1997, p. 216

That is, interactive signs are those that accept input (handling), have both permanent and transient (mutable) features, and can affect features of other signs—a description similar to what I have described as semiotic "context." Andersen, however, constrains semiotic interactivity within the formal domain of a preexisting context: the rigid-rule context of a programming language. Likewise, an "interactive" work is bound within the semiotic domain of that work.

> An interactive work is a work where the reader can change the discourse in a way that can be interpreted and makes sense within the discourse itself. An interactive work is a work where the interaction of the reader is an integrated part of

the work's signification, meaning that the interaction functions as an object-sign *that refers to the same subject as the other signs, not as a meta-sign referring to the signs of the discourse.*

Andersen, 1992 (as cited in Juul, 2001, p. 20) [italics added]

In his analysis, Andersen considers many of the fundamental issues I have raised concerning the use and form of signs and symbols: "If language is our means to describe the world, to reason logically about it, and to coordinate our actions therein in a rational way, then why has it developed circular definitions and paradoxes?" (1997, p. 6). However, in discussion of this and similar dilemma, Andersen summarily dismisses the explanation I have offered as most likely: an innate and intractable signification process. Andersen places this explanation within the "generative tradition":

The generative tradition addressed the problem of the stability of language and the physical existence of rules by postulating that most rule schemata are innate and that only certain parameter-settings are learned.

Inside-out (IO) theories tend to rely on the maturation of innate structure, describing the adult form in great detail. The maturation of innately given rules or forms is primarily responsible for adult linguistic competence in the IO theories [...]; thus, these theories argue that the innate component of language is of primary importance, and the environment represents raw material which triggers the development of these innate forms.

(Tucker and Hirsch-Pasek 1993: 360)

But this explanation runs into two major problems:

It has not been possible to prove the physical existence of linguistic 'rules' in the brain or in the genome (although centers of language have been documented). Even if this were possible, the burden of explanation would just be shifted, because then we would need to explain how the linguistic genes were able to develop and become stable in the first place.

Andersen, 1997, p. 4

These two objections—lack of physical evidence (i.e., the biological mechanism) of semiosis, and lack of an explication of the origin (i.e., the natural evolution) of semiosis—move Andersen to provide a taxonomy of logically explicable *computer* semiotic functions. If this were either more

effective or more definitive than current speculations concerning the mechanisms and evolution of *human* semiotic functions, it would be welcome and useful. But Andersen's taxonomy is definitive only within its specified domain and, therefore, is not satisfying in at least two respects.

First, restricting interactivity to "an integrated part of the work's signification" is especially disparaging to the study of interactivity during *play.* For, if interactivity were restricted to a preexisting semiotic domain (i.e., if it were context bound), then it could not, through processes and forms like those earlier described, generate values of novelty.

Alternatively, Andersen's analysis might be found wanting by reader-response theorists—and game players—for more general reasons:

> A semiotic analysis of computer games such as Andersen's is doomed to fail, exactly because it does not regard the actual text but merely a representation thereof.
>
> Kucklich, 2001, paragraph 1

Thus, Andersen's approach suffers from its inability to generalize an analysis of computer language forms to human semiotic functions.

In parallel, humanistic analyses of computer games as literary devices often fail to locate the origin of new media interactivity in a semiotic process prior to and more fundamental than the recognition and interpretation of *text.*[1]

As a rule, the emphasis of *text* in either formal or functional analyses is particularly unfavorable to a full understanding of interactivity during game play because texts and textual signs—like those employed by *Colossal Cave* and other early adventure game designs—are grounded in second-order significations. Signification during game play then depends on signification of words (or word elements) that compose the game, or, more exactly, on those relationships that are most dominant among these words: relationships of contextualization. Interpreting game "texts" through a second-order signification process involves the application of that second-order signification process to itself; and this, a recursive signification process *without bound,* motivates the inclusion of contexts beyond that of the game—

e.g., the culture within which the game/text has been conceived and constructed.[2] Any resulting values of play are therein diminished and subsumed within an endless progression of context; and, instead of being defined *as* paradox, interactivity is often defined *within* paradox.[3]

In order to resolve the related problems of overdetermined and ambiguous significations (on the functionalist/humanist side) and underdetermined and overly restrictive significations (on the formalist/scientist side), there must be some reference to first-order significations—or firmer *ground*. Humanists have often finessed this requirement by transposing the paradoxes of unbound significations to a domain of ethical and moral values; significations therein remain overdetermined and multiple, but some of those are recognized as more privileged, more useful, or simply more common than others. Humanistic analysis then seeks to determine through what means certain significations gain precedence over others with reference to, among other things, the first-order significations of historical necessity—e.g., Foucauldian analysis.

Scientists, on the other hand, have been more likely to find their ground elsewhere: in the still unresolved mysteries of the human biological organism or, equally, in the formal properties that the human organism displays.

> The conflicting species of cognitive science uniformly view meaning as residing in minds, however intricately distributed. Research in cognitive science searches for regularities across individual minds, for structures and processes of mind, and for constraints on the mental construction of meaning. It assumes that the science of mind can inform us about human acts, including linguistic and literary acts, and that mind is in crucial ways prediscursive: not entirely created or structured through cultural discourse as a patchwork of narrow historical contingencies.
>
> Turner, 1995

> ...then it follows that we must henceforth model linguistic structures using mathematical models which generalize those of computational vision, and which belong therefore to the mathematical universe of dynamical systems, differential geometry, partial differential equations and functional analysis.
>
> Petitot, 1995

Unavoidably, however, even when algorithmic simulations of a natural human semiosis employ the first-order significations of physical and/or historical necessity, their signifieds still must be valued and understood through a second-order signification process. That is, these simulations are constructed by the same semiotic machine they represent: the human machine; such a circumstance can result only in paradox, unless or until this semiotic machine develops the capability to refer to itself *without representing itself*. This is precisely the capability of cognitive play and, most particularly, computer game play.

Computer games—originally in the shape of *Spacewar* and increasingly with the aid of more veridical displays and consoles—reveal a more fundamental and natural semiosis than that associated with the interpretation of text. Unlike conventional texts, certain genres of electronic games and gaming contain an *emptiness* of meaning, which is simultaneously formal paradox and its own functional resolution. This realization of electronic games is not the result of some fantastical transformation of the senses, as early media determinists (e.g., McLuhan) asserted; it is rather part of the prior and omnipresent underside of words and texts, a semiotic process that functional analyses of text and proponents of reader-response theories have alluded to but never revealed insofar as they have remained fixed on sequences of words—plots, characters, and narratives—rather than on relationships among signifiers and signifieds.

A semiosis of play

I have now described three semiotic processes, which will serve hereafter as the basis for a phenomenological analysis of individual computer games and game play. These processes are signification of opposition, signification of contextualization, and the interactive process during which these two significations take place and are recursively applied. Interactivity is not set far apart from significations of contextualization by this scheme, but it is given a unique function during play. Interactivity indicates the process by which a human player activates and values those significations motivated by game design and form. Interactivity is therefore to be considered, in accordance with Rafaeli's definition, as a functional, interpretive process best measured indirectly with reference to semiotic form

(i.e., game design). It is, put most directly, a bounded recursive contextualization.[4]

> The most fundamental characteristics of computer games [are] in the patterns of interactivity between player and game.
>
> Myers, 1990b, p. 294

> Computer games are pervaded by structures of recursive context shifting.
>
> Myers, 1991, p. 343

Prior to examining specific games to locate characteristic significations of play, it may be useful to make some brief and explicit comments—in addition to those already implied—concerning theoretical approaches and concepts that I will *not* employ during any subsequent "close reading" of computer games. Chief among these is the detailed application of literary theory beyond sporadic references of the sort already made. For instance, I will not directly attempt to describe either differences or similarities between games and "fictions," or between games and "narratives." This may well be because these terms are not well defined; it is certainly because I am unable to define these concepts—or find them defined elsewhere—in a formal and consistent way. (See Andersen, Holmqvist, & Jensen [1993] for alternative views.) It is my impression that my analysis of game semiotics takes place at a sort of assembly language level, whereas literary theory is more commonly conducted at some higher, operational level.[5]

At an extreme of this impression is the possibility that "narratives" originate in the same manner that Gould & Lewontin (1984) suggested spandrels originate—as the result of initially unforeseen but structurally necessary arrangements of more fundamental processes and forms. That is, narrative and fiction may have no meaningful origin of their own accords; nor might any meaningful delineation of their characteristic forms be possible without reference to the more fundamental parts of which they are the subsequent, emergent wholes.

Less extreme, perhaps, is the possibility that a literary analysis of computer games is inconsonant with my own only insofar as that analysis, as I have earlier charged, remains fixed on sequences of words rather than on

relationships among signifiers and signifieds. If literary analysis were to focus more on the relatings rather than the results of semiosis, then that analysis would be less foreign to my own. For instance, there is this within Aarseth's (2001) interesting, literate, and literary analysis of adventure games as "ergodic" literature: "Fiction should be regarded as a category not of form but of content (i.e., the same sentence might be fact or fiction, depending on its reference)" (pp. 84–85).

I would agree, but only as a result of the parentheses added, which seem to introduce a confusion between "content" and "reference." Briefly: if three elements compose the sign—signifier, signified, and the relationship between the two—then form and content can be reasonably understood to substitute for the first two of these. The third element, the relationship (or, better, the *relating*) between signifier and signified, can also reasonably be labeled "reference," but only insofar as this remains distinct from "content."[6]

My concern is that this distinction is not often made definitively or, if made, not often held among literary theorists. This distinction between formal structures and formal structurings—with greater theoretical significance given the latter—is critical to a proper understanding of electronic game form. Indeed, the relating between signifier and signified is the most fundamental component (or "componenting") of semiotic structures.

> Mine is ultimately a strategy of describing play with text by describing textual "playings." This strategy is most effective where the infinitive is given precedence over the noun. Unfortunately, such a strategy is difficult to follow in a largely noun-based language. For instance, I do not want to deal with isolated elements of the computer game text but rather with their relationships. Even then, my true topic is more properly these elements' "relationshipping" or, somewhat less exactly, their *relating*.
>
> Myers, 1991, p. 335 [italics in original]

> My own expectation is that when the almost totally unknown realm of processes whereby DNA determines embryology is studied, it will be found that DNA mentions nothing but relations. If we should ask DNA how many fingers this human embryo will have, the answer might be, 'Four paired relations between (fingers).' And if we ask how many gaps between fingers, the answer would be

'three paired relations between (gaps).' In each case, only the '*relations between*' are defined and determined. The relata, the end components of the relationships in the corporeal world, are perhaps never mentioned.

<div align="right">Bateson, 1979, pp. 157–158</div>

PART 4

INTERACTIVE PLAY

Chapter 11

The phenomena of computer game play

Unlike the abstractions of form described earlier, a natural semiosis does not isolate individual acts of signification; the semiotic process that takes place during electronic game play entails multiple, even simultaneous, oppositions and contextualizations. Likewise, computer game designs are not often pure and simple exemplars of the genres to which they are assigned.

Computer games—as a result of the interactive processes during which those games are designed and played—often display disparate combinations of semiotic forms. Over time, these combinations might reveal consistent patterns of form for a variety of reasons: because certain combinations of forms have a common aesthetic appeal among designers, or because certain forms are more easily constructed and implemented within a particular technological context, or because certain forms have achieved recent commercial success and are, for that reason alone, reproduced in great number. Taken together, however, these factors provide no assurance that any resulting consistencies of form—genres—are either fundamental or lasting.

However, random factors alone are unlikely to have resulted in the sort of organization and structure that computer game designs display. On the other hand, if there were a limited number of basic semiotic structures—as this argument maintains—then any subsequent combinations of those structures, even if randomly generated, might have resulted in a correspondingly limited number of generic forms. This latter position is the one I take here.

In any case, regardless of their origin, differences among the signs and symbols of computer games and accompanying differences within their

significations during interactive play have established clearly recognizable genres. In this section, I examine the play phenomena associated with three particular games within three basic genre categories in order to demonstrate the consistent forms and functions of play as semiosis. The three games—actually game series—are these: *Doom,* an action series; *Might and Magic,* a role-playing series; and *Civilization,* a strategy series.

I have chosen these three for a variety of reasons, some idiosyncratic. However, most important is that these three games well represent the particular genres to which they are assigned; that is, aspects of each of these three games are very close to typifications of the characteristic semiotic processes previously associated with action, role-playing, and strategy game play, respectively. In achieving this exemplary status, these games are relatively rare; most computer game designs initially appear in a roughshod form that is not often—particularly if the game is less than successful—further revised and polished. However, if the game design *is* successful (i.e., fun to play), then its initial design seems inevitably drawn into an extended variation-and-selection process very similar to that process Douglas Lenat used in conjunction with EURISKO (see chapter 5) to win the *Traveller TCS* competition. This evolutionary process revises game form and content according to feedback gained during repeated play, and this process is very similar across genres.[1] In all genres, revisions of individual games over time tend to particularize the genre to which those games belong, isolating their basic semiotic forms from intruding and inconsistent forms.

Certainly, all three of the games I discuss in the following chapters have been and continue to be, as such things are measured, quite successful; each has had a long shelf life, and each has received widespread play in its original and revised forms. Because each game has undergone significant changes over several years, each reveals much of the common evolutionary process of game design and play. The continued popularity of these games and their ability to sustain player interest results directly from the degree to which each game has reproduced the forms and functions of a natural semiosis.

More conventionally, of course, the success of each game is judged by the degree to which it is fun to play. And these three games are fun not only based on my own experience but also based on the experiences of others—which implies that these games not only exemplify theoretical genres, but also the common and natural cognitive processes that evoke pleasure during play.

Although each of these three games is relatively rare in being among the most fun, the most successful, and the most representative of their respective genres, they are not unique. Many other games have similar forms—in particular, the game marketplace has seen a large number of three-dimensional (3D) shooters virtually identical to *Doom*. And, although I would like to think that this might be indicative of real-time action games converging toward a particular semiotic form, it is equally and more probably indicative of the influence of market forces on shaping the copycat output of computer game companies. Nevertheless, there are important semiotic reasons why so many game companies licensed id Software's graphics engine (or created similar software engines of their own) after the release of *Doom*—reasons that I will discuss in this chapter.

Within the role-playing genre, there have been several games over the past decade sharing design components with the *Might and Magic* (*M&M*) series. *Baldur's Gate,* for instance, is a well-known—and, in many ways, aesthetically superior—role-playing competitor of *Might and Magic;* but *Baldur's Gate* is a slightly newer game that represents less of role-playing game history and evolution than does *Might and Magic.* The *Ultima* series, on the other hand, is both similar in design to and has a longer pedigree than the role-playing versions of *M&M;* unfortunately, that pedigree has shown, in its most recent editions, diminished quality. The *M&M* role-playing series has proven more consistent and more typical in design[2] than the *Ultima* series and, for that reason, more instructive during analysis of its play. And, because the *M&M* role-playing games overlap thematically with the *Heroes of Might and Magic* strategy games, *Might and Magic* provides opportunities for contextual analyses that are not available with equally popular role-playing games restricted to a single generic form and/or a single technological platform (e.g., Nintendo's *Zelda* series).

I am hard pressed to find any strategy game superior in form or play to *Civilization,* though there are certainly similar designs that rate highly in play value, historical importance, and theoretical utility—e.g., *Empire,* an early computer game influencing the later *Civilization* design, and *Master of Orion,* which followed closely on the heels of *Civilization.* There are also several interesting variations of the fundamental strategy game design, including designs that have, for one reason or another, become associated with genre-defining characteristics: the cut scenes in the *Wing Commander* series, the cross-gender appeal of the *Sim* series, the "god game" perspective of *Populous* and its offspring, and the real-time components of *Dune* and *Age of Empires,* among others. However, none of these is as centrally placed in computer game history nor as widely acclaimed by players and reviewers as *Civilization.* For these reasons, I will discuss in most detail the phenomena of game play within *Civilization*—and most particularly within *Civilization II,* which best represents the fundamentals of the strategy genre's basic semiotic form.

A brief history of *Doom*

Doom lies at the thematic center of a formally related and ongoing sequence of games, which includes publication of *Castle Wolfenstein* (*CW*) in the early 1980s, extends through distribution of *Quake* in the late 1990s, and, most recently, has been revived by a graphically refurbished version of *CW* carrying the original Wolfenstein name: *Return to Wolfenstein 3D* (2002).

The first *Castle Wolfenstein* was designed by Silas Warner and distributed by Muse Software in 1983. It was one of those conglomerations of form that borrowed its design from several sources—most obviously from the graphic adventure games popular during the early 1980s. Its contemporaries included, among others, the more lush and literary *King's Quest* (see chapter 3).

During *Castle Wolfenstein* play, a single, third-person player-character ran from room to room within a Nazi stronghold populated with a lot of Nazi guards and an occasional low resolution table. Players viewed and controlled their player-character from a top-down perspective displaying a no-frills schematic of castle rooms, one room at a time. Character ac-

tions during play included running (sometimes sneaking) from room to room, finding food, ammunition, and the prototypical adventure-game keys (security passes) that allowed access to still more doors and rooms, and shooting and killing Nazi guards wherever and whenever they happened to appear.

None of these design elements of *Castle Wolfenstein* was particularly innovative[3]—except perhaps the game's use of digitally sampled speech. (The Nazi guards cried "Mein Leibe!" while dying.) However, transposing common elements of the fantasy adventure game—hero, dungeon, monsters—to a more realistic, WWII setting had a fortuitous result: It allowed *the isolation* and iterative opposition of player-character and computer opponent. This confrontation between player-character and a continually replenished supply of Nazi guards came to define the signification process during *CW* play. That is, the constantly recurring opposition of hero and guard within *Castle Wolfenstein* turn a mixed genre, action-adventure design into a colorfully staged action game in which the adventure game's goal of exploration became secondary to the more visceral and immediate goal of survival. During *Castle Wolfenstein* play, players cared little for storybook plot or role-playing context; they just wanted to shoot that other guy before that other guy shot them.

Once significations of opposition came to dominate game play in this manner, movement from one set of rooms to the next within *CW* was equivalent to moving from one level to the next within a more conventional arcade game (e.g., *Asteroids*)—the obstacles got a little more numerous and the guards got a little faster on the draw, but otherwise it was the same guards and the same rooms and the same iterative process of play.

Castle Wolfenstein sold enough copies to motivate a sequel: *Return to Wolfenstein*. But the *CW* game design faced a technological obstacle that, during the early 1980s, proved difficult to overcome: The game used second-order, connotative signs to create a first-order signification process. Put simply, *Castle Wolfenstein* had poor graphics. While the signs within *CW* could become denotative during extended game play—just as *Spacewar*'s Needle and Wedge became denotative during extended play (see chapter 2)—these denotations had little value or appeal outside the game context. This meant that it was still necessary to properly value the game context (i.e., play the

game many times) prior to properly valuing its oppositional signs: a backwards sort of semiosis similar to that of the adventure game.

In order to isolate and particularize a denotative signification process, game signs needed to be first-order *prior* to play, not as a result of play. At the time Silas Warner and Muse Software created *Castle Wolfenstein,* the combination of hardware and software necessary to create first-order signs in real time and real space—e.g., signs as seen from a first-person, human perspective—was unavailable for home computers. And, though some arcade games using vector graphics and open figure objects (like those in Atari's *Battlezone*) had accomplished the effect with partial success, the result of that success was similar to the result of the first kinetoscopes: Any illusion of movement remained an obvious illusion— something more than connotative, yet still less than denotative in any context beyond that of the game itself.

Smoothly *scrolling* games, on the other hand, in which the illusion of movement took place in only one flat and linear direction, had been available for some time on dedicated (i.e., arcade and Nintendo) game platforms; this achievement in graphic display represented the next step up for home computer games.

In the late 1980s, John Carmack developed a successful side-scrolling routine for home computers that he used to construct the shareware hit *Commander Keen.* The success of this game enabled Carmack and some of his game programming cohorts—notably John Romero and Tom Hall— to form id Software in 1991. A year later, inspired by the game play of the original *Castle Wolfenstein,* the id Software team designed and released *Wolfenstein 3D.* This game, powered by id's in-house graphics engine and released almost ten years after its namesake, gave those significations motivated by the original *CW* play a more natural, more visceral, and more effective symbolic form.

Wolfenstein 3D, I can well recall, was the first computer game to make me sick. Its graphics engine produced the first home computer graphic display that somehow intercepted the visual relays of cognition—and distorted them. The distortion, of course, was not as significant to the game design as was the interception. Playing *Wolfenstein 3D* motivated a rudimentary and *instinctive* sense of motion through representation of player-

character movement with first-order signs. The signs within *W3D* remained blocky and crude and much less than photorealistic, but their relationships within the home computer display motivated something close to a physical sensation of movement—close enough, in my case, to induce motion sickness during extended play.

Like *Commander Keen*, *W3D* was released by id as shareware. And its success as shareware depended on fundamental characteristics of the game that were also to determine the subsequent success of its more commercial progeny: *Doom* and *Doom II*. The shareware version of *W3D* was a tease. Players were given free access to a limited number of levels (called "episodes") in the original *Wolfenstein 3D*. Playing an abbreviated portion of the game—roughly equivalent to reading the first chapter of a novel—was intended to incite sales of the full version, which applied id's graphics engine to a broader canvas.

Because of the unique semiotic form of *W3D*, this shareware strategy worked particularly well. After playing the first episode of *Wolfenstein 3D*, players knew exactly how the game played and what it was about: It was not about picking up keys or solving puzzles; it was about getting off the first shot. Players possessed an embedded sensorium that instinctively contextualized the significations of opposition within *Wolfenstein 3D;* and, therefore, the opposition of player-character and opponent within *W3D* was assimilated and interpreted according to values already implicit within that common, natural, and preexisting context. A single episode of *W3D*, in other words, was more than enough to portray the essence—the fundamental significations—of game play.

In contrast, those significations that characterized the role-playing genre—significations that determined context rather than those that were valued according to context—could not be so quickly evaluated in abridged form. Episode one of a role-playing game might be quite interesting, but the remainder of the episodes damningly poor. The values of common signs in role-playing games—their meanings—evolved only over time through significations of contextualization. This was exactly the opposite of what happened in *Wolfenstein 3D*, where what you saw in the first episode was exactly what you got in the later episodes—and also what you got in subsequent refinements of the design that produced *Doom* and *Doom II*.

Doom (1993) and *Doom II: Hell on Earth* (1994) represented a peak in the development of the 3D shooter; it was only after the design and development of these games that the action and adventure/role-playing components of the original *Castle Wolfenstein* went their separate ways. This paring down of the action genre to its most fundamental semiotic form was marked by a parallel split within the id Software team.

Tom Hall, the team's primary level designer, was the first to leave; Hall departed id for Apogee Software in order to create game designs he believed were not possible to create within a "technology driven company."[4] After the development and release of *Doom/Doom II*, John Romero left for similar reasons. Romero had served as the team's software tools developer and resident expert in game play.[5]

Neither of these two designers' contributions to *W3D* and the *Doom* series—neither the dramatic structures of Hall nor Romero's insight into and expertise with practical applications of the games' graphics engine— were crucial to revision and refinement of the game design once that design had achieved widespread success and play. In fact, both of their particular talents were, by the mid-1990s, widely (and freely) available within a large and growing population of *Doom* players. In particular, Romero's intimate knowledge of the game may well have put him at a disadvantage in evaluating the game's appeal in its increasingly popular multiplayer form; that is, Romero was much more likely to employ significations of contextualization (strategy) and much less likely to employ significations of opposition (action) than were new and less sophisticated players.[6]

This breakup of the original *Wolfenstein* design team left John Carmack, id's original and leading graphics programmer, as the single major influence on the subsequent design and release of *Quake*. And, as a result, Carmack became the computer game industry's prototypical action game designer. Carmack's design decisions had always focused on creating action settings rather than dramatic stories, with technological breakthroughs in graphics display, processor speed, and/or software routine preceding and ultimately determining refinements within id Software's ongoing game series. Increasingly, Carmack was free to make design decisions in disregard of the superfluous demands of "narrative." From this "technology driven" design perspective—a perspective fundamental to the action

genre—the id graphics engine and the relationships it established among signs and symbols within the *Doom* environment *was* the game. Everything else—levels, plots, characters—provided extended opportunities rather than vital necessities for play.

Play in *Doom II*

Doom II was arguably the most difficult of the *Doom* series. *Doom II* was played from a relentlessly first-person perspective that confronted the player with oppositions (i.e., monsters to be killed) immediately upon loading the game; this first-person perspective remained the single contextual frame within which virtually all game play took place.

Most of the action—and most of the fun—within *Doom II* occurred during face-to-face confrontations with monster-opponents inside thirty-two different levels (ostensibly arranged in order from easiest to hardest to complete), each supplemented with its own soundtrack. Once a level or portion of a level had been cleared of monsters, players might—or might not, depending on their style of play—make use of the game's "automap" function. The *Doom II* automap screen depicted the player-character from a top-down perspective similar to that of the older *Castle Wolfenstein* display. Prior to shooting and destroying all monsters within a level, this automap view was used only infrequently and, in many cases, was a particularly disadvantageous tactic to employ with monsters still about.

The monsters that faced the player-character in the initial levels of *Doom II* were very close in superficial form to the player-character. After vanquishing these first and easiest-to-vanquish opponents, the player-character was gradually introduced to monsters that were increasingly threatening and formally distinct from the player-character. These distinctions of form, however, were superficial. Within a rigid-rule game context like that of the *Doom* series, all opponents were cut from the same cloth of algorithm. That is, while the more-difficult-to-vanquish *Doom II* monsters were represented as spiders, demons, and other nonhuman forms, their *dynamic* representations within the game—their actions valued in relation to all other game actions—closely mirrored the dynamic representations of the player-character.

To demonstrate the fundamental similarity among the dynamic representations of player-characters and monster-opponents—and all similar representations in action games dominated by significations of opposition—it is useful to think of each of the characters in *Doom II* as composed of (or having the sub-elements of [see chapter 7]) offensive, defensive, and movement dimensions.

For instance, in *Doom II,* the player-character's offensive value was signified by the type of gun being used: pistol, shotgun, plasma gun, etc., and the player-character's defensive value was signified by, among other things, the type of armor being worn. In *Doom II,* these two value dimensions were determined by a second-order signification process, i.e. the player-character's defensive value depended on the relationship of the current armor being worn to all other armor available within the game (including armor worn by monsters, which remained unknown to the player). In contrast, the *Doom II* player-character's movement value was determined by a first-order signification process. This value was determined immediately—and remained constant throughout play—whenever the player-character moved within the relational mechanics of the *Doom II* graphics engine.

With full knowledge of these three values—offense, defense, and movement—both monster-opponents and player-character in *Doom II* could be located in the same three-dimensional value-space. And the relative positions of player-character and monster-opponents in this value-space were exactly what the player needed to know—and therefore had to learn—to successfully play the game. Learning the first two values could be as simple as reading them off a chart (though game designers seldom, if ever, provided such charts for player perusal—there were none in the commercial release of *Doom II*). Learning movement values, on the other hand, was a phenomenological task—very much like learning to ride a bike, a lesson learned only through trial and error and the experience of play.

All thirty-two levels in *Doom II,* unlike the hierarchical levels of an adventure game, were equally accessible from the initial game menu. However, it was very difficult—if not impossible—to succeed at the higher levels without having progressed through the more gradual learning curve offered by the lower levels. Succeeding at *Doom II* was not simply a matter

of knowing where to go and what to do (although certainly that was required); it was much more a matter of actually being able to go there and do it. Advanced play was a physical activity made more or less difficult by a player's skill and by whatever manual controls and computer hardware were available to that player. Thus, the progression of play in *Doom II* was not directly motivated by the progression of its hierarchical levels, or its background story, or any similar contextual semiotic overlay; game progression was motivated solely by those activities that increased the denotative values of game signs.

Play in action games was frequently choreographed through the use of levels and the sequencing of oppositions in particular ways—i.e., lots of little monsters followed by a big boss monster—and *Doom II* was structured in just this way in its single-player form. However, *Doom* and *Doom II* received long and extended play in forms that either subverted or simply ignored these preplanned structures of the conventional action game.

The *Doom* series was released as virtually (there was still some hacking to be done) open code. Though the basic graphics engine remained sacrosanct, the graphics settings (walls, backgrounds, windows, doors, etc.) were designed as "wad" files that, with little effort, could be either modified or replaced entirely with similar files created by game players. This resulted in a huge number of publicly available wads—many of them at least equal to, if not better than, the original *Doom II* single-player levels. And the homemade wad files were not simple substitutions for the commercial versions; they were more numerous, more varied, and, inevitably, more disjointed than the single package of thirty-two levels originally constructed for *Doom II*.

The ability of the *Doom II* design to motivate wad creation is not so important here—many games across many different genres have motivated design revisions during play—but the ability of the *Doom II* design to sustain play across such a variety of wads was remarkable. Commonly, in all previous game designs within the action genre, context and settings were fixed in order to create and maintain a proper balance among oppositions. In *Doom* and *Doom II,* all design contexts beyond that of the core graphics engine proved unnecessary.

In addition to successfully incorporating multiple wads, the *Doom II* design successfully incorporated multiple players. The *Doom* series was one of the first action games to provide, through LAN and modem connections, an easily accessible multiplayer mode. Players could band together to hunt and kill monsters in *Doom II* or, alternatively, players could become opponents in the game's DeathMatch mode. Although many action games prior to *Doom II*—going as far back as *Spacewar*—had provided head-to-head competition, none had done so within the same visceral context as the *Doom* series, and as a result, none had quite the same effect.

Much of conventional action game play was (and is) iterative and focused on those repetitive sequences of player-character actions necessary to finish a particular level or defeat a particularly tough monster. Players save and reload incessantly in all computer games and particularly so in action games—a play technique certainly required within the single-player version of *Doom II*. In the process of successfully completing a difficult level in *Doom II,* players normally completed some initial portion of the level, were killed, reloaded the game, restarted the level, retraced their steps to the point of their player-character's death, and proceeded from that point. During play of the most difficult levels, this die and reload (or, with the proper planning, *save* and reload) process could occur literally dozens of times—resulting in the player-character passing through some parts of the same level so many times that those parts could be (and were) played without much thought or variation. The game's multiplayer mode, however, was much more chaotic, less structured, and increasingly dependent on player-character actions (and all accompanying signs) *of the moment. Doom II*'s DeathMatch play, in particular, seldom resulted in a consistent set of player-character moves; on the contrary, DeathMatch play more often rewarded variation than iteration.

No doubt, there were technological reasons why multiplayer modes of play became increasingly popular after *Doom*'s release and distribution—but there could also be little doubt, in light of the subsequent release and popularity of *Quake, Quake Arena, Unreal Tournament,* and similar games, that multiplayer *Doom* revealed an element of action game play that had not been actualized in previous game designs. Through its multiplayer mode, in the absence of any predetermined context of design

(i. e., wad files), the *Doom* series and the action game genre were able to adopt a form most representative of that genre's fundamental semiotic structure: the signification of opposition within a visceral sensorium.

Indeed, the single most important elements of play within *Doom II* were the game's small moments, not its large ones: the placement of a single shot, or a single, initial, and often surprising moment of confrontation. The signification process involved in these small moments was always a signification of opposition: an awareness of difference. And the signs that motivated such isolated and focused signification within the visceral context of the action game I will label *cruxic* signs.

Cruxic signs. If the signification process that conflates signifier and signified is called *iconic,* then, in a similar manner, the signification process that determines differences without reference to a context of design will here be called *cruxic.* Just as the icon requires no reference to a signified Other, the *crux* requires no reference to a contextual Other.

A crux might also be called a *visceral* sign, and multiple visceral signs (cruxes) can then be arranged by something like the *Doom* graphics engine into a model of the preexisting visceral context of the human sensorium. Since visceral contexts are unavailable for transformation by semiosis, significations within a visceral context are necessarily oppositional and function solely to explicate the denotative values of all other signs bound within that context. Cruxic signs are those signs within such a context that, during their signification, both motivate and *resolve* significations of opposition. In this resolution, cruxic signs function as their own context (by default, a context of design) and thus transcend the visceral context of their origin. For this reason, signification of cruxic signs lies at the root of human semiosis and, similarly, at the culmination of play within the computer game action genre.[7]

There is the widespread tendency to explain a great variety of human behavior in terms of some single and particular moment—as the "crux" of the matter (e.g., "for want of a nail..."). In *Doom II* play, there was likewise the tendency to isolate particular moments of play as crucial to winning the game. These defining moments were never locating the blue

key or finding the secret door or selecting the right weapon—for such moments were generic. Keys could be found and doors could be opened and weapons could be selected by anyone at all; these and all other similar game tasks might be accomplished through reflection, referral, or simple persistence. The defining moment in *Doom II* play was rather some moment peculiar to play: a defining moment of irreproducible results.

The final battle in *Doom II* might have been a battle fought—and lost—many times previously; it might have been a battle ultimately won only through some rare and indeterminate circumstance of good fortune; yet any subsequent, more skillful, and more successful repetition of that battle was diminished in effect. It was only that first, original, and fleeting moment that allowed the player to claim victory over—and semiotic release from—the game.

The persistent appeal of the action genre came from the possibility that every single action—*any* single action—could well determine the meaning of all actions, not only in terms of winning or losing the game, but also in terms of defining the relationship between game player and game character. Defining actions of this sort transformed the crux of the moment into a semiotic *context* and therein valued the player-character beyond the rigidly visceral context of the sensorium. Until that moment was experienced phenomenologically—and confirmed semiotically—the game player remained bound within the visceral context of the game's player-character.

Action games repeated this theme at all scales, from sign to level. Each level had some gradual buildup to a final confrontation with that level's boss—the sort of false denouement that both suggested and evaded significations of context. And, after this false denouement, there remained the urge to play on, to once again seek and engage that singular and particular moment that spread in quick ripples outward—similar to the single move in *Go* that turns the board from black to white, or to the miraculous transformation of ugly duckling into swan, or to the last-second, unforeseen intervention that propels the One Ring into Mount Doom.

So vital was this urge to transcend the bounds of the action genre, to break through to the other side, that action game designs provided ready access to the experience, regardless of player skill, with various levels of

difficulty (from "Don't hurt me, Daddy" to "Ultra violence" in *Doom II*) and with embedded cheat codes that turned player-characters into invincible juggernauts who might walk through walls, destroy monsters with a single glance, and preside over the game's visceral context as though they were the same software lords who had created it. Yet, though the urge to do so was strong and universal, once this urge to conquer, to transcend, to *contextualize* had been satisfied—once the game had been won, all opponents vanquished, and all oppositions resolved—action game play quickly came to an end.

The signification of cruxic signs within the action genre ultimately valued the visceral oppositions of the action game within a newly constructed and novel *context of design*—a design that could be constructed only during the signification of play. This transformation of crux to context subsequently led to the transformation of context to character within the role-playing genre.

Chapter 12

Might and Magic

Unlike the *Doom* series designs, role-playing games like *Might and Magic* depend very little on cruxic, or visceral, signs; play within this genre is motivated by significations of contextualization that construct and manipulate second-order signs.

A brief history of *Might and Magic*

The second edition of *Might and Magic I: The Secret of the Inner Sanctum* appeared in 1987. Jon Van Canegham had created the first version of the game—"a fantasy role-playing simulation"—some time earlier and sold individual copies from his apartment prior to the game's publication by New World Computing and broader distribution by Activision. The original *Might and Magic* design was blatantly derivative of at least two earlier game forms: all those other computer role-playing games that were, by the mid-1980s, widely available (see chapter 3) and the inspiration for all those other games, i.e., *Advanced Dungeons & Dragons*.

From the beginning, the *Might and Magic* series was consciously designed to represent preexisting forms— including its own (the first game was subtitled *Book One*). Under Van Canegham's supervision, the series found its long-lived success in a consistent and always conventional interpretation of those forms. And, since signs within the role-playing genre were distinguished precisely by their reference to and/or signification within some preexisting context of design, the *M&M* series therein typified the semiotic structure of the role-playing genre.

The full sequence of the *M&M* games, with official release dates, is shown below:

Might and Magic I: Secret of the Inner Sanctum (1987)
Might and Magic II: Gates to AnotherWorld (1988)
Might and Magic III: Isles ofTerra (1991)
Might and Magic IV &V: Clouds of Xeen / Darkside of Xeen (1993)
Might and Magic VI:The Mandate of Heaven (1998)
Might and Magic VII: For Blood and Honor (1999)
Might and Magic VIII: Day of the Destroyer (2000)

The original *Might and Magic* was a contemporary of the longer run-ning *Ultima* and *Wizardry* series, the more widely distributed and reviewed *Bard's Tale,* the well received *King's Quest* games (*I* and *II*), and Strategic Simulations, Inc.'s (SSI's) more accurately realized version of the *AD&D* rules in *Pool of Radiance*—among others. Each of these computer role-playing games has since (or had previously) displayed a history of design and play similar to that of *Might and Magic;* over time, all role-playing game designs tend to add superficial enhancements (sound, graphics, er-gonomics) to a single, common, and fundamental semiotic form. For this reason, the most recent episodes of the early role-playing games (e.g., the newest *Pool of Radiance,* released in 2001, and *Might and Magic IX,* released in 2002) retain the characteristic significations of computer role-playing games from decades earlier. None of the distinguishing significations of the role-playing genre involve, like those dominating *Doom* play, cruxic signs.

The Apple IIc graphics of *Might and Magic I* were crude by today's standards and, even in context, were not significantly different from the graphic displays of older *Wizardry* games. Nevertheless, the *Might and Magic* graphics were praised at the time for providing a fully textured first-person perspective—and the series' graphics have continued to receive attention, update, and, upon occasion, favorable comment.[1] However, regardless of the game's graphics, it has always been the behind-the-scenes mechanics of *Might and Magic* that have most appealed to gamers and first roused, at least among Apple II owners, a cult following.

The original game's character creation system was a streamlined ver-sion of that in *Advanced Dungeons & Dragons* (*AD&D*), as were its rules of combat and character development. These rules of character interaction constituted the *Might and Magic* game engine much more than did the soft-

ware routines governing the visual representation of player-characters. In fact, the *M&M* game rules immediately undermined the visceral context associated with a first-person perspective by assigning that perspective to not one, but multiple characters.

Prior to play, *Might and Magic I* required the construction of multiple characters (or, at minimum, the selection of preconstructed characters). During further play, these characters were assembled inside a six-member party, which navigated through city and countryside solving puzzles, completing quests, and bashing monsters. The results of play were mediated and ultimately determined by the role-playing rules administered through the game's software engine; these results were displayed as second-order signs, within a rudimentary (at first) and increasingly sophisticated (later) three-dimensional display. The realism of this visual display, however, regardless of its perspective or pixel count, remained irrelevant.

A similar sequence of play was found in all *M&M* games—and no instance of this play was particularly novel when compared with other games in the series or other games in the genre; the fundamental characteristics of *M&M* game play were exactly those of all other role-playing games, including those designed for nonvisual and noncomputer media (*Dungeons & Dragons*). This play was distinguished not by its visceral signs but by its rules-bound context of design and, simultaneously, by those significations that determined and expanded that increasingly massive context.

Might and Magic I came with a forty-page manual.[2] The first quarter of this manual described how to create characters prior to play; the rest concerned the mechanics of play—e.g., which parts of the keyboard accomplished which game functions. Since *M&M I* was intended to be a simulation of a generic fantasy role-playing system that most players would already be familiar with (i.e., the *AD&D* system), the first game manual did not refer to narrative structures (plots, characters) unique to the *M&M* game world. That would soon change.

The manual of the next *Might and Magic* game (*II: Gates to Another World*) devoted its first 2500 words to a history of the expanding *M&M* game context. And each manual thereafter added, with words and illustrations, further information about preexisting characters and legends

within the *M&M* fantasy universe. By the third installment of the series, *M&M* players were very familiar with the series' basic narrative structure.

Through the gradual accumulation of information during play, player-characters discovered that the world of Varn (*M&M I*) or CRON (*M&M II*) or Terra (*M&M III*) or Xeen (*M&M IV* and *V*) or whatever it was called this time had been settled by a star faring race, whose culture and knowledge had, over time, regressed to medieval ignorance. It was the role of the player-characters to recover that long-forgotten knowledge and, along the way, restore power to some equally long-forgotten Advanced Technological Device that did some Very Important Thing. In order to accomplish this Very Important Thing, player-characters had to get the Advanced Technological Device before the Bad Guy(s) got it and, in a final demonstration of game mastery and player-character prowess, engage the Bad Guy(s) in a climactic Big Battle.

By the end of the first three *Might and Magic* games, this narrative form was set in place and thereafter altered little; for players familiar with the series—and it was returning players who were the most dedicated of the *M&M* aficionados—there was little mystery as to the goals of the game. Likewise (in sharp contrast to *Doom*), there was little mystery as to *how* the goals of *Might and Magic* were to be accomplished: by long hours at the keyboard. Game play was not so much a test of skill as it was a test of endurance; eventually, if you kept at it long enough, you *would* win the game.

Because of the series' familiarities and the inevitability of its outcome, the narrative components of *Might and Magic* became increasingly superfluous to play. That is, the game's narrative, as such, took less and less of an active role in the game's ongoing signification processes. It was only the degree to which the game's narrative structures provided a consistent semiotic *context* for valuing game signs that those structures remained important and necessary components of the series design.

There were at least two indications of the hollowing of role-playing plot from a dynamic value of novelty to a static value of convention. The first was the obvious repetitiveness of both small and large plot elements: Many elements of the early *Might and Magic* games became recurring features in the series.

For instance, a variety of game design elements appearing early in the *M&M* series (employing hirelings, buying supplies, translating cryptic messages, traveling among towns—just to name a few) were retained in the same symbolic forms and continued to function in the same semiotic roles within subsequent games. Learning the contextual values of these elements in one game greatly advanced play in all other games—a result not possible without the continuity provided by the series' common, rules-based, *D&D*-derived software engine.[3]

A more specific example: Player-characters found treasure (armor, gold, etc.) in chests in the *Might and Magic* games; and these chests inevitably blew up in the face of unskilled characters who attempted to open them. While such might be common within the role-playing genre, the values (meanings) of these chest explosions were unique within the *M&M* game world. During initial play, these values were established by such criteria as these: How much damage did each explosion cause? What were the limits of the damage? What was the range of the damage? How could the damage be healed? What skills were necessary to avoid the damage? What was the value of the treasure in the chests—i.e., what sort of risk-reward ratio was involved in opening the chests? And so forth.

Prior to *M&M* game play, these questions were largely unanswerable; certainly, comprehensive answers could not be found in the printed versions of the game rules (i.e., in the game manuals). It was only during game play that the various relationships among damage suffered, treasure gained, and all alternative actions were fully contextualized and, during that contextualization, fully signified and valued. Thereafter, however, although the same signs did not always have exactly the same values in all *M&M* games, the variations among these values were slight. And, importantly, the dominant signification process that assigned meanings to these recurring game elements—a signification of contextualization—was identical throughout the series; thus, as the series continued, significations conducted during current game play more and more often referred to a single, all-encompassing context determined beyond the immediacy of current game play. This was a situation very different from that characterizing *Doom* play, in which contexts were more visceral and immediate and, in a sense, instinctive.

Another important indication of game plot functioning as convention rather than novelty was that the *M&M* plots were neither necessary nor sufficient to motivate extended play. Playing the *M&M* games involved a long series of starts and stops—saves and reloads—but these stutter steps did not involve, as they did in *Doom,* easily accessed (or enjoyable) replay. That is, once a particular dungeon had been cleared of monsters, or a quest had been successfully completed, this clearing and completion became part of the game context for valuing subsequent signs.

To replay a level in *Doom* was to reexperience the signification of the crux: a first-order, phenomenological experience with no historical value; to replay a level in *Might and Magic* was to revalue signs within that level according to some alternative game context. This latter sort of replay required—at least temporarily—erasing and rewriting some part of the *M&M* game history that now functioned as context; as a result, replay in role-playing games like *M&M* was not pursued nearly as frequently as replay in action games like *Doom.*

Because *Might and Magic* prioritized the signification of context over the revelation of plot, its narrative elements—e.g., its plot—had to be contextually expanded rather than iteratively extended. That is, narrative elements within the role-playing genre had to serve the necessities of semiotic process; or, put another way, semiotic form was more fundamental to role-playing game design than was narrative form. Symbolic forms within the *M&M* games could—and did—appear in nonlinear sequences (side quests and the like) entirely irrelevant to the game's plot. Insofar as the signs in these side quests were valued according to the common rules of the game (i.e., through significations of contextualization), they motivated play through reference to game context *without* reference to any portion of the games' contrived, regaining-the-lost-knowledge-of-the-ancients plot.

Similarly, player-characters—here considered elements of the game's narrative—had to be *expanded* (transformed) during play; these characters could not simply be renewed (reborn) from time to time, as were the player-character signs in, for instance, *Asteroids* and other action games.

Certainly, deaths and rebirths of player-characters were common during *Might and Magic* play; and, as in action games, player-character re-

births incurred significant penalties.[4] But there was never the circumstance in *Might and Magic* in which player-characters were "reborn" all the way back to the beginning of the game. Player-characters retained their experience points, their accomplishments, and, most importantly, their contextual values after each death; their losses at rebirth were restricted to those values associated with significations of opposition (i.e., player-character combat values): the loss of armor, weapons, magical potions, and such. Though game play after being stripped of all *M&M* worldly possessions was tactically difficult and tedious, it was not, strictly speaking, repetitive. The sequential contextualizations of the game were maintained through all player-character death-rebirth sequences and, as a result of that maintenance, those contextualizations continued to motivate the further expansion of context that was necessary for prolonged play within the genre.

Though the *M&M* games retained many of Van Canegham's original design elements, the *Might and Magic* series was not stagnant. Most significantly, later releases of the game experimented with and eventually incorporated options for synchronous (real-time) play. Real-time design elements had not been initially associated with the role-playing genre, and, according to the scheme developed here, are in fundamental conflict with that genre's basic form.

Adding real-time design elements to *Might and Magic* posed this problem: Despite requiring a sequential progression of significations, play within the role-playing genre did not create a *temporal* history; the role-playing game history was constructed with reference to context—not time. For this reason, extended game play required less movement from past to present to future than from small to large to larger.[5] Real-time design elements did not readily conform to such a sequential, but nontemporal, progression.

The first use of a real-time design element in the *M&M* series came at the end of *Might and Magic II*, during the game's penultimate moment of signification. And this particular innovation was not well received. Here is the pertinent portion of a review by Scorpia, longtime adventure game critic and maven:

> The ending itself is remarkable for its pointlessness. Having fought your way to and past the final confrontation, you are suddenly presented with a cryptogram that must be solved in fifteen minutes: real time! This comes out of nowhere and is quite a shock. Nothing before this prepares you for it (well, at least you're prepared *now*). I have no idea why this is in the game. It certainly doesn't fit with anything else.
>
> Scorpia, 1989, p. 50

Eventually, as the game's graphics engine improved in concert with general improvements in computer gaming hardware, *M&M VI* offered a broader range of real-time play—but only during the combat portions of the game. Restricting real-time play to significations of opposition (combat) proved more enjoyable and popular than forcing real-time decisions to be made during significations of contextualization. Real-time combat was kept separate from and did not interfere with the more fundamental semiotic structures of *Might and Magic*—character creation, development, and interaction—which were still accessed and manipulated asynchronously. And, in fact, even during the game's combat mode, players could still opt for asynchronous, turn-based play.[6]

The *Doom* design team was driven apart by the same oppositional significations that isolated and emphasized cruxic signs within the *Doom* series designs: a signification process that tended to focus on competitive performance rather than community achievement. In contrast, Van Canegham's *Might and Magic* design incorporated fewer (though more varied) significations of opposition. The contextual significations that expanded context and transformed character within the *M&M* series—both during game design and during game play—tended to create a self-sustaining collective, an extended family of designers and players. Van Canegham's design team came to include a much greater variety of graphic artists, sound engineers, coders, and assorted producers than those associated with *Doom* and its derivatives. And, at least as regards *Doom* and *M&M*, designers of different game genres adopted working relationships very similar to those adopted by players of their games.

As an object of design, play, and employment, *Might and Magic* has steadily gained momentum since 1987—and necessarily so: All role-playing games

must continually expand their contexts of design in order to motivate extended play. The *Might and Magic* series has been very successful in this regard—its contextual significations now extend well beyond its genre (e.g., the *Heroes of Might and Magic* strategy games).

In addition, as of 2001, there were gathering plans to adapt the *M&M* games to an online, multiplayer environment (*Legends of Might and Magic*). This would involve the creation of a MUD-like context, which would be a natural and congruous expansion of the role-playing genre's basic semiotic form. Online versions of similar role-playing games—*Ultima, Everquest*—had proven increasingly feasible technologically and economically; *Might and Magic* was equally well suited for future adaptations that might reacquire the natural semiotic context—the social community—that was the original object of mimicry of the role-playing genre.[7]

Each *Might and Magic* game depended on those significations of contextualization that had taken place in previous games. However, the dependencies of some of the games in the series resulted from a more purposeful design than those of other games. The *M&M II* game design, for instance, did not recycle *M&M I* characters or settings so much as it recycled their forms; these first two games of the series were set in distinct times and places, and each was promoted as a separate (though obviously formally similar) game-playing experience. Other games in the *M&M* series were less distinct.

Might and Magic IV and *V* were sold as a single game: The game map of *The Clouds of Xeen (IV)* was a mirror-image of the game map of *Darkside of Xeen (V)*, and several quests in each game shared a common landscape. Creating two games within a single design context was of some benefit to the series through economies of scale. However, this strategy did not allow, as became common within the *M&M* series, graphic embellishments, additional character classes, skills, weapons, and armor, and other superficial tweaks of the game's interactive software engine. These sorts of changes were necessary to incorporate novel significations of opposition—and therein values of novelty—within the increasingly conventional context of the *M&M* fantasy role-playing environment. Deprived of such novelties, play in *M&M V* was experienced either as a replay of those significations of contextualization previously completed in *M&M IV* or as

artificially prolonged play of those significations of contextualization that *should have been* completed in *M&M IV*—both resulting in less than satisfactory play in one of the two games.

Over time, with the widespread success of the series, this became the central problem facing *M&M* game designers: how to expand the *M&M* game context by incorporating out-of-context design elements. If *M&M* play included *no* such novelties, then that play was valued through significations of opposition bound to the series' preexisting context—resulting in an increasingly visceral and graphics-dependent play of the hack-and-slash sort, similar to that of the *Doom* series. Yet, if play included *only* novelties, then that play might come to be valued within some context other than that of the preexisting *M&M* game world: It might become play within an entirely different game context that would then irrevocably disrupt the continuity and semiotic safe haven of the broader series.

M&M VI: The Mandate of Heaven, Might and Magic VII: For Blood and Honor, and *Might and Magic VIII: Day of the Destroyer* (the particulars of all *M&M* game titles were meaningless) were released as a thematically related sequence. Though these three games were not nearly so closely connected as were *IV* and *V,* each was set in a common world (on the continents Erathia, Enroth, and Jadame), and sequential play of these three games revealed information relevant to many of the same non-player-characters and plots. However, unlike the *Xeen* pair, each of these three games was released a year apart from the others; and *VII,* in particular, added new character classes, restrictions, and spells (*Invisibility*), which subtly transformed some (though not all) of the oppositional relationships between player-characters and monsters within previous games.[8] The graphic displays of *VII* were also updated from their implementation in *VI* in order to include Direct 3D, but, as was characteristic of the *M&M* series, this implementation lagged behind the graphics of other games in the genre (e.g., *Everquest*) and far behind the more immediate and visceral displays of the action genre.

Taken as a whole, this related three-game sequence—*VI, VII,* and *VIII*—was well represented by the design elements and play mechanics of the middle game, *Might and Magic VII: For Blood and Honor.*

Play in *Might and Magic VII*

Play in *Might and Magic VII* did not begin immediately after purchasing and installing the game. *Might and Magic VII* was released on two CD-ROMs that, like most games of the period, required online updates. Players without Internet access were at a disadvantage in obtaining the most recent version of the game software—and suffered in other important respects as well. The outside-the-game social community that communicated and maintained the ongoing *M&M* game context was vital to most enjoyable and successful play; this community was most easily and fully accessed online. I have known of no players who have successfully completed a game as complex as *M&M VII* without reference to and use of play aids beyond those contained within the game itself—i.e., the game manual and the tutorial portions of the game software. It may well be impossible to complete such a game without third-party aids; it is certainly not very much fun to do so.

Play aids ranged from more detailed maps than those provided by the game to cheat programs ("trainers"), which allowed player-characters to skip large portions of the game's linear narrative and develop their characters more quickly than the game otherwise allowed. Unlike action games, *Might and Magic* had no difficulty levels per se, and, therefore, the game had no cheat programs making it easier to play per se; most cheats simply made the game far *quicker* to play. Cheats in *M&M* transported player-characters to some advanced portion of the game context; they did not transport player-characters outside that game context entirely (as did, for example, the invincibility cheat code—*iddqd*—in *Doom II*).

Play aids came into play very early—during initial construction of player-characters. Once player-characters had been constructed, selected, and positioned at the beginning of *Might and Magic VII*, aids then primarily focused on telling those player-characters where to *go*. In fact, expansions of the game's semiotic context during play were closely analogous to the spatial positions and movement capabilities of the game's player-characters: "Beginnings" in *Might and Magic VII* corresponded to limits on player-character movement (small spaces); "endings" in the game corresponded to unlimited player-character movement (large spaces).

Play in all *Might and Magic* games began in some relatively unassuming, backwater locale: an innocuous little village offering little danger, little reward, and, when compared with the rest of the game, little player-character movement. However, this initial and most circumscribed context of play had to be fully navigated in order to gain character levels and player-character knowledge necessary to contextualize subsequent game events and objects. For novice *M&M* players, this navigation and its accompanying signification determined values of novelty. For advanced and practiced *M&M* players, this navigation determined values of convention. Thus, the first and core context of the game (and, in fact, all subsequent contexts) was the object of at least two separate signification processes: one restricted to the context of the game at hand; the other to the context of the entire game series.

Almost all play aids, hints, and codes for the *Might and Magic* games remained bound to the broader series context and were, for that reason, less play cheats than they were play *supplements*. That is, these hints, aids, and "cheats" subverted narrative structures and temporal sequences within the current game; yet they maintained—and sustained—the more fundamental semiotic forms (contextualizations and the rules that determined them) of the *Might and Magic* series.

Of course, the degree to which these third-party player aids subverted the "proper" *M&M* rules context was debatable. Few players agreed as to just what was—and what was not—"cheating."

For instance, the rules of combat normally required monster attacks to subtract from the ablative armor of a player-character's "hit points"—until those hit points had reached zero, at which point the player-character became unconscious and, eventually, died. However, one of the game's monsters—the most formidable of the Titans—could kill player-characters without any reference to hit points. Some players considered such an attack outside the context of the game's rules of interaction and, therefore, a Titan "cheat." Likewise, a player-character dodging monster attacks by using vertical flight (real-time movement) during the game's turn-based combat mode was also officially outside the rules-based context of combat and was, therefore (despite its popularity and frequency of use), "cheating." Some purist players even considered saving and reloading to be

outside the context of proper game play—particularly when saving and reloading was done with foreknowledge of how that technique could be used to gain an advantage during play.

In any case, regardless of what was and was not ultimately determined to be a cheat, all related discussions delineated the *M&M* role-playing context—that is, these discussions and considerations involved significations of contextualization. For this reason, some number of out-of-context design elements within the *M&M* games—including software bugs—functioned to aid and expand the *M&M* series context. Because these elements involved significations of contextualization outside the immediate game context but within the broader role-playing genre, they were an important—and fun—part of game play. And, particularly as the *Might and Magic* series progressed and its increasingly conventional context required further expansion, these out-of-context game elements came to be expected by players and purposefully included by the game designers. If inserted on purpose, such elements were called *Easter eggs*.[9]

Qualifying as Easter eggs within *Might and Magic* were names of non-player-characters that recalled characters from fantasy fiction, or old television shows, or, upon occasion, real people (e.g., "William Setag" for Bill Gates). The most complex, recurring Easter egg of the *M&M* games was an entire dungeon with the same floor plan as the offices of New World Computing—complete with elevators, reception areas, snack rooms, and conference tables.

An engaging implementation of this particular Easter egg in *Might and Magic VI* allowed player-characters to access a fly scroll (a magical spell) immediately after beginning the game. Under normal (non-aided) circumstances, player-characters would never find this scroll, much less be able to use it in any meaningful way. However, if player-characters possessed the proper knowledge (available only from outside-the-game sources), they could then use the scroll to fly to a rooftop, access a hidden doorway, and be transported to a portion of the game context where, again, under normal, non-aided circumstances, they would very quickly die and be reborn at the beginning of the game with no benefits gained. However, if the player-characters knew *exactly* what to do after their transport, they could manage, if lucky, with a couple of saves and reloads, to

survive the few moments necessary to escape into the supracontext of the Easter egg: the New World Computing offices. Inside this pseudo-dungeon were treasures unavailable through any means other than long hours—literally days and sometimes weeks—of game play. Of course, in order to make use of these items, further complications ensued, but, significantly, even if player-characters managed, by hook or by crook, to find the scroll and dodge the monsters and retrieve all the treasures in the NWC offices, those treasures provided no panacea similar to the state of grace granted by the simplest of the *Doom* cheat codes. With or without the benefit of insider knowledge, *M&M* player-characters still had to reenter the conventional game context and play the game according to the conventional game rules—any advantages gained from out-of-context cheats were only in the ability to move the game forward in time.

In a very similar way, in-context design elements rigidly controlled the expansion of game context through limits put on player-character movement. Movement by player-characters in *Might and Magic VII* was initially limited to walking on land—i.e., from house to house within a village. Gradually, player-characters gained the ability to purchase carriage/ boat rides to and from different game locations: from village to village within the *M&M* fantasy landscapes.

Once player-characters had fully mapped the landlocked game environment, they gained the ability—through a magical spell—to walk on water. The water-walk spell allowed further exploration of all previously visited sites.

Next, after having gained access to all the game's ground-level nooks and crannies, both wet and dry, player-characters learned how to fly. Flying subsumed both land- and water-walking and added a third and final layer of signs and symbols to the game context. Player-characters returned by the same routes to the same villages earlier visited to now for the first time fly over mountains, search rooftops, and add vertical depth to the game's flatlands.

The game's ultimate magical spell—*Lloyd's Beacon*—did not affect oppositional values between player-characters and monsters at all. That is, this spell didn't help player-characters defeat monsters; it only helped

them move to and from those monsters. *Lloyd's Beacon* was a transportation spell, a rules-based manifestation of the otherwise out-of-context player strategy of saving and reloading. And, in this manifestation, the movement of player-characters using *Lloyd's Beacon* was something like the movement of Needle and Wedge through *Spacewar's* hyperspace.

Lloyd's Beacon allowed players to return to any game site they had previously visited—without having to retrace the route that had first gotten them there; it effectively allowed players to value game elements *outside the visceral context of the game*. Using *Lloyd's Beacon,* player-characters could rearrange game design elements and prioritize them according to their value *during interactive play* rather than according to their value within the game's superfluous narrative structure. For, once player-characters had reached the advanced stage of the game that allowed them to cast *Lloyd's Beacon,* the game was won. All significations of contextualization motivated by the game rules had been completed, and any remaining play consisted of routine mop-up operations: the well-rehearsed and by now predictable significations of opposition between player-characters and Bad Guys.

Significantly, these final, oppositional play sequences were often avoided by players. Player-characters in the final stages of *Might and Magic VII* were in no rush to finish the game. They had, by this time, all means necessary to access any part of the game context they wished. And, what they wished was to return to those elements of the game (using *Lloyd's Beacon* to do so) that valued player-characters *contextually*. These design elements were quite apart from those that valued characters oppositionally (i.e., the game's combat sequences, including the final Big Battle).

In *M&M VII,* the most readily accessible game elements that significantly altered a player-character's contextual value were the weapons, armor, and magic item shops within the game's villages. Purchasing items at these shops transformed player-characters much more quickly and much more radically than the slower and more difficult to attain transformations of "leveling up." (The game's combat sequences, meanwhile, transformed player-characters not at all.[10]) And, importantly, these item shops were—in contrast to the Easter eggs—*in-context* design elements; that is, the items gained in the shops did not require or reference out-of-context

play. Throughout the game, item shops aided a normal, progressive, and *bounded* expansion of context.

During the game, there were many in-context restrictions on the items the shops provided, and the value of many of these items diminished as the game progressed. However, by the end of the game, with *Lloyd's Beacon* and full knowledge of the game context, player-characters had the ability to generate *random* items of value within the village shops. Some of these items retained their value within *all* contexts of game—and several had values even beyond that context, i.e., some items possessed super or "supra" value, far above and beyond what was required to win the game.

The desire to collect and possess these supravaluable items motivated play in the latter stages of *Might and Magic VII* much more than did the desire to win the Big Battle. Randomly generating magical items in the village shops (or gaining them through other means) sustained significations of contextualization that allowed the expansion and, potentially, the transcendence of game context. Even *after* winning the game, player-characters continued to flit across the game's fantasy hills and dales, mapping all unexplored portions of the game world, and collecting randomly generated magical items.

Ultimately, however, this postgame play failed to uncover any context beyond that provided by the game rules—and faded away. Though the lure of the ultimate suit of armor and the most devastating of all weapons remained strong, the game's software engine generated no supracontext within which to value such items through their use. As a result, the values of all those yet-to-be-generated, best-of-all items were indistinguishable from the values of all those previously generated, almost-best-of-all items that had already been used and discarded. Play in *Might and Magic VII* ended with player-characters wandering aimlessly through castles filled to overflowing with various preliminary versions of their last and final, context-of-the-gods wardrobes: all dressed up with nowhere to go.

Unlike the abrupt end of play within *Doom II*, the end of play in *Might and Magic VII* lingered, as player-characters exhausted all possibilities of hidden dungeons and secret transports to the more comprehensive semiotic landscape of some hypothetical next game in the series. At the end of the

game, the last symbols left standing were those of the player-characters themselves: abandoned constructions of the game's contextual play that, by the end of that play, had transcended the game's rules-based context.

This transformation of game context to game character completed the semiotic process characterizing the role-playing genre. To play on required either further expansion of the role-playing context—a new game in the series—or play within a new genre entirely: the strategy genre.

Player-characters floated helplessly out of context at the end of *Might and Magic VII;* the strategy genre was able to reinsert similarly transcendent game elements within a *recursive* semiotic form, which both sustained play and more closely mimicked the culminate processes of a natural human semiosis.

Chapter 13

Civilization

More than either *Doom* or *Might and Magic, Civilization* has had a complicated, controversial, and somewhat contentious design history. Like *Might and Magic,* however, the *Civilization* computer game began as a simulation of a simulation: a computer game adaptation of a board game.

A brief history of *Civilization*

Sid Meier's Civilization was loosely based on an older board game also called *Civilization.* The board game was designed by Francis Tresham and released by Harland Trefoil, Ltd. in the United Kingdom during the early 1980s. Avalon Hill purchased the rights to distribute *Civilization* in North America, broadened the context of the game, streamlined its rules, and released two versions: *Civilization* and, supplemented by an expansion pack, *Advanced Civilization.*

All versions of the *Civilization* board game had a common theme. Several players (from two to eight) competed as ancient civilizations attempting to claim cultural, economic, political, and/or military victory over their counterparts. One of the game's unique and most characteristic design elements was the use of civilization "advances": literature, metalworking, and the like. That is, during play, players gained advances that transformed game unit values: Ships were able to travel farther, for instance, and game events such as famines were reduced in effect for players in possession of the proper civilization advance. Playing the right sort of civilization advance, at the right moment, at the right cost, was key to winning the game.

In the late 1980s, while a partner at MicroProse, Sid Meier adapted *Advanced Civilization* into a 2.6 megabyte, MS-DOS game: *Sid Meier's*

Civilization. MicroProse released the game in 1991 and it became a huge success.[1]

At the time *Civilization* was released, Meier was already an accomplished and well-known designer. His earlier design of *Pirates!* (MicroProse, 1987), a mixed genre game, had become one of the industry's first named games: *Sid Meier's Pirates!* Subsequently, Meier designed *Railroad Tycoon* for MicroProse (1990); *Railroad Tycoon* was a strategy game blending elements of resource management and empire building that were fundamental to *Civilization* and most other computer games within the strategy genre (see the earlier discussion of *Hammurabi* in chapter 5). Other contemporary strategy game designs with similarities to *Sid Meier's Civilization* included Will Wright's *SimCity* (Maxis, 1989) and a variety of "space-exploitation" games like *Reach for the Stars* (Roger Keating & Ian Trout, Strategic Studies Group, 1983).[2]

Sid Meier's Civilization had the same theme as the *Civilization* board game, but played very differently. Unlike the board game, the computer game was a single-player game, with one human player opposing up to seven computer-controlled civilizations. The board game had concentrated on the development of ancient civilizations within the Mediterranean oval; the computer game also began in ancient times, but extended play within both historical and random landscapes through the Middle Ages, modern warfare, and the space race of the twentieth century.

Most significantly, the computer game made sweeping changes to the civilization advances of the board game. Not only was there a much more complex and detailed progression of civilization advances, but the computer game also allowed competing civilizations to build twenty-one "Wonders of the World"—ranging from the Pyramids to the Cure for Cancer. Both civilization advances and World Wonders transformed the computer game context to a much greater degree than had the civilization advances of the original board game; players first achieving an advance, or building a Wonder, gained important and potentially game-winning advantages over their computer opponents—until some other advance and/or its accompanying Wonder(s) transformed the game context anew.

During the design of *Civilization,* Meier relied heavily on co-designer Bruce Shelley, whom Meier had also worked with on *Railroad Tycoon;* their

working relationship emulated the variation-and-selection process that had guided Douglas Lenat and EURISKO (see chapter 5) to the *Traveller TCS* championship. Here's Bruce Shelley's description of that relationship:

> He [Meier] did all the prototyping himself. Once he had a build that was playable, we began an iterative process of talking about the game, then he'd recode it, we'd play it for a day and then we'd talk again. I usually came to work earlier than he did, but at some time in the morning, he'd come in with a new version of the game, he'd give it me, and he'd say, "Okay, play this for a couple of hours and tell me what you think." Then we'd get together in the afternoon and I'd give him feedback on what I was liking and what I wasn't liking. Then he'd work on a new version. So basically, he built a new version of the game every day for roughly a year.
>
> Bruce Shelley, as quoted in Chick, 2001, paragraph 3

Lenat optimized EURISKO's persistent and initially random generation of fleet sizes and tactics according to the demands of the *Traveller TCS* rules; Meier optimized Shelley's persistent and inevitably human interactions with the *Civilization* prototypes according to the demands of the rules of *play*. Achieving proper pacing, complexity, and balance among game elements was accomplished through no abstract formula or single moment of designer insight. The design process involved repeated and recursive significations of contextualization—that is, the design process was fundamentally *interactive* (see chapter 10); and the final design of *Civilization* reflected the recursive contextualizations of interactive human play.

After *Civilization* was released, Bruce Shelley left MicroProse and adapted *Civilization*'s turn-based template to real-time game designs, beginning with *Age of Empires* (Ensemble Studies, 1995). Sid Meier continued to develop turn-based sequels to *Civilization* through the same interactive design process he had used with Shelley. However, Meier increasingly adopted the player rather than programmer role, as indicated in his comments on the design of *Civilization III*:

> My role is to be the player's eye on things, to play the game and respond to what's working well, what feels like *Civilization* and what doesn't. We have a

great team of programmers and artists that are creating the pieces of the game, seeing what things work, while Jeff [Briggs] is leading the design process.

Sid Meier, as quoted in *PC Gamer,* 2001, paragraph 21

In the ten years between the 1991 release of *Sid Meier's Civilization* (*Civ*) and the 2001 release of *Sid Meier's Civilization III* (*Civ III*), there were several variant designs and redesigns of the original *Civilization* board game. In the wake of the popularity of *Sid Meier's Civilization*, Avalon Hill commissioned and released a computer game version of their *Advanced Civilization* game in 1995; this computer game played exactly as the board game played—and was not nearly as successful as the MicroProse version.

In 1996, MicroProse released *Sid Meier's Civilization II* (*Civ II*), with Brian Reynolds leading a design team that included Meier and Jeff Briggs (who would later oversee the design of *Civ III*). The *Civ II* design incorporated feedback and suggestions for improvements from veteran players of *Civ I*, with the basic design staying close to the Meier/Shelley original:

> So we got our "fun experts" together and began the mammoth task of sorting through ideas. And there were *plenty* of ideas. In the years since *Civilization* first appeared, we have received literally thousands of letters, phone calls, and e-mail messages offering suggestions for improvements, additions, and sequels....
>
> Of course, the biggest potential pitfall in working on a game like this is that none of us wanted to go down in history as "the guys who broke *Civilization*"! *Civilization* is about as complex and finely balanced as games get, and any misstep would quickly throw that magical pacing out of kilter. So just throwing in the kitchen sink wasn't going to cut it. Every addition or change needed to be carefully weighed to make sure it wasn't doing more harm than good. On the other hand, we knew we wanted this to be a lot more than a simple facelift—this was our big chance to take our favorite game and make it better than ever.
>
> Brian Reynolds, 1996, p. 179

Civ II added new rules and strategies, but primarily improved the player's ability to see, understand, and command the original game. Other variants, however, did not share Reynolds's allegiance to the earlier Meier/Shelley design.

In 1997, Activision licensed the *Civilization* name from Avalon Hill in order to develop their own, competing adaptation of Tresham's board

game. In response, in January of 1998, MicroProse filed suit against Activision and Avalon Hill to protect the *Civilization* name—and MicroProse later purchased Harland Trefoil to further secure their legal claims. As a result of the MicroProse legal action, Avalon Hill lost all rights to *Advanced Civilization* and ceased to exist as an independent game publisher; MicroProse granted Activision the right to use the *Civilization* name on an initial adaptation of the board game, with the *Civilization* name reverting to MicroProse thereafter. Activision called its variant *Civilization: Call to Power* (1999), a game widely considered inferior to the MicroProse series, but containing many of the same characteristic design elements—including the civilization advances that transformed game unit values and context(s).

Sid Meier, meanwhile, left MicroProse to form—with Brian Reynolds and Jeff Briggs—a separate computer game company: Firaxis. After Meier's departure, Hasbro purchased both MicroProse and Avalon Hill, effectively ending all lingering controversy over ownership and use of the *Civilization* name. In 1999, for Firaxis, Meier and Reynolds created *Sid Meier's Alpha Centauri,* a thematic sequel to *Civ I* with similar design and play. And finally, in 2001, a Firaxis team led by Jeff Briggs designed and released— through the French game company Infogrames, which had by this time purchased Hasbro Interactive—*Sid Meier's Civilization III.*

All the MicroProse-related variants of *Civilization* were created through a design process that involved repeated play, revision, and replay of game prototypes. This process was not unique to the design of *Civilization*—nor to game design in general—but it was a process that, in the specific instance of *Sid Meier's Civilization,* resulted in an extremely addictive design: a game that reproduced formal structures associated with semiotic paradox.

None of the *Civilization* computer games was an accurate reproduction of human history. Like *Spacewar* and most other computer games that began as simulations of real-world objects and events—and especially those games that began as simulations of simulations—the successive revisions of *Civilization* became increasingly less representative of human history and increasingly more representative of human semiosis.

Although each of the *Civilization* games—*I, II,* and *III*—had its own unique look and feel, all shared fundamental design elements of the strat-

egy genre. Longtime *Computer Gaming World* writer/editor Alan Emrich coined a "4X" description of play within the genre: explore, expand, exploit, exterminate.[3] The first two of these activities were equally associated with role-playing games and involved significations of contextualization; the latter two were equally associated with action games and involved significations of opposition. However, all signification processes within the *Civilization* computer games were shaped and transformed by the civilization advances and World Wonders; these design elements most distinguished the *Civilization* computer games from other, noncomputer strategy games, and these design elements were root and cause of the games' self-reflexive form.

Contextual transformations—*recursive* contextualizations—accounted for much of the "just-one-more-turn" addictiveness of *Civilization* play. And although each of the *Civ* series depended on these transformations to govern and motivate play, *Civilization II* offered the clearest and most accessible example of the series' common design; it is that game that I consider in most detail hereafter.

Play in *Civilization II*

Though the design changes from *Civ I* to *Civ II* were minor, they greatly improved play. The original game was an MS-DOS game—limiting its function within a multitasking operating system. *Civ II* was designed for MS Windows, with higher resolution graphics, allowing game elements to be more easily discerned and manipulated. But improvements in game graphics and operating system were common across game genres and did not particularly distinguish the *Civ II* design.

Most *Civ II* design changes were simple embellishments of the original game elements: a greater number of combat units, a greater variety of terrain types, and a longer list of World Wonders. These changes were made without fundamentally altering the game's rules context or the software engine that determined and maintained it. In fact, analogous changes had already been made to *Civ I* by many of its players—in a manner similar to how dedicated *Doom* players had created a variety of wad files for that game.[4]

The more significant changes in the *Civ II* design were those motivated by long hours of *Civ I* play. Public release and play of *Civ I* had

demonstrated the widespread appeal of the game's design and many of its flaws.

The design changes in *Civ II,* then, were of two fundamental sorts: changes that extended and refined the first game's rules context, and changes that corrected obvious flaws in the original design. Both changes altered the relative values of many game units—values that were discovered and manipulated during significations of play; however, neither change altered the *interactive* design and play that characterized all games in the *Civ* series.

Civilization II was played on a world map ranging in dimensions from 20 × 50 to 100 × 100 squares. In the beginning of the game, moving a game unit from one square to another exhausted an entire turn of play. And, in the beginning of the game, the vast majority of the map was unexplored and black. The *Civ II* player controlled but a single unit (a settler—sometimes two), which cast limited light on its surroundings; units illuminated map squares only when moved over them.

The game first required the player to select—in as few turns as possible—a city site from whatever options were available, move a settler to that site, and establish the capital city of a civilization.

Once this settler unit had turned itself into a city, that city provided resources to manage: food for growth and the creation of additional units, raw materials for the construction of city improvements, and commerce that provided the knowledge necessary to obtain civilization advances. Different land squares on the game map—grassland, plains, tundra, and the like—provided resources in different ratios and different amounts, each of which could be altered, at a cost, by the player.

The maps and starting positions in *Civ II* were randomly determined, and many starting positions were untenable or, at best, put the human player at a disadvantage against the computer opponents. In the beginning of the game, however, the relative value of each civilization's starting position was unknown and unknowable. Play might go on for some extended number of turns before enough of the hidden map had been revealed to make those values evident and the futility of further play clear. It was particularly galling, for instance, to find your civilization placed on some isolated island while competing computer civilizations roamed freely over

the map's broader, resource-rich continents. On the higher difficulty levels, it was impossible to recover from such an unfortunate placement and, on all difficulty levels, it was not much fun to do so. Given such a disadvantageous starting position, most players simply quit and began a new game.

In fact, even when given an advantageous starting position, it was difficult, with so much of the map hidden, to select the optimum position for that crucial first city. For this reason, initial play in *Civ II* often occurred in a series of saves and reloads. Since the game could be reloaded with game map intact, a player might choose to waste early turns exploring with her settler (a very dangerous tactic under most circumstances) solely in order to reveal the map; and then, if and when the overly adventurous settler had been destroyed by the game's roving barbarians, she could reload the game from its beginning and make a much quicker beeline to where, if the map had been completely revealed, she would have taken her settler and established her capital city in the first place.

This formal sequence was thematic and common during *Civ II* play: It was necessary to learn the context of play prior to playing the game properly, and it was necessary to play the game properly prior to learning the context of play. Thus, save and reload sequences in *Civilization* functioned very differently from those in action games like *Doom* and in role-playing games like *Might and Magic*.

In *Doom,* saving and reloading served to increase the number of attempts available to leap the chasm, or run the maze, or kill the boss—much like a golfer's mulligan. The play after the reload was virtually identical to the play preceding it. In *Might and Magic,* saving and reloading served to erase mistakes of play and funnel player-characters toward their predetermined roles within the game's social context—much like an errant train put back on its track. The play after the reload was a more purposeful and knowing extension of the play preceding it.

In *Civilization* play, however, saving and reloading were both more integral to and more destructive of previous play. *Civilization* was very often—much more often than games in other genres—reloaded and replayed *from its beginning.* Play after the reload was part repetition—like the play in action games—and part extension—like the play in role-playing games.

But, unlike play in other genres, *Civ II* play involved the manipulation and transformation of the game's *contextual* elements. There was no visceral, sacrosanct context like that of the adventure game, nor the imposition of a linear, "narrative" context like those common in role-playing games. Saving and reloading was both iterative and *recursive*. Values established during initial significations of play were constantly revalued within contexts transformed by subsequent play. Recursive play of this sort was fundamentally *interactive,* as earlier defined (in chapter 9): a formal process determined according to the degree to which

> messages in a sequence relate to each other, and especially the extent to which later messages recount the relatedness of earlier messages.
>
> Rafaeli & Sudweeks, 1997

Civ II play created long series of such related messages. This play was often halted and often restarted—but never quite finished, even when the game was won. Winning the game required expertise in resource management and in battle; but, more importantly, winning required interpretive expertise: It required valuing game elements through recursive contextualization.

Selecting the first city site was mere prelude to *Civ II* play. After founding a capital city, players had to decide how to manage city resources—whether to build further cities, build combat units to protect those cities, alter the terrain surrounding those cities (in order to increase the amount of resources available), or postpone all such activities in order to transform the game context (through the civilization advances and/or World Wonders) into some alternative context in which city building and terrain altering and activity postponing were more advantageous.

All these decisions were directly affected by actions of the computer-controlled opponents; as a result, decisions made during *Civ II* play required, simultaneously, both significations of opposition and significations of contextualization.

Most of the time, however, *Civ II* players built and maintained their cities: a play of contextualization similar to that of *SimCity,* in which the native context of the game map was gradually transformed into the farm-

lands and roads of civilization. However, unlike *SimCity* play, there was, at the same time, competitive play that determined the value of each civilization in opposition to all others. Spend too much time cultivating crops and building temples within your cities, and there would be no warriors to defend those cities against attack. Spend too little time tilling the land, and no city would grow fast enough to produce the cathedrals and universities and factories necessary to compete in the game's latter stages. Making the right decisions during the game's play of contextualization required assigning that play a value determined in reference to the game's play of opposition; this latter play—this *signification*—then had to reference a *supra*context composed of game elements that, when first and most required, were inaccessible.

Like squares on the game map, actions of the computer opponents in *Civ II* were revealed only when and if encountered. Computer-controlled civilizations might grow steadily and invincibly in the darkness of their distant continents, while the human player's civilization fought and won all local battles, only to lose the game's penultimate war. And, even after finally winning a game of *Civilization II,* with the game map and opponents fully revealed, there were no definitive values assigned to the game's contextual play by the preceding oppositional play of competition and conflict. Because game maps and game opponents were randomly determined, a winning strategy in one game, against one set of opponents, on one map, might fail in another game, against another set of opponents, on a different map.

In contrast, in conventional wargame play, an optimum strategy could be determined and fixed. Determining this strategy was, in fact, the original, single, and utilitarian function of the wargame (see chapter 5). This optimum strategy assigned meanings—values—for all wargame units within that wargame's rigid-rule context. The rules context of *Civ II*—due to the ability of the game's civilization advances to transform game contexts during play—was not of the same rigid-rule sort.

Flaws in the original *Civ I* design that were corrected in *Civ II* involved elements of the original game that had been assigned values impervious to the game's contextual transformations. That is, incorporating those design elements within game play assured a winning strategy *regardless of game context.*[5]

For instance, *Civ I* allowed the use of the game-breaking "Mongol" strategy—so-called in honor of one of the game's more aggressive computer-controlled civilizations. Players pursuing a Mongol strategy built very small cities, very close together, very quickly. By eschewing all technological advances, these cities produced a horde of primitive fighting units that, under all circumstances but the most extreme, overwhelmed other civilizations through sheer weight of numbers. Instead of advancing slowly from ancient to medieval to modern times, the game could be won in early B.C. In *Civ II,* however, subtle rule changes made this and other aberrant strategies much less effective. Players were forced to adjust their play according to the changing contexts of the game both during play *and between play*—that is, from one game to the next.

Finding a consistent winning strategy—an optimum strategy—within *Civilization II* required playing the game many, many times in order to encounter a variety of terrains, computer opponents, and computer strategies. During these encounters, players discovered—and constructed—the game's supracontext. This construction was embodied within the game's software engine but not made manifest by any conventional explication of the game's rules. The game's printed manual and on-disk help system did not and could not establish game element values *interactively*. In fact, the implicit message of these materials was that a great number of—perhaps even all possible—strategies were equally effective. This was not the case.

For instance, during play, there were clearly more valuable World Wonders (the Pyramids, Leonardo's Workshop) and less valuable World Wonders (The Great Lighthouse, Adam Smith's Warehouse)—despite these Wonders being equally valued by the game rules. Player civilizations building the more valuable Wonders gained advantages over computer civilizations building the less valuable Wonders. And players with knowledge of this sort—knowledge based on a supracontextual representation[6] of *Civ II*'s contextual transformations—were able to build cities and manage resources in a way that, regardless of the values assigned to them by the game's oppositional play, would win the game.

In effect, such knowledge allowed players to construct an advanced sort of Mongol strategy—a "suprastrategy" that subverted the game's rules context *within the rules context*. Expert *Civ II* play followed a relatively

narrow path from one civilization advance to the next, from one World Wonder to the next, in a manner sure to win the game[7] and in a manner that was possible only given foreknowledge of the game being won in just such a manner. This sort of expert play displayed the same formal characteristics that distinguished both unruly "super" characters within role-playing games (see chapter 3) and semiotic paradox (see chapter 7). Expert *Civ II* play involved the contextual transformation of all contextual transformations (including the game *rules* determining contextual transformations) that were not contextually transformable—or, put more directly in terms of the S-B system: $A(A(B))$.

This formal structure was common within play and certainly not unique to *Civ II;* however, the *Civilization* series—because of the civilization-advances design element—reproduced this formal structure in a unique and self-similar way. That is, the formal structure of *Civ II*'s recursive play modeled both the formal design of *Civ II* and, more broadly, the formal structure of semiosis. For this reason, the *Civ II* design was both model and mimicry (during play) of itself; it is precisely this paradoxical characteristic of its design that resulted in its well-documented addictiveness.

Anticonic signs.

Designs like that of the *Civilization* series—forms of play that incorporate contextual transformations as design elements within a rigid-rule context—attain special status during their signification and play. These forms function in a manner opposite to that of the icon, which I will call *anticonic.*

Iconic signs conflate signifier and signified; in this conflation, the icon erases the normal relationship between signifier and signified. Thus, the iconic signifier "references" its signified without reference to any Other or oppositional relationship. An icon, then, can be said to be "emptied" of *relating.* It is a first-order signification in which a signifier both references and represents itself through a recursive form of Self-contextualization.[8]

The *Civ II* design—as *anticon*—conflated representation and reference (see also chapter 10, note 6). The anticon is constructed by a second-order signification process that references the same signification process that constructs it. Since the anticon's signified is the semiotic *relationship* between the anticon and its signified, the anticon is "filled" with *relating*

(or, alternatively, "emptied" of any signified). And, given a human significa-
tion process fixed in form, this referencing/representing conflation is
likewise fixed in an endless loop of signification. Thus, during significations
of play, the anticon can be represented only through a recursive form of Self-
opposition—or paradox.[9] (See figures 13.1a and 13.1b at the end of this
chapter.)

In human semiosis, both icon and anticon are formal structures that,
during signification, do not result in conventional values. The former elic-
its awe at, seemingly, a self-constructed value; the latter elicits expecta-
tions of a conventionally fixed semiotic value at the completion of a
conventionally fixed semiotic process. This normal and expected value, how-
ever, is immediately transformed by play, according to game design and rules,
into a context for further value determination—and, thus, further semiosis.
(See figure 13.2 at the end of this chapter.)

The strategy genre allowed no sudden gratification and escape from
its play, as did the action genre, through the signification of crux. Instead,
characteristic strategy game play led to multiple, recursively constructed,
false cruxes. These false cruxes had the same semiotic form as the crux—
a form that referenced context without reference to any contextual Other.
Within *Civ II* play, however, this referenced context had no bracket, no
visceral ground, and no resulting conventional value.

For instance, the *Civ II* player found his player-character spread dif-
fusely throughout game play, with no direct representation. The player-
character in the *Civ* games was a composite signifier (see chapter 5) with
its signified those relationships among game elements that were actively
constructed during play. One player-character might be a quick developer
and be "represented" by a large, sprawling civilization; another might build
fewer and larger cities and be "represented" by a smaller, more compact
civilization. Separate player-character representations of this sort were
then assigned values, as were all elements of the game design, through
contextual transformations of play.

Since all or any elements of play might contribute equally to the com-
posite signifier of the *Civ II* player-character, the signification of this player-
character was, particularly during advanced and expert play,

indistinguishable from the signification of play. Within the self-recursive maze of the anticon, there was no single sign, no single signification, and no single and fixed set of relationships that distinguished play from player—or semiosis from Self.

During the most engaging and addictive sequences of *Civ II* play, each moment of play felt very much like that single moment in *Doom* in which the game was finally won or lost. But this subjective feeling resulted from the game's signification process alone, not from any particular decision made or action taken by the player. The player was always, it seemed, just on the verge of winning (or losing) the game—all it would take was just one more move, just one more advance, just one more turn.

During these most engaging and addictive sequences, game elements were both equally valued and valued equally—from the slightest adjustment made to the defensive posture of a single phalanx to the civilization-wide selling of city improvements to purchase a World Wonder. *Civ II* design and play blended each signification into the next, until the game's signification process ended in either game defeat or game victory, or until more pressing, visceral contexts of physical necessity—hunger and sleep-deprivation—intruded.[10]

Like play in *Might and Magic,* play in *Civ II* lingered for some time after the game was won. However, unlike play in either the action or role-playing genres, there was no clear indication in *Civ II* exactly when (or how) the game was won. There were obvious and clearly marked victory conditions—including the destruction of all opposing civilizations. But achieving these victory conditions in *Civ II* was most often a long, drawn-out sequel to a foregone conclusion.

Near the end of the game—in A.D. 1800, for instance—your civilization might be twice the size of any opposing it: a dominant position that allowed you to win the game in a variety of ways. But what aspect of play had led to such a dominant position? Initial city placement? Building more workers than usual? Battlefield acumen? Or the sheer luck of buying the right Wonder at the right time?

Without definitive answers to such questions, there was no absolute certainty that the game *was* won. Perhaps the computer civilizations still held unrevealed tricks up their sleeves. So you played on, assigning the

same level of significance to each game element as before, when the outcome had not been so clearly tipped in your favor. And, during this process, something interesting happened: The game was just as much fun to play when your expectations concerning the outcome were in doubt as when that outcome was *truly* (i.e., as determined by the game rules) in doubt.

Experienced players were sometimes shocked—and a bit dismayed— to learn that after several hours of city building, and army reinforcing, and the detailed planning of a large-scale invasion of multiple computer-held strongholds, those strongholds were little more than paper tigers, capitulating quickly and completely during the first probing attacks. Thus, for those several hours of play prior to the attack, the human player had been, in effect, playing alone: outside the game's rules context, guided by assumptions, expectations, and values other than those justified within the game's software engine.

Similarly, younger and inexperienced players often enjoyed playing *Civ II* on its easiest level of difficulty, where the game rules were so biased in favor of the human player that the outcome of the game was never in doubt. In instances like these—in novice and in expert play—the game's rigid-rule context neither motivated nor necessitated extended play. It was the formal structure of the game's design—its anticonic form, stripped of all values associated with the game's superficial themes or artificial victory conditions—that motivated play.

Since the supracontextual relationships and values constructed during *Civ II* play applied equally to the game and to its play, advanced *Civ II* play became increasingly self-directed, with goals of play superseding goals of the game. Experienced *Civ II* players might boot and play the game for several hours—prior to revealing the full game map or the full game context, and likewise prior to any clear resolution of the game's outcome—and then, during their next session of play, begin the game anew.[11]

This recursive pattern of expert play prioritized the formal structure of the game over its more practical, rules-determined outcomes. Though completing and winning a game of *Civilization II* remained a gratifying

experience, equally compelling were the recursive contextualizations of a play emptied of all signifieds, a play without goal or cause other than its playing.

Sign

Signifier	*Signification*	*Signified*
S1	S2	S3

Icon

S1	S3

Anticon

S1	S2	S2

Figure 13.1a: Components of signs.

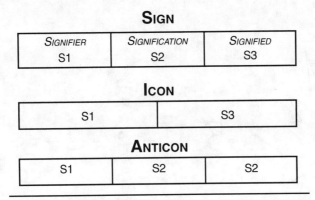

SIMULATION

Signifier				*Signified*		
Semiotic system **m**				Semiotic system **t**		
(e.g., map/Self)				(e.g., territory/Other)		

Mimicry

signs	significations	outcomes		signs	significations	outcomes
mS1a	mS2a	mS3a				tS3a
mS1b	mS2b	mS3b	*Signification*			tS3b
.	.	.	"referencing"			.
mS1x	mS2x	mS3x				tS3x

Model

mS1a	mS2a	mS3a			tS2a	tS3a
mS1b	mS2b	mS3b	*Signification*		tS2b	tS3b
.	.	.	"representing"		.	.
mS1x	mS2x	mS3x			tS2x	tS3x

DUPLICATION

Copy

mS1a	mS2a	mS3a		tS1a	tS2a	tS3a
mS1b	mS2b	mS3b	*Signification*	tS1b	tS2b	tS3b
.	.	.	"reproducing"	.	.	.
mS1x	mS2x	mS3x		tS1x	tS2x	tS3x

Figure 13.1b[12]**:** Components of composite signs.

DURING PLAY WITHIN THE ACTION GENRE...

1. A *sensorium*, containing oppositions (A, B, C...),

2. generates out-of-context iconic, *cruxic* signs,

3. which are thereafter valued by *significations of contextualization.*

DURING PLAY WITHIN THE ROLE-PLAYING GENRE...

4. *Distributed representations* constructed within *contexts of design*

5. generate out-of-context *characters/roles.*

DURING PLAY WITHIN THE STRATEGY GENRE...

6. *Formal representations* constructed during recursive and interactive play

7. generate paradoxical, *anticonic* signs, which are both mimicries and models of (referencing without conventionally representing) themselves.

These anticonic forms mimic and model a natural human semiosis.

A, B, C, D, E...

⇢ (A)

⇢ A(A)

⇢ (A(A))

⇢ (A(A(a(a(...)))))

⇢ ()

⇢ (()) = .

⇢ () () = ().

Figure 13.2: Play as semiosis.

PART 5

CONCLUSIONS

Chapter 14

Summary and implications

What to make of this?

Here's the argument:

* Computer game design and play are rooted in a distinctive representational form. That is, game design and play display formal characteristics of human semiosis. This assumption has implications for play theory.

* Through a variation-and-selection process, computer games—and, more generally, interactive media—conform to human semiosis. That is, media tend to evolve toward forms that are more (rather than less) compatible with and indicative of human semiosis. This has implications for media theory.

* Semiosis is an act of cognition, and cognition is a biomechanical activity subject to natural laws and, significantly, limitations. Computer games are constructed not only during their initial design but also during their subsequent play. Both constructions display similar formal qualities and limits.

This latter assumes computer game designs reflect human semiosis much as animal tracks might reflect the behavioral dispositions of those animals making them. Certainly, computer games are artifacts of human cultures and organizations; but, more fundamentally, computer games are artifacts of the natural world—as that world is interpreted and represented by the human mind.

Importantly in this regard, computer games are designed in an interactive process. That is, computer games are designed and redesigned over

time in order to remove those elements inhibiting play and to multiply and sustain those elements motivating play. By observing the transformations of game design elements over time—and, simultaneously, by observing those elements that, once in place, do *not* change (e.g., those design elements characteristic of computer game *genres*)—there is the opportunity to observe something of the persistent and mechanical nature of human semiosis.

The persistence of human play is most evident in the common and universal forms games assume—culminating in the anticonic form characteristic of the computer strategy game genre. The most dramatic evidence of the fixed mechanics of play is found in the paradoxical semiotic forms exhibited during play—forms that may well account for much of the addictiveness of popular computer games.

This argument is novel only insofar as it gathers, compares, and attempts to consolidate the assumptions of others concerning the nature and function of cognition. Let me outline a brief sample of these.

Research on human decision making (well summarized in Piattelli-Palmarini [1996]) has documented the extent to which human minds are guided by embedded cognitive processes that are, in many cases, obstacles to a full understanding of the natural world.[1] In an attempt to discover embedded cognitive processes, Johnson-Laird (1983) has rallied research around the notion that "mental models" structure human cognition—up to and including such basic and fundamental processes as human consciousness.

Further, mental-modeling theories assume that biomechanical activities within the brain are properly studied and verified through representational means (i.e., by constructing exterior models of the brain's interior models[2]). The most detailed and influential studies in this area are, in fact, those purposively designed to mechanically replicate, through artificial means (hardware or software), activities of human cognition. Due to the complexity of that cognition, however—and in accordance with common analytical practice—this task is tackled piecemeal. Mental-model representations deal with isolated components of cognition. It is then assumed, once each of these components is well understood (modeled properly), that the sum of their representations will be not a mental model but a mind model—perhaps similar to that offered by Minsky (1986).

Similar assumptions can be found in the combination of computer science and cognitive psychology (Craik, 1943; Miller, 1956) and in the combined study of the mechanics of perception and the mechanics of reason (e.g., Marr, 1982). Given similar origins, the goals of mental modeling are very similar to the goals of expert systeming. Just as some would construct expert systems practiced in logic and deduction within specific information domains, others would construct inexpert systems mimicking the fallacies of human logic and reason within specific problem domains. Both groups thereafter strive to generalize their systems to more fully represent cognition, whether that cognition be idealized, pragmatic, or simply true-to-life. But the assumptions and semiotic forms of these two groups are so similar—and their successes so similar—that it is difficult to imagine their failures would not be likewise.

In terms of the argument here, mental-modeling theories utilize the same semiotic form as the computer wargame genre. That is, mental-modeling theories attempt to value signs as human beings value them, and therein assume that human beings provide, like wargames provide, a rigid-rule context within which to assign values. This shares with the current argument the assumption that human cognition is bound by biomechanical limits; however, this approach does not attempt to demonstrate how those limits reflect anything other than fallacies and foibles of the human condition.[3]

The origins and causes of cognitive limits—"mistakes of reason" (Piattelli-Palmarini, 1996)—have been most often attributed to a natural and essentially random evolutionary process based on variation and selection; however, some (cognitive ecologists) assert that these limits are limits only for contrivances, and that the human mind is well and fully suited for the practical applications required of it.[4] Regardless, however, there is no significant body of analysis attributing cognitive limits to the *necessities* of representational form. Thus, if there is any part of the argument here that is novel, this is it: The necessities of representational form as exhibited within a natural semiosis should be given explanatory precedence over necessities of reason, logic, or (even) consciousness in order to properly analyze and, where possible, represent and model human cognition.

Of course, mental-modeling theories have never purported to solve all mysteries of the mind. An important corollary to the assumption of cognitive limits is the assumption that these limits have biomechanical origins. If so, then it can also be assumed that the limits of cognition are subject neither to wide variation within the species nor to such wide variation within individuals that there is some easily accessible software fix to the deep-rooted, hardwired, and hardware problems of "mindblindness" (Baron-Cohen, 1995). That is, the idiosyncrasies of human cognition are *unavoidably* part—and perhaps even the cause—of human cognitive engines. And, further, these idiosyncrasies are correctable (if need be) only insofar as they are revealed in comparison with the outcomes (values and meanings assigned) of other semiotic systems. These *Other* systems include mathematics, logic, and, for the empiricist, direct observations of the senses.

In chapter 4, I mentioned Lakoff (1987) and Johnson (1987), who have worked backwards from metaphor and rhetoric toward the mechanics of a human sensorium—an analysis that attempts to reverse-engineer the human mind. Guided by similarly correlative assumptions, but working from the opposite direction, neuroscientists—e.g., Edelman & Tononi (2000)—have attempted to pinpoint the origin of higher-level cognition (e.g., consciousness) within minute structures of the human brain. If successful, this attempt would provide a materialist solution to the symbol-grounding problem and, simultaneously, the mind-body conundrum. This success would not, however, complete the argument here.

Even if given human semiosis as an act of cognition originating in biomechanical properties of the human brain, the semiotic process as outlined in this text is neither fully explained nor wholly encompassed by humanity. The semiotic process appears as a peculiarity of neither human mind nor human society, but as an abiding principle of the natural world. If so—if semiosis occupies more fundamental ground than either logic or science or any of those Other systems used to measure and evaluate human knowledge and understanding—then games as form and play as process are the only means available to explore Self and Other. It then remains an open question whether this exploration is bound within some rigid-rule context of the natural world that limits values and meanings to those

of convention, or whether this exploration has, by means yet unknown and perhaps unknowable, the capacity to construct novelties by force. In either case, human play appears to take its own course and remain its own master.

Colin McGinn's concept of *transcendent naturalism* (1993) harbors parallel notions about the intractability of the mind-body problem.

> Applied to the mind-body problem, TN [transcendent naturalism] tells us that, although consciousness can be seen as a natural, emergent property of the brain, we lack the biological capacity to articulate such a relation. Insofar as consciousness is considered as an emergent property of a brain, it represents as much a natural phenomenon as those studied by physics, chemistry, or biology. However, to determine exactly how such an emergence takes place requires a kind of method that we are biologically incapable of defining.
>
> To use a loose metaphor, the solution to the mind-body problem is as cognitively closed to us as the solution to quantum mechanics equations for the hydrogen atom might be cognitively closed to a chimpanzee. To put it bluntly, we are not smart enough, as a species, to solve the mind-body problem, a limitation that is biologically imposed. So, it's not that the mind-body problem does not have a solution, but that its solution lies outside our cognitive abilities.
>
> Burgos, 2001, paragraphs 1–2

While plausible, this seems, in fact, rather optimistic compared with the argument here. It may well be that "nontrivial epistemic limits" are characteristic not of our *undeveloped* future minds but of our *fully* developed current minds. Indeed, the limitations and confusions of paradox seem integral to intentionality (Brentano). If so, then this circumstance would closely conform to the self-similar, paradoxical structure of play as semiosis I have presented here.

Play theory

Neither media theory nor play theory occupy well-formed, rigid-rule contexts. Both present moving theoretical targets with no universally applied methodologies or consensual paradigmatic cores. Play theory is currently best represented by a diverse set of multidisciplinary studies. Two recent compendia of these are Spariosu (1989) and Sutton-Smith (1997), which

catalog diverse theories of play and offer some resolutions among them. Though concentrating on the conclusions of these two theorists must necessarily shortchange the great variety of theories of play that each considers in detail, I find these conclusions well considered, representative, and, most importantly, useful in positioning my own notion of computer game play as semiosis within existing theoretical contexts.

Spariosu categorizes values (meanings) within various theories of play by incorporating them within a sociology of *power;* in contrast, Sutton-Smith (1997) advocates no similar thematic subordination of play. Sutton-Smith's conclusions are both more immediate and more biologically oriented than those of Spariosu, who denies the possibility of universal values for play.

> According to the... historical-hermeneutical model... the play concept(s) appear, in evolutionary fashion, as a series of interpretations that cumulatively constitute their object *ad infinitum.* By contrast, in an interpretive-configurative model [Spariosu's], the play concept no longer appears as the sum total of its interpretations or as a dialectic of temporality and permanence, but as an incommensurable, discontinuous series of interpretations engaged in a supremacy contest.... Therefore, my intention here is not to offer yet another definition of play as "universal" phenomenon, but to show how any definition of play functions in the concrete, historical context of our culture.
>
> Spariosu, 1989, p. xi

Thus, Spariosu maintains the persistence of social conflict and, given such, emphasizes the historical contingencies of social discourse and cultural context that bind play to rules of power. Sutton-Smith (1992), in a review of Spariosu's *Dionysus Reborn,* acknowledges the importance of historical context to the study of play...

> One can fairly say that there have been only two substantial works of scholarship dealing comprehensively with the history of play: The first was *Homo Ludens* by the famous Dutch historian J. Huizinga, published in 1938; the second is the present work by M. Spariosu.
>
> Sutton-Smith, 1992, p. 314

...but is not persuaded that play finds any grounding value within it:

> The questions to be raised critically about his [Spariosu's] work probably have
> to do with a) the limitations of the metaphor of contest as his own historical
> paradigm... and b) the subordination of play to the mentality of power.
>
> > Sutton-Smith, 1992, p. 315

Sutton-Smith (1997) categorizes prevailing interpretations of play as one of seven ideological "rhetorics." These rhetorics are then examined to determine if there is any "unifying discourse" (Sutton-Smith, 1997, p. 9) among them. Ultimately, Sutton-Smith conceptualizes play as a cause of individual transformation rather than as an effect of social discourse; that is, he promotes a *functional* description of play as "potentiation of adaptive variability." While implicitly biomechanical in origin and design, this potentiation operates most explicitly within a representational domain (i.e., "facsimilization," p. 231)—a domain assumed to be yet beyond positivist verification, but not necessarily alien to it.

However, despite Sutton-Smith's emphasis of rhetorical representations of play, neither he nor Spariosu[5] embraces the ontological position offered here: that play is most fundamentally a semiotic process. Nor does either theorist explore the epistemological assumptions of phenomenological structuralism[6]—though others have.

Sutton-Smith uses the latter term to describe Csikszentmihalyi's (1977) notion of "flow," but then immediately rejects that notion as muddying important distinctions among various "grammars of play." Spariosu likewise finds Csikszentmihalyi's work an overgeneralization insofar as it idealizes play as "optimal experience." Though I have my own quibbles with Csikszentmihalyi's analysis[7], his methodologies are consonant with my own, and his explication of a universal form and value for play finds parallels here—and even, upon occasion, among his critics.

For instance, Sutton-Smith (1997) offers a speculative analysis of his seven rhetorics of play—including Spariosu's play of power—as a potentially universal semiotic phenomena.

> If each of the present rhetorics does indeed contain a binary relationship between strong and weak play, and is thus in different ways a repeat of Spariosu's struggle, then the six forms of weak play may be seen to be the irrational, frivolous, and feeble opposites of progress, fate, power, identity, the imaginary,

and the self. Showing that each rhetoric not only is a persuasive discourse but also implies a cultural hegemony of one group over others would provide the theory of rhetorics with much more substance than their mere description as value systems has done to this point. Each of the seven rhetorics can be examined *as a representation of the way people value some kind of play.*

Sutton-Smith, 1997, p. 204 [italics added]

If so, then at issue would be whether the abstraction of a human valuing process—a semiosis—is as similar, as universal, and as genre independent within Sutton-Smith's "rhetorics" as I have claimed it is within computer game play. And, if so, then the claims Sutton-Smith makes for the "ambiguity" of play might be more properly directed toward the formal ambiguity (paradox) of semiosis.

Media theory

I consider media theory to be in a slightly worse state than play theory— not because it is less focused but because it is ostensibly more so. Mass media theories and the broader set of mass communications theories are in fact equally disjointed (see Potter, Cooper, & Dupagne, 1993, 1995; Sparks, 1995a, 1995b; Craig, 1993; Beniger, 1988, 1990; Peters, 1986, 1988; Gonzales, 1988), but the mass media set has the most obvious and widely known counterpoint to the argument here: a strong technological determinism, such as that attributed to Marshall McLuhan. Indeed, the McLuhan determinism is austere:

> It would seem that the extension of one or another of our senses by mechanical means, such as the phonetic script, can act as a sort of twist for the kaleidoscope of the entire sensorium.
>
> McLuhan, 1962, p. 55

Similar claims about human bodily functions—e.g., radical changes to the digestive system resulting from some mechanical extension of the human palate (say, forks and spoons)—are less common. But media theory, in divorcing sign and symbol functions (cognition) from other bodily functions (digestion), has been allowed poetic licenses of the McLuhan sort.

McLuhan's media theory has been largely discredited as a result of telling criticism from humanists—prominently Carey (1968, 1981)—

and lack of empirical verification. However, the debate surrounding media determinism remains informative in that it reproduces the debate presented earlier (beginning in chapter 8) concerning formal and functional definitions of interactivity. The earlier resolution—based on Rafaeli's definition of interactivity—was found within formal properties of the functional process of semiosis.

I have presented an explication of computer game genre and computer game play that assumes that, over time, computer game design and play replicate natural forms of human semiosis. Computer game play as semiosis is then both grounded in objective form and, paradoxically, seemingly without ground during interactive function.

This argument, set in broader contexts, implies that media technologies are more often effect than cause of human interactivity—a claim in direct conflict with media determinism. Simultaneously, however, this argument acknowledges important and necessary limitations to the interactive process that motivates signification during play. These limitations (mimicked with the aid of Spencer-Brown's laws of form) constitute an important and necessary biomechanical *ground* for semiosis. Verification for this argument is, at present, indirect.

However, it would be hard to argue that computer games have not evolved during their short history—particularly those games within the action genre, from *Spacewar* to *Doom*—toward the visceral: from no sound to mono to stereo sound, from black-and-white to color graphics, from two- to three-dimensional displays, from individual to group and social play. Each successive transformation has created a game-playing environment increasingly similar to that most familiar to the human senses: a sensorium.

Similarly motivated symbol transformations have occurred in other instances under similar circumstances, particularly when conventional signs and symbols are divorced—as they are during computer game play—from conventional values. For instance, the military phonetic alphabet[8] has seen subtle changes during its history that can be attributed both to the prevailing linguistic environment and, more fundamentally, to the biomechanics of a natural language.

The phonetic alphabet was originally constructed to more efficiently distinguish among letters of the alphabet during radio communications,

—i.e., the similar-sounding *m* and *n* were replaced by *Mike* and *November*. The resulting alphabetic list assigned value to each of its symbols solely on the basis of that symbol's oppositional relationship(s) to others within the list—and, of course, according to the contextual function(s) of those symbols within the grounding mechanics of the human ear and human cognition. Some transformations of the 1913 version of the list— e.g., *George* and *Jig* were transformed to *Golf* and *Juliett*—seem, in retrospect, straightforward: *Golf* is in more obvious opposition to *Juliett* than *George* is to *Jig,* and, thus, the more contemporary pair is a less confusing representation of that pair's distinctive signifieds: *g* and *j*.

However, other transformations of the list were more subtle and determined as much by significations of contextualization as opposition. For instance, the original list had twenty-one monosyllabic symbols; the 1957 version had only two (*Golf* and *Mike*). Some particulars of this latter transformation were, no doubt, partially determined by speech and vocabulary patterns related to social and cultural norms; nevertheless, all transformations had to conform to the original goal of the phonetic alphabet: to reduce confusion during radio transmissions. Therefore, a significant decrease in the number of monosyllabic symbols from 1913 to 1957 revealed something of the relative value (meaning) of mono- and multisyllables within this particular functional context. And, significantly, this functional context is most definitively determined by its *ground:* the biomechanics of language and the limited ability of ear and brain to distinguish among monosyllabic sounds.

Of course, in many instances, technologies can and do overcome limitations of the physical senses. There are mechanical means of distinguishing among sounds beyond the normal range of hearing, and there are mechanical means of distinguishing among electromagnetic wavelengths beyond the normal range of sight. In modern astronomy, the human eye is no longer either the most common or the preferred instrument for gathering empirical data—and this example is telling. For radio astronomy does not extend the capabilities of the human eye; it replaces those capabilities with a sign and symbol system totally alien to the eye. If astronomy were limited to those signs and symbols that functioned most efficiently

within the biomechanical context of human vision, that astronomy would be likewise limited in meanings and values.

The argument here presents the case that, just like hearing and vision, semiosis functions within a biomechanical context with discernible limits. These limits might conceivably be overcome by mechanical means, but this mechanical substitution would then be—if analogous to mechanical substitutes for hearing and vision—totally alien to human cognition.

Human vision works best within those three-dimensional spaces within which we as a species have evolved and are most familiar; a tesseract is simply beyond those capabilities, regardless of all effort expended or practice time afforded. Likewise, our ability to use signs and symbols works best within the individual and social spaces within which we as a species have evolved and are most familiar; there is no more reason to consider this an unlimited and infallible capability than there is to consider hearing or vision unlimited and infallible.

Increasingly, in mass media environments, signs and symbols—significations within a natural semiois—that human beings have found to function most efficiently within the biomechanical context(s) of our unique natural history are applied within alien domains. And, just as our hearing fails, just as our vision fails, our semiosis fails—regardless of all effort expended or practice time afforded.

If computer games and computer-based media do adapt, as claimed, to the limitations and necessities of a natural semiosis, then these media must, at some point, distort the natural world and bring us an increasingly comfortable and familiar but an increasingly illusionary—*emptied of meaning*—version of it. This is both the finality and the lure of the anticon: the absorption of Other into Self during play, regardless of whether the game being played is thereby won or lost.

Epilogue

Computer game play and computer game culture originate within significations of opposition and, for that reason, are confrontational. All is set aside to evoke, within play, the crucible of conflict. In parallel, some portions of this book are confrontational. The goal has been to clearly differentiate among assumptions and values guiding the study of play, computer games, and computer media. This is done most quickly and efficiently, as all computer game players know, by placing those assumptions and values in direct and immediate opposition to one another; and, in the argument presented here, it is exactly a direct and immediate opposition that is most likely to result in values of novelty.

And, finally, the study of computer game play is often considered a frivolous topic within academia, and I would like to address that charge briefly here—but I find, after considerable tenure within academia, that I do not understand the charge well enough to do so.

Play theorists have long noted that the study of human play is not often pursued and, if pursued, not often validated by those Other semiotic systems commonly used to objectify human experiences. I suppose this is expected and even inevitable, given that play functions to transform Other into Self.

But what, then, of the labyrinth of the Self? Too often in areas of academia—the humanities—which prioritize semiotic systems of Self, constructionists have emphasized the endless possibilities of a semiotic process without sufficiently cataloging and prioritizing the constraints and limits of that process. Without limits, it seems, play and semiosis are bound

within conventional analysis. Given limits, play and semiosis transcend that analysis. Such is the paradox of play as semiosis.

Appendix

Definitions of terms

Symbol indicates something that may serve as a sign, similar to Peirce's *representatum*. This is somewhat different from its use as a type of sign distinguished from other sign types—icon and index—by an abstract and/or arbitrary relationship between signifier and signified. I use "symbol" in this way in order to encompass icons, indexes, and all other symbol variations within the single phrase "symbolic form." Also note that signs may function as symbols within composite signifiers.

Sign may be used synonymously with *signifier;* in this use, a sign is the dynamic aspect of a symbol: that which represents something else. In more rigorous use, however, the sign is distinguished from the signifier in that the sign constitutes signifier, signified, and the relationship between the two.

The *signified* is that which a sign represents or refers to. The signified can also function as a signifier, leading to (potentially) unlimited or *open* semiosis (Eco, 1989). However, this begins to require some distinction between signified and referent—which I do not address directly here.

For communication purposes, the isolated *signifier* is normally bound to a visceral object or event; the signified is not. In *composite/procedural signifiers* (see chapter 5), this binding does not hold.

The *signification process* (or simply *signification*) includes the process of assigning value and meaning to a sign within a semiotic system as well as the process of relating signifier and signified—therein turning a symbol into a sign.

First-order and *second-order* signs are distinguished by the relationship between the signifier and its signified. First-order relationships are determined within preexisting contexts; these are commonly visceral (sensory) contexts,

which, because of their immediacy and lack of prior reference, are often assumed to be objective and value-free (similar to *qualia*). Second-order relationships are determined within previously constructed semiotic systems, or contexts of design. First-order signs denote value and meaning and are therefore *denotative;* second-order signs commonly connote value and meaning and are therefore *connotative.*

The *meaning* of a sign consists of its signified and the relationship of that signified to other signifieds—that is, its semantic *value* (Saussure, 1983) within a semiotic system.

A *semiotic system* is a coherent and unified set of signifier-signified relationships; these relationships can be used to create a semiotic context that enables the assignation of values to signs and the further construction of signs that are then interpreted and valued within that context.

Semiosis refers to the signification process as that process functions within a biological system. Semiosis is bound within human biological systems by, among other things, human cognitive limits.

Opposition is one of the two operations of the signification process; opposition recognizes differences between and among signs in order to assign value. Significations of opposition must reference a preexisting semiotic context. *Contextualization* is the other operation of the signification process; contextualization recognizes similarities between and among signs in order to assign value. Significations of contextualization are used to reference and therein construct semiotic systems or *contexts of design.*

An *interactive* signification process involves a temporal series of significations during which successive signs (messages) are used to construct a context of design within which subsequent signs (messages) are interpreted, valued, and given meaning; this process involves *recursive contextualization.*

Mine is, of course, a somewhat idiosyncratic and much streamlined version of all terms semiotic. Definitions similar to those above could be found— during the summer of 2001—within Daniel Chandler's informative website (http://www.aber.ac.uk/media/Documents/S4B/semiotic.html).The reader may also wish to consult Nöth (1990), O'Sullivan, Hartley, Saunders, & Fiske (1983), and Barthes (1972)—as well as the figures associated with chapters 5 and 13.

Notes

Chapter 1: Introduction

1. In many publications of the period, this game is labeled "Spacewar!"—inclusive of the exclamation point. I have chosen a slightly less unwieldy representation.
2. William Higinbotham, a physicist at the Brookhaven National Laboratory in Upton, New York, created an electronic tennis game (similar to the more widely known *Pong* design) in 1958, predating *Spacewar* by about four years (Department of Energy Research and Development, 2002).

 While I do not mean to debate the origin of electronic games (see Baer, 1996), I would maintain that electronic games, regardless of date of origin, display similar characteristics of evolution and form. For instance, Higinbotham's game—like *Spacewar*—was originally created for utilitarian purposes and was also modified over time to more closely conform to the needs of play.
3. I do not intend this to be a full history of computer games or gaming. I select historical examples of games and play insofar as those examples clarify—and verify—my analysis of the semiotic form of electronic games. It is my position that any randomly chosen set of games would serve equally well.

 A readable account of videogames past and present is found in Herz (1997). This account includes references to *Spacewar* and most other games discussed hereafter. Specialized gaming forums on the Internet are also worth a look in gathering the names and dates of early computer game designs and designers.

 The history of *Spacewar* is well covered in Graetz (1981), and a very playable version of the original *Spacewar* game could be found—during the summer of 2001—at http://mevard.www.media.mit.edu/groups/el/projects/spacewar.

 Since, unlike all other games I discuss, I have not played *Spacewar* in its original, PDP-based form, let me reproduce the pertinent portion of that game's *readme* file from the above site:

 > Spacewar! was conceived in 1961 by Martin Graetz, Stephen Russell, and Wayne Wiitanen. It was first realized on the PDP-1 in 1962 by Stephen Russell, Peter

Samson, Dan Edwards, and Martin Graetz, together with Alan Kotok, Steve Piner, and Robert A. Saunders. Spacewar! is in the public domain, but this credit paragraph must accompany all distributed versions of the program.

This is the original version! Martin Graetz provided us with a printed version of the source. We typed it in again—it was about 40 pages long—and re-assembled it with a PDP-1 assembler written in PERL. The resulting binary runs on a PDP-1 emulator written as a Java applet. The code is extremely faithful to the original. There are only two changes. 1) The spaceships have been made bigger, and 2) The overall timing has been special cased to deal with varying machine speeds.

4. *Asteroids* used vector graphics—a display technology unsuited for the display of photorealistic images. To some extent, then, the abstract symbols within *Asteroids* resulted from formal characteristics of the game's display technology. Simultaneously, these symbols met the functional needs of play.
5. A *Spacewar* scoring system was implemented that maintained, through the accumulation of "points," continuity from the end of one game to the beginning of the next. However, this scoring system was used more often to limit play—in order to let others gain access to the single PDP-1 console—than to motivate extended individual play.

Chapter 2: Symbolic form

1. Much of the history of Crowther's *Colossal Cave* has been drawn from secondary sources, including a variety of duplicative Internet-based accounts, but most particularly from Nelson (2001).
2. This was especially true of action games extended through iterative and, in more sophisticated forms, recursive levels of play. Recursive design elements and their impact on signification are discussed in much further detail in later chapters.

Chapter 3: Symbolic process

1. For a history and overview of wargame design, see Dunnigan (1992)—available online at http://www.hyw.com/Books/WargamesHandbook/Contents.htm
2. An excellent examination of fantasy role-playing games as they are played and valued by their players can be found in Fine (1983).
3. Here there are fascinating links with theories involving social discourse, social constructionism, and, among other things, autism. These are too involved to pursue in detail, but I point you to this suggestive passage in Davies & Harre (1990):

Any narrative that we collaboratively unfold with other people thus draws on a knowledge of social structures and the roles that are recognisably [sic] allocated to people within those structures. Social structures are coercive to

the extent that…as a person we must operate within their terms. But the concept of a person that we bring to any action includes not only that knowledge of external structures and expectations but also the idea that we are not only responsible for our own [story] lines but that there are multiple choices in relation not only to the possible lines that we can produce but to the form of the play itself.

<div style="text-align: right">Davis & Harre, 1990, paragraph 38</div>

And there is this suggestive notion: that a sort of "mindblindness"—a biological/mechanical malfunction of the brain—causes social disorders such as those associated with autism. See Baron-Cohen, Tooby, & Cosmides (1995) and the discussion in Currie (1995).

My argument maintains that 1) social relationships are determined by contextual significations, and 2) contextual significations result from cognitive processes located in the individual organism, as demonstrated by the manifestation of those processes during individual play (i.e., play in role-playing games). Statements and theories like those above appear at least consonant—and more probably compatible—with this argument.

4. "Preexisting" contexts, in this instance, also imply "rigid-rule" contexts. (See the discussion following this chapter concerning the difference between algorithmic and experiential simulations.)

Chapter 4: Intrinsic form

1. Natural language, for instance, is recursive, but not infinitely so; there are limits. For this reason, Christiansen & Chater (1999) label language "quasi-recursive."

2. In "hypertext," for instance, there is likewise an upper limit on the effectiveness of multiple links. As Ryan puts it in her analysis of hypertext narratives:

Whatever advantage interactive narratives present over standard ones in the creation of forking paths and multiple realities leads to a degree of complexity that no longer supports narrative motivation. Two to four different endings, a structure easily realized in print, will for instance receive serious individual consideration, and the various outcomes will invite comparison; sixty-four endings only convey the message "there are lots of possible endings," and each of them is lost in the crowd.…The brain may be a "massively parallel processor" on the neural level, as cognitive science tells us, but on the level of the more conscious operations involved in reading, it remains very difficult to keep track of several strands at the same time, and it seems doubtful at best that systematic exposure to hypertext will significantly increase the mind's performance in distributed parallel processing.

<div style="text-align: right">Ryan, 2000</div>

Chapter 5: Derivative forms

1. From the abstract of Harnad (1990):

 > This paper describes the "symbol grounding problem": How can the seman-
 > tic interpretation of a formal symbol system be made intrinsic to the sys-
 > tem, rather than just parasitic on the meanings in our heads? How can the
 > meanings of the meaningless symbol tokens, manipulated solely on the ba-
 > sis of their (arbitrary) shapes, be grounded in anything but other meaning-
 > less symbols?

2. The reasons for this are not well understood. It is very possible, however, as Harnad
 (1990) suggests, that a humanlike signification process requires some physical foun-
 dation, a biological ground state, as a basis for subsequent symbol manipulations.
 Interesting in this regard is Hofstadter's Copycat program (see Hofstadter, 1995),
 which attempts to build a contextual signification process from the biological/
 mechanical necessities of perception—cf. Lakoff (1987) and Johnson (1987).
 For whatever reason, however, no current expert system can be said to "under-
 stand" (i.e., properly value) human semiosis in the same way that the original
 EURISKO could be said to "understand" the rules of *Traveller TCS*.

3. In myth, the trickster/prankster figure is a common personification of this semiotic
 function. The literary genre of science fiction/fantasy often plays with similar
 themes—for instance, compare the contextual powers of Neo in the film *The Matrix*
 with the response of *Star Trek*'s Kirk to the "Kobayashi Muru simulation."

4. A sample run of *Hammurabi*, from Dowd (1978):

```
TRY YOUR HAND AT GOVERNING ANCIENT SUMERIA
SUCCESSFULLY FOR A 10 YEAR TERM OF OFFICE.
HAMURABI: I BEG TO REPORT TO YOU.
IN YEAR 1, 0 PEOPLE STARVED, 5 CAME TO THE CITY.
POPULATION IS NOW 100 THE CITY NOW OWNS 1000 ACRES.
YOU HARVESTED 3 BUSHELS PER ACRE.
RATS ATE 200 BUSHELS.
YOU NOW HAVE 2000 BUSHELS IN STORE.
LAND IS TRADING AT 21 BUSHELS PER ACRE.
HOW MANY ACRES DO YOU WISH TO BUY?
?10
HOW MANY BUSHELS DO YOU WISH TO FEED YOUR PEOPLE?
?2000
HOW MANY ACRES DO YOU WISH TO PLANT WITH SEED?
?999
HAMURABI: I BEG TO REPORT TO YOU.
IN YEAR 2, 0 PEOPLE STARVED, 3 CAME TO THE CITY.
A HORRIBLE PLAGUE STRUCK! HALF THE PEOPLE DIED.
POPULATION IS NOW 51 THE CITY NOW OWNS 1010 ACRES.
```

YOU HARVESTED 1 BUSHELS PER ACRE.
RATS ATE 45 BUSHELS.
YOU NOW HAVE 1045 BUSHELS IN STORE.
LAND IS TRADING AT 23 BUSHELS PER ACRE.
HOW MANY ACRES DO YOU WISH TO BUY?
?0
HOW MANY ACRES DO YOU WISH TO SELL?
?10
HOW MANY BUSHELS DO YOU WISH TO FEED YOUR PEOPLE?
?500
HOW MANY ACRES DO YOU WISH TO PLANT WITH SEED?
?1010
HAMURABI: THINK AGAIN. YOU OWN ONLY 1000 ACRES. NOW THEN,
HOW MANY ACRES DO YOU WISH TO PLANT WITH SEED?
?1000
BUT YOU HAVE ONLY 51 PEOPLE TO TEND THE FIELDS. NOW THEN,
HOW MANY ACRES DO YOU WISH TO PLANT WITH SEED?
?500
YOU STARVED 26 PEOPLE IN ONE YEAR!!!
DUE TO YOUR EXTREME MISMANAGEMENT YOU HAVE NOT ONLY
BEEN IMPEACHED AND THROWN OUT OF OFFICE, BUT YOU HAVE
ALSO BEEN DECLARED 'NATIONAL FINK'!!
SO LONG FOR NOW.

5. Game design/editing tools have long been marketed—as forms of play—alongside computer games. *The Quill,* written by Greame Yeandle and published by Gilsoft International in 1983, was an early software system for constructing text adventures. Of course, prior to Microsoft's Windows operating system, designing and editing computer games—e.g., *Hammurabi*—were more easily and widely accomplished through direct access to and manipulation of the game code.

6. Real-time strategy games did not appear in great numbers until after the success of *Dune II,* published by Virgin Interactive in 1992. *Warcraft* (1994) and *Command & Conquer* (1995) soon followed and helped popularize the real-time format. However, there were instances of similar real-time play at least as early as Chris Crawford's *Legionnaire* (1982).

7. The three basic characteristics of wargame units are offense, defense, and movement. "Real-time" elements of strategy/wargames are then incorporated into the last of these. For instance, in the popular *Age of Empires* (1997) series of real-time strategy games, some of the games' oppositional elements (tribes) have more powerful attacks than others, some have more resistant defenses than others, and some have quicker "real-time" movements than others. An analogous turn-based design would replace speed of movement during "real time" with distance of movement during a single turn.

8. See also the figures in chapter 13. And, to be clear:

In this chapter, *model* is used to indicate a composite/procedural signifier whose semiotic relationships represent semiotic relationships within some other semiotic system (the *Other*). Likewise, *mimicry* is used to indicate a composite/procedural signifier that produces signified(s) similar to those produced by some other semiotic system. Action game play mimics a human sensory process; strategy game play mimics (and models—see chapter 13) a human semiotic process.

Both *reference* and *representation* are used to indicate characteristic relationships between and among signifiers and signifieds within a composite/procedural signifier. A reference is a relationship between signifier and signified that is necessary but not sufficient to create a model. *Referencing* is characteristic of mimicries: a mimicry references the Other. A representation is a relationship between signifier and signified that reconstructs the Other. *Representing* is characteristic of models: A model both references and reconstructs the Other.

Strictly speaking, however, a model cannot reconstruct the Other without becoming the Other; therefore, *representing* is best thought of as reconstructing the Other *in the domain of the Self*. Of course, there may well be (see the discussion in chapter 14) some Others that are unrepresentable (*noema*).

The *context of Self* is equivalent to the *domain* of Self and not-Self. The formal delineation of these terms becomes more important in chapters 6 and 7. For a further (albeit brief) explanation of domain, see note 1 in Myers, 1999, p. 228.

Chapter 6: Generic form

1. Phenomenology emphasizes the phenomenal experience as necessary and, sometimes (as in existential phenomenology), sufficient for an understanding of experience. From the online *Dictionary of Philosophy of Mind:*

> The term 'phenomenology' is often used in a general sense to refer to subjective experiences of various types. In a more specialized sense it refers to a disciplined study of consciousness from a 1st-person perspective. As a discipline it is often associated with the German philosopher Edmund Husserl (1859-1938) and numerous European philosophers influenced by him, including Martin Heidegger, Jean-Paul Sartre, and Maurice Merleau-Ponty.
>
> Gallagher, 2001

2. It is equally difficult to discuss the foundations of language using language to do so. Spencer-Brown said it like this:

> I have to use words about the construction of the physical existence in order to talk about forms of existence that do not have these qualities.... Basically, to do what I am attempting to do is impossible. It is literally impossible,

> because… one is trying to describe in an existence which has certain quali-
> ties an existence which has no such quality. And, in talking about the sys-
> tem, the qualities in the description do not belong to what we are describing.…
> but it is perfectly recognizable to those who have been there. To those who
> have not, it's utter nonsense. It will always be utter nonsense to those who
> have not been to where the speaker is describing.
>
> Spencer-Brown, 1973

3. This symbol was "⌐" in the original text, so that $(A)B$ is equivalent to $\overline{A}\,|\,B$.
4. The calling assigns *item* values; the crossing assigns *class* values—though not exclu-
 sively so. The distinction between these two values might also be thought of as that
 between foreground and background, or between token and type. It is vital to re-
 member, however, that these examples are mimicries—not models—of the basic
 forms of signification.
5. For a worthwhile discussion of the proliferation of Peirce's signs, see the online version of
 Chandler (2001) at http://www.aber.ac.uk/media/Documents/S4B/sem02.html.
6. *Content* and *value* are terms used in synonymy with *signifier* and *signified*. However, content
 and value differ in that they are intended to include representation of elements behind or
 beyond the signification process—which signifier and signified cannot represent. For this
 reason, "content" is a broader category than "signifier" and exists prior to it. For instance, the
 S-B mark of signification—()—cannot truly exist as a sign. Therefore, this mark exists
 only as content; and, as content, this mark can undergo signification (reference to itself)
 and thereby be assigned a value, i.e., a value of *paradox*.

Chapter 7: Semiotic conditions

1. Recently, Priest (1997) has reiterated this position in explicating the seemingly non-
 self-referential Yablo's paradox.
2. *Syntagmatic* characteristics of signs are those that determine their syntactical place-
 ment within phrases and sentences; normally syntagmatic differences among signs
 are based on differences among parts of speech—differences such as those among
 nouns, verbs, articles, etc. *Paradigmatic* characteristics of signs are those that concern
 semantic relations among signs; normally, paradigmatic differences among signs are
 based on differences of meaning beyond those determined by syntagmatic con-
 text—differences among "lie," "falsehood," "fib," etc.
3. That is, this expression results in a value of paradox—see the discussion of the mean-
 ing of () in the previous chapter.
4. This is a difficult condition to verbalize as it involves conflation within the basic
 human signification process between entailment (or something close to synonymy)
 and presupposition. The conflation of item and class, discussed later, has similar
 form.

5. If **A** presupposes **B**, then **((B)A) = (A)B**. If so, then **A(A(B))** again reduces to **()** .

6. A further example, using the Liar's paradox: The assertion of all assertions that are not true.

 If [**A** = assertion] and [**B** = unclassifiable-as-true-of-itself-or-not], then **A** presupposes **(B)**, and **B** presupposes **(A)**, and the semiotic conditions of novelty hold. Using these two components within **A(A(B))** produces "The assertion of all assertions that are not unclassifiable as true of themselves or not," and this phrase reduces to a value of novelty that resolves the Liar's value of paradox: "An assertion that is unclassifiable as true of itself or not."

 This semiotic transformation is available for all the other given paradoxes—see Myers (1999).

7. Hoffman (1998) delivers a taxonomy of illusions along with their implications for the cognitive processing of visual data.

8. Heyting (1956) offers one of the more widely cited explications of intuitionist logic, which avoids those paradoxes related to double negation within classical logic. For that reason, however, intuitionist logic does not well mimic human significations of play and paradox.

9. These semiotic relationships—iconic, distributed, formal—are familiar within a variety of theoretical contexts and, for that reason, carry with them some values of convention that may or may not inform their use here. I have borrowed these terms most directly from Haugeland (1991), but I use them in a much more hierarchical fashion than they appeared there.

10. This is exactly why contexts are held relatively constant in action game designs—so that players can return to these singular contexts over and over again and properly value oppositions within them. Once these values are properly determined, the game is won, the play is over, and, in order to continue the game and the play, the game context must be replaced by a new context: a new level, a new scenario, or a new game entirely.

11. While **((A)(B))** can be reduced no further, **((A(A))(B(B)))** reduces to **(())**—which is saved from further reduction only under circumstances in which the innermost crossing indicates a multiple (or "supra-") game context, while the outermost crossing indicates, as it does in iconic representations, a singular context of game play. This result can then be translated as "a context of contexts"—and remains paradoxical. Its paradox is resolved through particularization of the innermost crossing(s) as a sub-element of game play—which occurs during formal representation. In this way, formal representation generates an anticonic sign—**()**—which allows game play to continue within a newly constructed, supracontext (a context of design).

Chapter 8: Interactivity

1. However, Schudson (1978) noted early that face-to-face conversation was not entirely appropriate as the standard of comparison for group computer-mediated communication; see also Rice (1999).

2. Upon subsequent examination, social presence has been defined in a variety of ways. Check the variety in Lombard & Ditton (1997).

3. See Beaugrande (1991, 1997) for further discussion of the fundamental nature of formalism/functionalism divisions in language theory.

Chapter 9: Defining interactivity

1. Compare "endlessly recursive process" with Heidegger's "hermeneutic circle" and Peirce's "unlimited semiosis"—and then with the discussion of computer strategy game play in chapter 13. Though these concepts are logical extensions of the formal system(s) within which they originate, a more natural (grounded) semiotic process imposes limits on their operations. See also chapter 4, note 1.

2. In this context, "langue" is a formal characteristic of language or...

> ... it could be said that it is not spoken language [*le langage parlé*] which is natural to man, but the faculty of constituting a language system [*une langue*], that is to say, a system of distinct signs corresponding to distinct ideas.
>
> Saussure, 1959, p. 26

"Parole," on the other hand, is a functional characteristic of language, or simply common speech.

3. Ricoeur (1981) contains further attempts to synthesize the formal and the functional—as does chapter 14.

Chapter 10: Valuing interactivity

1. Equally disappointing in this regard is Rafaeli & Sudweeks's own (1997) study of interactivity, which used traditional content analysis techniques to identify message relatedness—without moving toward a more general consideration of the semiotic origins of interactivity. Turner (1995, 1991) is one of the few humanist critics to deal directly with these issues at length.

2. Note, for instance, how Jenkins (1998)—as humanist—attributes the origin of genre within film/text to historical contingencies:

> Urbanization provoked highly charged and often deeply ambivalent feelings even for—or perhaps especially for—those who lived in New York or Los Angeles.... Often, they came to the city seeking a social mobility and personal freedom they could not enjoy in the villages where their families had lived for generations. However, they also feared the alienation and isolation of inhabiting a world of strangers and they felt buffeted by the rapid pace and fragmented nature of modernity. Hollywood's spatial stories gave expression to both these utopian and dystopian impulses, seeking to reconcile them through a more totaling account of the city.

Though our contemporary relationships to the city are dramatically different from those that shaped these earlier spatial stories, the genre conventions that emerged during this important transitional period continue to exert a powerful influence over subsequent representations. Contemporary artists give new form to their perceptions of urban life, but often, they do so in dialogue with these earlier representations. They quote them, as Allen does in *Manhattan* when he evokes a succession of classic photographs representing the New York skyline, or they rewrite them, as we will see in the example of *Dark City*, which merges the visual vocabulary of the film noir tradition with more contemporary science fiction trappings. For those reasons, any attempt to understand the contemporary cinematic city must always position those representations in relation to earlier images.

<div align="right">Jenkins, 1998, paragraphs 12–13</div>

To avoid an endless progression of "earlier" images, I would here position representations in relation to a common and universal imaging/representing *process*.

3. Thus, the analysis of adventure games as text (e.g., as interactive fiction) subsumes values of novelty within values of paradox—instead of locating both within a common and natural semiotic process. Significations of contextualization like those dominant within the adventure game genre—absent of any natural limits—display the symbol grounding problem of an unbound semiosis. (See also chapter 9, note 1.)

4. Empirical studies on this topic include Miall (1998), Miall & Kuiken (1998), and Christiansen & Chater (1999), which concluded "that the recursive constructions that people actually say and hear may be explained by a system in which there is no representation of unbounded grammatical competence, and performance limitations arise from intrinsic constraints on the processing system. If this hypothesis is correct, then the standard distinction between competence and performance, which is at the center of contemporary linguistics, may need to be rethought" (p. 205).

5. There are many, many ongoing efforts to design interactive narratives. See, for instance, Mateas & Stern (2001). Many of these designs are consonant with my analysis here. Compare, for instance, comments on player-character development in role-playing games and in strategy games in the following chapters.

6. Perhaps, in this instance, *reference* is used as *referent*—i.e., to indicate some object in the external world—while *signified* remains conceptual, and the set of *content* then includes both referent and signified. Or perhaps not.

 In any case, to clarify: I have used *reference*—here and elsewhere—to indicate a relationship necessary, but not sufficient, for *representation*. Mimicries, for instance, reference rather than represent; models can do both. *Representation* then indicates a fixed (but not necessarily singular) relationship between signifier and signified. Or, put more generally, semiotic relationships (or, even better, semiotic *relatings*) include both references and representations.

Chapter 11: The phenomena of computer game play

1. Sid Meier, who designed *Civilization,* consciously and purposively worked on the *Civilization* series in just this manner: in close collaboration with his co-designer, Bruce Shelley. Shelley tested Meier's designs during repeated play, and Meier adjusted his designs so that those designs more closely conformed to Shelley's optimum play experiences. (See Chick, 2001—and chapter 13.)

2. The most recent release in the *M&M* series and the first without a subtitle—*Might and Magic IX* (2002)—updated the game's graphics with three-dimensional representations (using the LithTech engine) of player-characters and landscapes. However, improvements in the visceral and action-related components of the game were not paired with improvements to those contextual significations that were so important to play within the series and the role-playing genre. Most significantly, the character development system in *Might and Magic IX* was altered and made more cumbersome than that of its predecessors, resulting in a series of poor reviews of the game and its play.

3. Of course, according to the argument I present—in which an embedded, preexisting human signification process determines successful game designs—the only truly innovative designs were those that got there first: designs that first translated the intractable significations of play into computer media form. Noteworthy in this respect was Stuart Smith's *Ali Baba and the Forty Thieves* (Quality Software, 1982), a mixed genre, action-adventure game for multiple players, which predated *Castle Wolfenstein* and might have, under different circumstances, been inspiration for several later genre refinements.

4. See *Gamespot*'s online interview with Tom Hall, available through CNET Network Media at http://www.gamespot.com/features/tomhall/

5. Romero had earlier set the "par times" within *Wolfenstein 3D* by running through each level as fast as possible. He was certainly the best player among the core id Software programmers and regarded as a "DeathMatch deity" by other *Doom* players. (See Lombardi, 1994.)

6. This is the common predicament of the expert. Aficionados of art, of music, and of other semiotic domains—including computer games—apply more complex semiotic processes to the interpretation of common signs within their field of interest than do initiates.

 The difference between the computer game play of expert and newbie was most fundamentally a difference in the quantity and quality of contextual significations. Newbies reacted to the immediacy of the moment—just the sort of reaction the *Doom* designs motivated. Experts, on the other hand, reacted to the moment as it was valued within some larger context of moments—and, upon occasion, at least within the visceral context of the 3D shooter, this meant that the expert contextualized too much and too often.

7. Broader analyses have referred to this oppositional root of play as "conflict," or *agon.* See, for instance, Caillois (1961) and Spariosu (1989)—see also chapter 14. How-

ever, these earlier works did not define opposition as an integral part of a natural human semiosis.

Chapter 12: *Might and Magic*

1. *M&M I*, in fact, slightly predated the graphically similar, but more technically sophisticated *Dungeon Master*. *Might and Magic* received a variety of best role-playing game awards over the years, though none specifically for its graphics.

2. In comparison, ten years later, *Doom II* shipped with a mere sixteen-page manual.

3. Many of the game designs, in fact, offered players the opportunity to transport their player-characters from the end of one game context to the beginning of the next, in an obvious (though technically awkward and often aesthetically unsuccessful) attempt to create a single gaming environment.

4. In *M&M*, full party death resulted in all treasure, armor, and weapons lost—but all experience points remained intact. And, most of the time, when your whole party died in *M&M*, you were much more likely to reload to some earlier, more salubrious moment than to suffer through the tedious replay required to reestablish your player-characters' combat values.

5. See Myers (1992b) for a more involved discussion of how semiotic processes construct and/or distort the perception of time during play.

 Also, for clarity's sake, it is important here to distinguish between *extended play* (prolonged play of any sort), *extended design* (repetition of design elements without involving significations of contextualization, i.e., the sort of extensions that occurred within adventure game designs such as *Zork*), and *expanded design* (the "extension" of design elements with significations of contextualization, i.e., the sort of extensions that occurred within role-playing game designs such as those found in the *Might and Magic* series).

6. The third game in the *Zelda* series (*The Legend of Majora's Mask,* 2000) imposed a similar, time-dependent design element that required player-characters to complete a long sequence of play under penalty of returning to the beginning of the game if they did not play the game punctually. This design was much less successful than the more traditional, time-independent, role-playing structures of the two previous *Zelda* games.

7. It is interesting to note that in online role-playing games there is both online, synchronous play and a great deal of offline, asynchronous play. That is, although current online role-playing games force players into single-character roles and a single-person perspective similar to that of the action genre, multiple player groups quickly form that communicate and maintain the game's social context.

 Similar, self-motivated constructions of outside-the-game communities have long been common among *Might and Magic* players. Websites, fanzines, cheat sheets, walkthroughs, message boards, and a variety of supplemental publications provided further extensions to and reinforcements of the *M&M* game context. These extensions and reinforcements were often promoted by *M&M* game designers and producers

directly and indirectly, including through the release of other computer games—in other genres— that shared the conceptual landscape of *Might and Magic*.

Even non-game-specific MUDs, MOOs, and online communities display role-play within a rules-based social context very similar to play, as I have described it, within the role-playing genre of computer games. The common and pervasive nature of this play suggests a common human semiotic process—not narrative, not plot, not even game design per se—motivating and sustaining that play.

8. *Might and Magic VIII* received, in comparison with its predecessors, poor reviews due to a perceived lack of innovation in design. There were several design differences between *M&M VII* and *VIII*, but none significantly expanded the *M&M* game context.

Might and Magic VIII allowed the creation and development of but a single player-character. Other members of the game's multiple-character party of adventurers were then selected from a rotating stable of nonplaying characters, including some of the previous game's monsters (e.g., vampires and dragons). This was reminiscent of the series' earlier attempt to prolong play in the *Xeen* games by re-presenting game oppositions in reverse, mirror-image form. However, player-character perspectives—whether first-person or third-person, good guy or bad guy—were irrelevant to game play. All significations of opposition resulted in exactly the same values insofar as they were valued within the same context; for that reason—because the *relationships* between oppositional elements were more important than the identity/content of those elements—it really didn't matter on which side of the oppositional relationship player-characters played.

Further indication of the relative lack of novelty within *M&M VIII* was that, when compared with *VI* and *VII*, *Might and Magic VIII* was skimpy. Whereas each of the two previous games had provided 50 to 100 hours of game play, *M&M VIII* could be completed in well under 50 hours. Eliminating the atemporal component of the earlier games' significations of contextualization allowed the *M&M VIII* game design to more narrowly focus on the temporal requirements of narrative structure—resulting in a more linear design and correspondingly quicker (and less satisfying) play.

9. Easter eggs included any design element that had value within some context other than that of the *Might and Magic* games.

Kent (2001) locates the first computer game Easter egg within Warren Robinett's *Adventure* for the Atari 2600 in 1980, yet the formal structure for Easter eggs more likely originated in comment (REMark) lines used to organize and annotate software code. These comments had no impact on the code; they were only acknowledged and read, if at all, by other programmers. So, these comments could really say anything at all—and often did: inside jokes and private messages meant only for other programmers. And that was basically what computer game Easter eggs were—a slightly tidier and more public form of the inside joke, a context within a context.

10. Combat in *Might and Magic VII*—and in most other computer games—was a repetitive affair. There were always twists and turns in the combat learning curve, but

eventually players found those tactics and strategies that worked best—and stuck to them. These tactics and strategies continued to work because game combat took place within a fixed context. Significations of opposition required a common and consistent context to determine values—which is why character identities in combat could be exchanged so easily without affecting game play (see this chapter, note 8).

In most computer games—including *Might and Magic VII*—the monsters in opposition to player-characters came in three flavors: easy, medium, and hard. For instance, a first-level monster in *M&M VII* was the dragonfly, of which there were three sorts: Dragonfly, Fire Dragonfly, and Queen Dragonfly. An advanced-level monster in *VII* was the Titan, of which there were also three sorts: Regular, Blood, and Storm. This tripartite form was common among all monsters. The first of the triplet had the least hit points; the last had the most. The first had the least powers of attack; the last had the most formidable. And so forth.

The medium and hard monsters were, in effect, substitutes for a contextual expansion of the easy monster. That is, the medium monster subsumed the characteristics of the easy, and the hard monster subsumed the characteristics of the medium. This common and cross-genre design of monster types found wide application within computer game play because it subordinated significations of contextualization to those significations of opposition that characterized the visceral play of the action genre.

As player-characters advanced from level to level, their characters were transformed and, with those transformations, the game context grew larger. Monsters, however, were not transformed; they were replaced. They were replaced because the context that sustained their values in opposition to the values of player-characters (i.e., the context of combat) did not grow larger. Similarly, while player-characters were in combat, they could not be transformed. Player-character transformations occurred only inside the game's villages, safely apart from both monster attacks and the implacable context of the action genre within which those attacks took place.

Chapter 13: *Civilization*

1. The success was not immediate, as, at the time, strategy games were out of vogue. However, *Sid Meier's Civilization*—and *Civilization II*—have since received many popular and critical awards. The selection below is a partial list of these awards as displayed at the Firaxis promotional website during August, 2002 (http://www.firaxis.com/company_awards.cfm):

> *Sid Meier's Civilization*®
> Best Game of All Time, 1996, *Computer GamingWorld* magazine
> Game of the Year, 1992, *Computer GamingWorld* magazine
> Best Simulation, 1992, *PCM* magazine
> Hall of Fame, 1991, *Computer GamingWorld* magazine

Game of the Year, 1992, *Byte* magazine
Strategy Game of the Year, 1992, *PC Games Plus* magazine
PC Special Achievement Award, 1992, *Game Player's PC Entertainment* magazine
Game of the Year, 1991, *Tilt* magazine

Sid Meier's Civilization II®
#4 of 50 Best Games (*Civilization I* and *II*) of All Time, *Next Generation*, February 1999
Game of the Year, 1996, *PC Gamer* magazine
Editor's Choice, 1996, *PC Gamer* magazine
Golden Triad Award, 1996, *Computer Game Review* magazine
Best Game Award, 1996, British Interactive Multimedia Associations

2. Meier and Shelley make reference to these influences in Chick (2001)—and in numerous interviews elsewhere.

It should also be noted that *Reach for the Stars* was, like *Sid Meier's Civilization,* based on an earlier design—*Stellar Conquest* (Metagaming, 1975)—that had been purchased and released, as a board game, by Avalon Hill. Another frequently mentioned influence on *Civilization* was Walter Bright's mainframe version of *Empire,* a world conquest game modified for and released to the home PC market by Mark Baldwin and Interstel in 1987.

3. Alan Emrich (with *Computer Gaming World* founder and publisher Johnny L. Wilson) also wrote a popular strategy guide for *Sid Meier's Civilization: Computer Gaming World presents Sid Meier's Civilization, or Rome on 640K a day* (Prima Publishing, 1992). In 2001, Emrich was working at Interplay Games producing a new version of another classic 4X game: *Master of Orion*.

4. Similarly superficial changes to *Civ II* were released by MicroProse in 1997 as an expansion pack (*Civilization II: Fantastic Worlds*) rather than as a separate game.

5. See also the related discussion in chapter 3 concerning the difficulty of incorporating "super" characters in role-playing games.

Player discussion of the *Civilization* games inevitably turned toward which civilization, or which World Wonder, or which game strategy was optimum. For the original *Civ,* the CompuServe Gamer's Forum (prior to the purchase of CompuServe Interactive Services (CIS) and its subsequent dissolution by AOL) served as a popular online meeting ground and information distribution point for game players and game designers—similar in many respects to some of today's fan-supported websites, e.g., apolyton.net.

One of the longer original *Civ* strategy threads on the CIS forum concerned the relative value assigned to nuclear power within the game. Some thought nuclear power was overvalued in relation to a more ecologically sound power source such as wind or sun. Others thought the game design had been politicized to carry a dire message—a warning—concerning the consequences of unfettered technological growth. And, in-

deed, at the end of many *Civ* games, the game map was peppered and ruined with pollution squares. Game-wide global warming had turned grasslands into plains and plains into deserts, and player-civilizations escaped the devastated landscape only by blasting off to Alpha Centauri—one of the *Civ* series' long-standing victory conditions.

Game elements like nuclear power were easily incorporated into discussions that attributed game design—and, indeed, entire genres—to social contexts: economic, political, or cultural. That is, much of the *Civ* discussion assumed that the values of the game's signifiers originated within and were therefore determined by semiotic systems existing prior to game play.

However, if play is, as I have maintained, a semiotic process, then play of games such as *Civilization* interactively constructs its own semiotic system: i.e., the play of such games is a *meaning-making machine*. Although electronic games frequently borrow signifiers from semiotic systems other than their own, these games do not often share the same signifieds, nor do they often, if ever, assign the same values to game symbols that are assigned to those symbols in conventional social contexts. In fact, most games cannot do so, since those values are multiple, ambiguous, and volatile in broader social contexts—circumstances anathematic to rigid-rule games.

In this particular instance, it is both interesting and informative that the greater "meaning" of nuclear power was more definitively assigned by play of the game than by critical or cultural analysis. For instance, the Mongol strategy that led to a relatively easy victory in *Civ I*—and thereby most optimally valued elements within the game context—had no obvious economic or political or cultural origin. And once a player had adopted those unit values associated with such a suprastrategy, this adoption precluded all debates concerning the game's much later (and irrelevant) inclusion of nuclear power.

6. These are what I earlier called "formal" representations—see the discussion of *Street Fighter II* in chapter 7.

7. Actually, in order to remain within the game's rules context, there had to be some instances in which suprastrategies failed—and indeed there were. Whether through player fatigue, variations in the computer's artificial intelligence routines, or simply bad luck, *Civ II,* on its highest difficulty levels, could not be consistently beaten. Therefore, from the player's point of view, the game rules remained above and beyond suprastrategy assaults.

8. In the S-B system, an act of Self-contextualization is indicated by the law of crossing:

$$(\ (\)\) = \quad .$$

This particular formula cancels all references to relating.

9. In the S-B system, an act of Self-opposition is indicated by the law of calling:

$$(\)(\) = (\)\quad .$$

This formula results in a reference to a relating, or a signifier without a signified, or, as described earlier, a paradox.

10. See Myers (1992b) for further player quotes and confirmations of the extreme addictiveness of *Civilization* play—including its proclivity to transform a player's sense of time.

11. The bane of all games within the strategy genre, certainly of all 4X games, was the slowly mounting player burden of micromanagement (a design issue most negatively affecting the most recent revision and release of the *Civilization* computer game design: *Civ III* [2001]). Once the number of cities within your civilization had become sufficiently large, there was a great deal of city building—significations of contextualization—that became repetitive rather than recursive. New cities had to be rapidly brought up to the current state of all older cities and, in order to do so, these new cities had to adopt the same set of values—now values of convention—as the old cities. Managing these new cities involved manipulating contexts that had already been transformed and revalued by the larger, more powerful, and more important older cities. Thus, dealing with these new cities during play was "micromanagement"—an activity beneath and trivial to the current contextualizations of play: busywork.

Because this was a problem originating in the game's most basic signification processes, the micromanagement problem affected all aspects of *Civ* game design—not just city building and maintenance. As the number of combat units of the same sort increased, for instance, the mechanics of ordering and organizing those units became increasingly less novel and increasingly more conventional and tedious.

Civ III suffered greatly from this problem, especially when played on its larger map sizes. The game design team attempted to address the problem of micromanagement with city governors and the like, which automated many of those activities associated with the assignation of conventional values. However, the automation routines were either notoriously inefficient—making a huge botch of important matters—or notoriously unfun—operating in a manner that either ignored completely, restricted unnecessarily, or delayed indefinitely the interactive significations of play.

In the latter stages of a large-map *Civ III* game, for instance, much of play was spent aimlessly staring at the game screen while legions of workers and/or combat units darted to and fro, back and forth, driven by various automation routines that were largely outside the player's control and, eventually, totally outside the player's interest.

12. In this figure, outcomes are equivalent to values or "meanings" as determined by relationships among signifieds within a semiotic context. See the definitions in the appendix.

Chapter 14: Summary and implications

1. Even those proposing alternatives to mental models—inference rules theorists, for instance—equally assumed these embedded cognitive processes. It is the precise nature of those processes that has been controversial.

2. There is not a great deal of attention paid to the *semiotic* implications (however, see Scwamb, 1990) of mental modeling, but it is clear that the mental-models paradigm

proposed by Johnson-Laird functions as what I have called a *mimicry,* or a reproduc-
tion of the *outcomes* of human cognition. Johnson-Laird is not specific as to exactly
what portion of the brain functions as his mental models do. Others, however—
neuroscientists (see Damasio, 1994)—more explicitly hold that the mental models
of theory are analogous in function *and* in form to the brain's representation and
manipulation of spatial/kinetic relations. If so, then mental models can be said to
both mimic and model their signified: human cognition.

3. Or, in the phraseology of the game marketer: "Those aren't bugs—they're *features.*"

4. This is more complex than a couple of paragraphs might indicate. See, for instance,
Stanovich & West (2000a, 2000b)—especially the distinction between "performance
errors" and "computational limits."

5. Nor do those combining the study of human and animal play through behavioral
analyses (e.g., Fagen, 1981; Burghardt, in press) have much cause to investigate a
phenomenology of representation.

6. This is how I describe my own methodology (cf. Ingarden, 1973, and Holenstein's
[1976] comments on Jakobson). Some might consider the term oxymoronic and/or
prefer "phenomenological hermeneutics" (e.g., Ricoeur [1981]). I would retain "struc-
turalism" to emphasize the biological necessities and the irrevocable consequences of
a natural semiosis—see also Varela (1996).

7. In brief: Csikszentmihalyi (1977) and Csikszentmihalyi and Csikszentmihalyi (1988)
claimed that, within some positive and pleasurable psychological state called "flow," hu-
mans experienced a relative balance between boredom and challenge (or anxiety). How-
ever, much computer game play is rote—even boring at times—and seems to take place
almost against the will of the player, i.e., is addictive and involuntary. Rather than have the
nature of play be determined by the subjective experience of the player, I have found the
subjective experience of the player reflects a more objective form: semiosis.

8. For the purpose of this brief discussion, I refer to those symbols used in the 1913 and
the 1957 editions of *The Bluejackets' Manual* (Annapolis: Naval Institute Press), as
cited in Department of the Navy (2001). These systems are listed below.

> *1913:* Abel, Boy, Cast, Dog, Easy, Fox, George, Have, Item, Jig, King, Love,
> Mike, Nan, Oboe, Pup, Quack, Rush, Snail, Tare, Unit, Vice, Watch, X-ray,
> Yoke, Zed

> *1957:* Alfa, Bravo, Charlie, Delta, Echo, Foxtrot, Golf, Hotel, India, Juliett,
> Kilo, Lima, Mike, November, Oscar, Papa, Quebec, Romeo, Sierra, Tango,
> Uniform, Victor, Whiskey, X-ray, Yankee, Zulu.

The latter, 1957 list corresponds to the current NATO and International Aviation
phonetic alphabet. There are several alternatives to these military-based systems,
including those within languages other than English.

Bibliography

Aarseth, E. J. (2001). *Cybertext: Perspectives on ergodic literature*. Baltimore: Johns Hopkins University Press.

Ahl, D. (1978). *Basic computer games*. New York: Workman.

Andersen, P. B. (in press). Dynamic semiotics. November 2001. http://www.cs.auc.dk/~pba/Preprints/dynSem.pdf

Andersen, P. B. (1997). *A theory of computer semiotics: Cambridge series on human-computer interaction 3*. Cambridge: Cambridge University Press.

Andersen, P. B. (1992). Interaktive værker. En katastrofeteoretisk tilgang. *Almen Semiotik*, 5, 89–112.

Andersen, P. B., Holmqvist, B., & Jensen, J. F. (Eds.) (1993). *The computer as medium*. Cambridge: Cambridge University Press.

Baer, R. (1996). Who did it first? April 2002. http://www.pong-story.com/inventor.htm

Baron-Cohen, S., Tooby, J., & Cosmides, L. (1995). *Mindblindness*. Cambridge, MA: The MIT Press.

Barthes, R. (1972). *Mythologies* (Annette Lavers, Trans.). New York: Noonday Press.

Bateson, G. (1979). *Mind and nature*. Dutton: New York.

Beaugrande, R. D. (1997). On history and historicity in modern linguistic: Formalism versus functionalism revisited. *Functions of Language*, 4(2), 169–213.

Beaugrande, R. D. (1991). *Linguistic theory: The discourse of fundamental works*. London: Longman.

Beniger, J. R. (1990). Who are the most important theorists of communication? *Communication Research*, 17(5), 698–715.

Beniger, J. R. (1988). Information and communication: The new convergence. *Communication Research*, 15(2), 198–218.

Boudourides, M. A. (1995). *Social and psychological effects in computer-mediated communication*. Contributed paper at the 2nd Workshop/Conference "Neties '95" TEI of Piraeus, Greece. August 2001. http://www.math.upatras.gr/~mboudour/articles/csi.html

Brandt, P. A. (2000). The architecture of semantic domains—a grounding hypothesis in cognitive semiotics. November 2001. http://www.hum.au.dk/semiotics/docs/epub/arc/paab/SemD/SemanticDomains.html

Burghardt, G. M. (in press). *The genesis of animal play: Testing the limits*. Cambridge, MA: MIT Press.

Burgos, J. E. (2001). Transcendental naturalism. In *Dictionary of philosophy of mind* (C. Eliasmith, Ed.). January 2002. http://www.artsci.wustl.eud/~philos/MindDict/transcendentalnaturalism.html

Caillois, R. (1961). *Man, play, and games*. New York: Free Press.

Carey, J. (1981). McLuhan and Mumford: The roots of modern media analysis. *Journal of Communication, 31*(3), 162–178.

Carey, J. (1968). Harold Adams Innis and Marshall McLuhan. In Raymond Rosenthal (Ed.), *McLuhan: Pro and con* (pp. 270–308). Baltimore, MD: Penguin.

Chandler, D. (2001). *Semiotics: The basics*. New York: Routledge.

Chandler, D. (1999). *Semiotics for beginners*. August 2001. http://www.aber.ac.uk/media/Documents/S4B/sem02.html

Chenault, B. G. (1998). Developing personal and emotional relationships via computer-mediated communication. *CMC Magazine*. August 2001. http://www.december.com/cmc/mag/1998/may/chenault.html

Chick, T. (2001). The fathers of *Civilization*: An interview with Sid Meier and Bruce Shelley. January 2002. http://www.cgonline.com/features/010829-i1-f1.html

Chomsky, N. (1986). *Knowledge of language: Its nature, origin, and use*. New York: Praeger.

Chomsky, N. (1965). *Aspects of the theory of syntax*. Cambridge, MA: MIT Press.

Christiansen, M., & Chater, N. (1999). Toward a connectionist model of recursion in human linguistic performance. *Cognitive Science, 23*, 157–205.

Craig, R. T. (1993). Why are there so many communication theories? *Journal of Communication, 43*(3), 26–33.

Craik, K. (1943). *The nature of explanation*. Cambridge: Cambridge University Press.

Crawford, C. (2001a). *Understanding interactivity*. San Francisco, CA: No Starch Press.

Crawford, C. (2001b). Chapter 1: What is interactivity? August 2001. http://www.erasmatazz.com/Book/Chapter%201.html

Csikszentmihalyi, M. (1977). *Beyond boredom and anxiety*. San Francisco: Jossey-Bass.

Csikszentmihalyi, M., & Csikszentmihalyi, I. (1988). *Optimal experience*. New York: Cambridge University Press.

Culnan, M. J., & Marcus, M. L. (1987). Information technologies. In F. M. Jablin, L. L. Putnam, & K. H. Robert (Eds.), *Handbook of organizational communication* (pp. 420–443). Beverly Hills, CA: Sage.

Currie, G. (1995). Cognitive development and literary meaning. In Stefano Franchi and Güven Güzeldere (Eds.), "Bridging the gap": Where cognitive science meets literary criticism. *Stanford Humanities Review, 4*(1). October 2001. http://www.stanford.edu/group/SHR/4-1/text/currie.commentary.html

Daft, R. L., & Lengel, R. H. (1986). Organizational information requirements, media richness and structural design. *Management Science, 32*(5), 554–571.

Daft, R. L., & Lengel, R. H. (1984). Information richness: A new approach to managerial information processing and organizational design. In L. L. Cummings & B. M. Staw (Eds.), *Research in organizational behavior* (pp. 191–234). Greenwich, CT: JAI Press.

Damasio, A. R. (1994). *Descartes' error.* New York: Putnam & Sons.

Darnell, M., Moravcsik, E., Newmeyer, F., Noonan, M., & Wheatley, K. (Eds.). (1999). *Functionalism and formalism in linguistics: Volume I, General Papers.* Amsterdam: John Benjamins.

Davies, B., & Harre, R. (1990). Positioning: The discursive production of selves. *Journal for the Theory of Social Behavior, 20,* 43–63. http://www.massey.ac.nz/~alock/position/position.htm

Department of Energy Research and Development. (2002). Video games—Did they begin at Brookhaven? October 2002. http://www.osti.gov/accomplishments/videogame.html

Department of the Navy (2001). Frequently asked questions: Phonetic alphabet and signal flags. February 2002. http://www.history.navy.mil/faqs/faq101-1.htm

Derrida, J. (1976). *Of grammatology* (G. C. Spivak, Trans.). Baltimore: Johns Hopkins.

Dowd, J. (1978). Hamurabi. *Processor technology access, 2*(1). January 2002. http://www.thebattles.net/sol20/articles/access_v2n1.pdf

Dunnigan, J. (1992). *The complete wargames handbook: How to play, design, and find them* (2nd ed.). New York: William Morrow and Co. August 2002. http://www.hyw.com/Books/WargamesHandbook/Contents.html

Eco, U. (1989). *The open work* (Anna Cancogni, Trans.). Cambridge: Harvard University Press.

Edelman, G. M., & Tononi, G. (2000). *A universe of consciousness: How matter becomes imagination.* New York: Basic Books.

Emmeche, C. (1992). Modeling life: A note on the semiotics of emergence and computation in artificial and natural living systems. In T. A. Sebeok & J. Umiker-Sebeok (Eds.), *Biosemiotics: The semiotic web* (pp. 77–99). New York: Mouton de Gruyter. http://www.nbi.dk/~emmeche/cePubl/92c.modlif.html

Emmeche, C., & Hoffmeyer, J. (1991). From language to nature—the semiotic metaphor in biology. *Semiotica, 84*(1/2), 1–42. http://www.nbi.dk/~emmeche/cePubl/91a.frolan.html

Fagen, R. (1981). *Animal play behavior.* New York: Oxford University Press.

Fine, G. A. (1983). *Shared fantasy: Role-playing games as social worlds.* Chicago/London: University of Chicago Press.

Gallagher, S. (2001). Phenomenology. In Chris Eliasmith (Ed.), *Dictionary of philosophy of mind.* http://www.artsci.wustl.edu/~philos/MindDict/

Gonzales, H. (1988). The evolution of communication as a field. *Communication Research, 15*(3), 302–308.

Gould, S. J., & Lewontin, R. (1984). The spandrels of San Marco and the Panglossian paradigm: A critique of the adaptationist programme. In E. Sorber (Ed.), *Conceptual issues in evolutionary biology: An anthology* (pp. 252–270). Cambridge, MA: MIT Press.

Graetz, J. M. (1981). The origin of *Spacewar. Creative Computing.* August 2001. http://www.enteract.com/~enf/lore/spacewar/spacewar.html

Hall, B. (1997). Character attributes in role-playing games. September 2001. http://hiddenway.tripod.com/articles/attrib.html

Harmon, W., & Holman, H. (1996). *A handbook to literature* (7th ed.). Upper Saddle River, NJ: Prentice Hall.

Harnad, S. (1990). The symbol grounding problem. *Physica D*, *42*, 335–346.

Haugeland, J. (1991). Representational genre. In W. Ramsey, S. P. Stich, D. E. Rumelhart (Eds.), *Philosophy and connectionist theory*, pp. 61–89. Hillsdale, NJ: Erlbaum.

Heeter, C. (1989). Implications of new interactive technologies for conceptualizing communication. In J. L. Salvaggio and J. Bryant (Eds.), *Media use in the information age* (pp. 217–235). Hillsdale, NJ: Erlbaum.

Herz, J. C. (1997). *Joystick nation: How computer games ate our quarters, won our hearts and rewired our minds*. Boston: Little, Brown and Company.

Heyting, A. (1956). *Intuitionism: An introduction*. Amsterdam: North-Holland.

Hoffman, D. B. (1998). *Visual intelligence*. New York: W. W. Norton & Co.

Hofstadter, D. R. (1995). *Fluid concepts and creative analogies: Computer models of the fundamental mechanisms of thought*. New York: Basic Books.

Holenstein, E. (1976). *Roman Jakobson's approach to language: Phenomenological structuralism* (Catherine and Tarcisius Schelbert, Trans.). Bloomington: Indiana University Press.

Hoops, J. (Ed.) (1991). *Peirce on signs: writings on semiotic*. Chapel Hill: University of North Carolina Press.

Ingarden, R. (1973). *The literary work of art: An investigation on the borderlines of ontology, logic, and theory of literature* (George C. Grabowicz, Trans.). Evanston, IL: Northwestern University Press. (Original work published in 1931)

Jenkins, H. (1998). Tales of Manhattan: Mapping the urban imagination through Hollywood film. March 2002. http://web.mit.edu/21fms/www/faculty/henry3/manhattan.html

Johnson, M. (1987). *The body in the mind: The bodily basis of meaning, imagination, and cognition*. Chicago: University of Chicago Press.

Johnson-Laird, P. N. (1983). *Mental models: Towards a cognitive science of language, inference, and consciousness*. Cambridge, MA: Harvard University Press.

Juul, J. (2001). *A clash between game and narrative: A thesis on computer games and interactive fiction* (version 0.99). M.A. thesis. Institute of Nordic Language and Literature. University of Copenhagen. January 2002. http://www.jesperjuul.dk/thesis/AClashBetweenGameAndNarrative.pdf

Kenny, K., Gorelink, A., & Mwangi, S. (2000). Interactive features of online newspapers. *First Monday*, *5*(1). July 2001. http://www.firstmonday.dk/issues/issue5_1/kenney/

Kent, S. L. (2001). *The ultimate history of video games*. Roseville, CA: Prima Publishing.

Kiesler, S., Siegal, J., & McGuire, T. W. (1984). Social psychological aspects of computer-mediated communication. *American Psychologist*, *39*(10), 1123–1134.

Klabbers, J. (1996a). Problem framing through gaming: Learning to manage complexity, uncertainty, and value adjustment. *Simulation & Gaming*, *27*(1), 74–92.

Klabbers, J. (1996b). Problem framing through gaming: A rebuttal to Law-Yone. *Simulation & Gaming*, *27*(1), 98–102.

Kling, R. (1996). Social relationships in electronic forums: Hangouts, salons, workplaces and communities. In C. Dunlop & R. Kling (Eds.), *Computerization and controversy* (2nd ed.). San Diego: Academic Press. August, 2001. http://www.slis.indiana.edu/kling/cc/5-FORUM4.html

Kucklich, J. (2001). In search of the lost text: Literary theory and computer games. November 2001. http://www.game-culture.com/articles/insearch.html

Lakoff, G. (1987). *Women, fire, and dangerous things: What categories reveal about the mind.* Chicago: University of Chicago Press.

Lenat, D. B. (1995). CYC: A large-scale investment in knowledge infrastructure. *CACM*, *38*(11), 32–38.

Lenat, D. B. (1983). Eurisko: A program which learns new heuristics and domain concepts. *Artificial Intelligence*, *21*(1-2), 61-98.

Lenat, D. B. (1976). *AM: An Artificial Intelligence Approach to Discovery in Mathematics as Heuristic Search.* PhD thesis, Stanford University.

Lombard, M., & Ditton, T. (1997). At the heart of it all: The concept of presence. *Journal of Computer-Mediated Communication*, *3*(2). August 2001. http://www.ascusc.org/jcmc/vol3/issue2/lombard.html

Lombardi, C. (1994). To hell and back again. *Computer GamingWorld*, *120*, 20–24.

Marr, D. (1982). *Vision: A computational investigation into the human representation and processing of visual information.* San Francisco: W. H. Freeman.

Mateas, M., & Stern, A. (2001). InteractiveStory.net. December 2001. http:/home.netcom.com/~apstern/interactivestory.net/

McGinn, C. (1993). *Problems in philosophy: The limits of inquiry.* Oxford: Basil Blackwell.

McLuhan, M. (1962). *The Gutenberg galaxy.* Toronto: University of Toronto Press.

McManus, B. F. (1999). Notes: Reader-response criticism. August 2001. http://www.cnr.edu/home/bmcmanus/readercrit.html

Merrell, F. (1995). *Semiosis in the post-modern age.* West Lafayette, IN: Purdue University Press.

Miall, D. S. (1998). The hypertextual moment. *English Studies in Canada*, *24*, 157–174.

Miall, D. S., & Kuiken, D. (1998). The form of reading: Empirical studies of literariness. *Poetics*, *25*, 327–341.

Miller, G. A. (1956). The magical number seven, plus or minus two: Some limits on our capacity for processing information. *The Psychological Review*, *63*, 81–97. http://www.well.com/user/smalin/miller.html

Minsky, M. (1986). *The society of the mind.* New York: Simon and Schuster.

Morris, M., & Ogan, C. (1996). The Internet as mass medium. *Journal of Computer-Mediated Communication*, *1*(4). August 2001. http://www.ascusc.org/jcmc/vol1/issue4/morris.html

Myers, D. (2001). A pox on all compromises: Reply to Craig (1999). *Communication Theory*, *11*, 218–230.

Myers, D. (1999). Play and paradox: How to build a semiotic machine. *Semiotica, 123*(3/4), 211–230.

Myers, D. (1992a). Simulating the self. *Play & Culture, 5*(4), 420–440.

Myers, D. (1992b). Time, symbol manipulation, and computer games. *Play & Culture, 5*(4), 441–457.

Myers, D. (1991). Computer game semiotics. *Play & Culture, 4*(4), 334–345.

Myers, D. (1990a). Computer game genres. *Play & Culture, 3*(4), 286–301.

Myers, D. (1990b). A Q-study of computer game players. *Simulation & Gaming, 21*(4), 375–396.

Myers, D. (1984). The pattern of player-game relationships. *Simulation & Games, 15*(2), 159–185.

Nelson, G. (2001). *The Inform designer's manual* (4th ed.). St. Charles, Ill.: The Interactive Fiction Library. September 2002. http://www.inform-fiction.org/manual/download_dm4.html

Newmeyer, F. (1999). Some remarks on the functionalist-formalist controversy in linguistics. In Darnell et al. (Eds.), op. cit..

Nöth, W. (1990). *Handbook of semiotics*. Bloomington: Indiana University Press.

O'Sullivan, T., Hartley, J., Saunders, D., & Fiske, J. (1983). *Key concepts in communication*. London: Methuen.

PC Gamer. Firaxis interview. August 2001. http://www.pcgamer.com/eyewitness/eyewitness_2001-08-22.html

Peters, J. D. (1988). The need for theoretical foundations: Reply to Gonzales. *Communication Research, 15*(3), 309–317.

Peters, J. D. (1986). Institutional sources of intellectual poverty in communication research. *Communication Research, 13*, 527–559.

Petitot, J. (1995). How can physical symbols act upon semiotic structures and "visualize" meanings? In Stefano Franchi and Güven Güzeldere (Eds.), "Bridging the gap": Where cognitive science meets literary criticism. *Stanford Humanities Review, 4*(1). January 2002. http://www.stanford.edu/group/SHR/4-1/text/petitot.commentary.html

Piattelli-Palmarini, M. (1996). *Inevitable illusions: How mistakes of reason rule our minds*. New York: John Wiley & Sons.

Potter, W. J., Cooper, R., & Dupagne, M. (1995). Is media research prescientific? Reply to Sparks's critique. *Communication Theory, 5*, 280–286.

Potter, W. J., Cooper, R., & Dupagne, M. (1993). The three paradigms of mass media research in mainstream communication journals. *Communication Theory, 3*, 317–335.

Priest, G. (1997). Yablo's paradox. *Analysis, 57*(4), 236–42.

Priest, G. (1994a). The structure of paradoxes of self-reference. *Mind, 103*, 25–34.

Priest, G. (1994b). Derrida and self reference. *Australasian Journal of Philosophy, 72*(1), 103–111.

Priest, G. (1987). *In contradiction: A study of the transconsistent*. Dordrecht: Martinus Nijhoff.

Rafaeli, S. (1988). Interactivity: From new media to communication. In R. P. Hawkins, J. M. Wiemann, & S. Pingree (Eds.), *Sage Annual Review of Communication Research: Advancing Communication Science, Vol. 16* (pp. 110–134). Beverly Hills, CA: Sage.

Rafaeli, S., & Sudweeks, F. (1997). Networked interactivity. *Journal of Computer-Mediated Communications, 2*(4). August 2001. http://www.ascusc.org/jcmc/vol2/issue4/rafaeli.sudweeks.html

Ramsey, F. P. (1931). *The foundations of mathematics and other logical essays* (R. B. Braithwaite, Ed.). New York: Harcourt Brace.

Reeves, T. C. (1999). The scope and standards of the *Journal of Interactive Learning Research*. August 2001. http://www.aace.org/pubs/jilr/scope.html

Reynolds, B. (1996). Designer's notes, pp. 179–183. In *Sid Meier's* Civilization II: *Instruction manual*. Hunt Valley, MD: MicroProse.

Rice, R. E. (1999). What's new about new media? Artifacts and paradoxes. *New Media and Society*, *1*(1), 24–32.

Rice, R. E., & Love, G. (1987). Electronic emotion: Socioemotional content in a computer mediated communication network. *Communication Research*, *14*, 85–108.

Ricoeur, P. (1981). *Hermeneutics and the human sciences: Essays on language, action, and interpretation* (J. B. Thompson, Trans.). New York: Cambridge University Press.

Russell, B. (1956). *Logic and knowledge: Essays 1901–1950* (R. C. Marsh, Ed.). London: George Allen & Unwin.

Ryan, M. (2001). *Narrative as virtual reality: Immersion and interactivity in literature and electronic media*. Baltimore: Johns Hopkins.

Ryan, M. (2000). Immersion and interactivity in hypertext. November 2001. http://www.dichtung-digital.de/2000/Ryan/29-Maerz

Ryan, M. (1994). Immersion vs. interactivity: Virtual reality and literary theory. *Postmodern Culture*, *5*(1). January 2002. http://muse.jhu.edu/journals/postmodern_culture/v005/5.1ryan.html

Saussure, F. (1983). *Course in general linguistics* (Roy Harris, Trans.). London: Duckworth. (Original work published 1916)

Saussure, F. (1959). *Course in general linguistics* (W. Baskin, Trans.). New York: Philosophical Library. (Original work published 1916)

Schudson, M. (1978). The ideal of conversation in the study of mass media. *Communication Research*, *5*(3), 320–329.

Scorpia. (1989). Might and Magic II. *Computer Gaming World*, March 1989, 28–9, 50.

Scwamb, K. (1990). *Mental models: A survey*. November 2001. http://www.isi.edu/soar/schwamb/papersw/mm-survey.ps

Sempsey, J. (1997). Psyber psychology: A literature review pertaining to the psycho/social aspects of multi-user dimensions in cyberspace. *Journal of MUD Research*, *2*(1). May 2001. http://journal.tinymush.org/~jomr/v2n1/sempsey.html

Short, J., Williams, E., & Christie, B. (1976). *The social psychology of telecommunications*. London: John Wiley.

Spariosu, M. I. (1989). *Dionysus reborn: Play and the aesthetic dimension in modern philosophical and scientific discourse*. Ithaca, NY: Cornell University Press.

Sparks, G. G. (1995a). Comments concerning the claim that mass media research is "prescientific": A response to Potter, Cooper, and Dupagne. *Communication Theory*, *5*, 273–280.

Sparks, G. G. (1995b). A final reply to Potter, Cooper, & Dupagne. *Communication Theory*, *5*, 286–289.

Spencer-Brown, G. (1973). Transcript from the Esalen Institute, California, March 19-20. July 2002. http://www.rgshoup.com/lof/aum/session1.html

Spencer-Brown, G. (1972). *Laws of form*. New York: The Julian Press.

Sproull, L, & Kiesler, S. (1991). *Connections: New ways of working in the networked organization*. Cambridge, MA: MIT Press.

Stanovich, K. E., & West, R. F. (2000a). Individual differences in reasoning: Implications for the rationality debate? *Behavioral and Brain Sciences*, *23*(5), 645–665.

Stanovich, K. E. & West, R. F. (2000b). Advancing the rationality debate. *Behavioral and Brain Sciences*, *23*(5), 701–726.

Sutton-Smith, B. (1997). *The ambiguity of play*. Cambridge: Harvard University Press.

Sutton-Smith, B. (1992). Dionysus reborn: Play and the aesthetic dimension in modern philosophical and scientific discourse [Book review]. *Play & Culture*, *5*, 314–322.

Turner, M. (1995). Cognitive science and literary theory. In Franchi and Güzeldere (Eds.), op. cit.

Turner, M. (1991). *Reading mind: The study of English in the age of cognitive science*. Princeton, NJ: Princeton University Press.

Varela, F. J. (1996). Neurophenomenology: A methodological remedy for the hard problem. *Journal of Consciousness Studies*, *3*(4), 330–349.

Whitaker, R. (1987). Thinking machines. December 2001. http://www.foresight.org/EOC/EOC_Chapter_5.html

Whitaker, R. (1986). *Engines of creation*. New York: Anchor Books.

Wolfe, J. (1991). Some comments on modeling the human component in computer-based business simulations. *Simulation & Gaming*, *24*(1), 21–33.

Index

Digital Formations

General Editor: Steve Jones

Digital Formations is the new source for critical, well-written books about digital technologies and modern life. Books in this series will break new ground by emphasizing multiple methodological and theoretical approaches to deeply probe the formation and reformation of lived experience as it is refracted through digital interaction. Each volume in *Digital Formations* will push forward our understanding of the intersections—and corresponding implications—between the digital technologies and everyday life. This series will examine broad issues in realms such as digital culture, electronic commerce, law, politics and governance, gender, the Internet, race, art, health and medicine, and education. The series will emphasize critical studies in the context of emergent and existing digital technologies.

For additional information about this series or for the submission of manuscripts, please contact:

Acquisitions Department
Peter Lang Publishing
275 Seventh Avenue 28th Floor
New York, NY 10001

To order other books in this series, please contact our Customer Service Department:

(800) 770-LANG (within the U.S.)
(212) 647-7706 (outside the U.S.)
(212) 647-7707 FAX

or browse online by series:

WWW.PETERLANGUSA.COM